T0041395

THE OFFICIAL

CIA MANUAL
OF TRICKERY
AND DECEPTION

THE OFFICIAL

CIA MANUAL OF TRICKERY AND DECEPTION

H. KEITH MELTON
AND ROBERT WALLACE

WILLIAM MORROW
An Imprint of HarperCollins*Publishers*

Images on pages 15, 28, 33, 46, 56, 58, 61, 65, and 245 are courtesy of the authors. All other illustrations by Phil Franke.

A hardcover edition of this book was published in 2009 by William Morrow, an imprint of HarperCollins Publishers.

HarperCollins books may be purchased for educational, business, or sales promotional use. For information, please e-mail the Special Markets Department at SPsales@harpercollins.com.

FIRST HARPER PAPERBACK PUBLISHED 2010.

Designed by Joy O'Meara

Library of Congress Cataloging-in-Publication Data has been applied for.

ISBN 978-0-06-172590-6

23 24 25 26 27 LBC 21 20 19 18 17

CONTENTS

ACKNOWLEDGMENTS

It is unlikely that either John Mulholland or Dr. Sidney Gottlieb, the CIA officer who authorized the creation of "Some Operational Applications of the Art of Deception" and "Recognition Signals," ever anticipated their manuals would become available to anyone without security clearances. Both men understood that their respective professions, as magician or CIA officer, required oaths of secrecy.

The magician's oath states:

> As a magician I promise never to reveal the secret of any illusion to a non-magician, unless that one swears to uphold the Magician's Oath in turn. I promise never to perform any illusion for any non-magician without first practicing the effect until I can perform it well enough to maintain the illusion of magic.

Members of the magic community disavow anyone seen as betraying this oath, but also recognize the necessity to expose secrets of their craft responsibly to students and others desirous of learning magic. In his 2003 book, *Hiding the Elephant: How Magicians Invented the Impossible and Learned to Disappear,* illusionist and author Jim Steinmeyer addressed the conundrum faced by those seeking to write about magic, yet still preserve its mysteries:

> In order to understand how Houdini hid his elephant, we're going to have to explain a few secrets. We'll have

to violate that sacred magician's oath. In the process, I promise that there will be a few disappointments and more than a few astonishments. But to appreciate magic as an art, you'll have to understand not only the baldest deceptions, but also the subtlest techniques. You'll have to learn to think like a magician.

In his popular general market book of 1963, *Mulholland on Magic,* the skilled practitioner himself revealed many of the principles of magic that a decade earlier had been included in his operational manuscript for the CIA. The real secret that Gottlieb and Mulholland sought to preserve, however, was not of specific tricks, but that professional intelligence officers, not just performing magicians, would be acquiring the necessary knowledge to apply the craft to the world of espionage.

In a sense, this book is the result of two historical accidents. The first "accident" is that of the thousands of pages of research conducted under the CIA's decade-long MKULTRA program, to our knowledge, only two major research studies—Mulholland's manuals—survived CIA Director Richard Helm's order in 1973 to destroy all MKULTRA documents. Mulholland's manuals are a rare piece of historical evidence that the CIA, in the 1950s, through MKULTRA, sought to understand and acquire unorthodox capabilities for potential use against the Soviet adversary and the worldwide Communist threat. The manuals and other declassified MKULTRA administrative materials further reveal that many of America's leading scientists and private institutions willingly participated in secret programs they agreed were critical to the nation's security.

The second "accident" was the authors' discovery of the long-lost CIA manuals while conducting unrelated research in 2007. Although portions of the manuals had been previously described,

referenced, or printed in part, we were unaware of the existence of a copy of the complete declassified work along with the original drawings and illustrations.

Notable public references to the Mulholland manuals were made by magician-historian Michael Edwards in a 2001 article, "The Sphinx & the Spy: The Clandestine World of John Mulholland," in *Genii: The Conjurors' Magazine,* April 2001, a partial reproduction of Mulholland's first manual in *Genii,* vol. 66 no. 8, August 2003, and Ben Robinson's *MagiCIAn: John Mulholland's Secret Life,* Lybrary.com, 2008. Neither the CIA's library, nor its Historical Intelligence Collection, contained a copy of Mulholland's manuals.

When retrieved by the authors, the manuals' text was legible, but the poor quality of photocopied pages of Mulholland's accompanying illustrations, drawings, and photographs required careful study to understand his original intent. To enhance the manuals' readability, corrections to grammar, punctuation, and related errors that do not alter the substance of the original material have been made. We are indebted to our HarperCollins editor, Stephanie Meyers, for recommending Phil Franke as the illustrator, who has re-created the style and precision of the original images. The reader will find Phil's mastery of capturing human hand and arm movements, which are central to Mulholland's explanation of his tricks, to be superb art.

From the first day we mentioned this project, Daniel Mandel, our agent at Sanford J. Greenburger and Associates, was an enthusiastic promoter. We are deeply appreciative for the personal interest in the subject by Steve Ross, then at HarperCollins, and his actions in making the project possible. Stephanie Meyers provided excellent suggestions and guidance in constructing the overall work and seeing it through to publication. The HarperCollins graphic design team has created a

Acknowledgments

distinctive cover that reflects the historical look and significance of the material.

While researching, writing, and rewriting the book, we received the daily good-spirited assistance of Mary Margaret Wallace in typing and editing drafts that bounced back and forth between the authors. Consistent encouragement and well-placed suggestions and criticisms from Hayden Peake and Peter Earnest substantially improved our initial drafts. Tony and Jonna Mendez offered perspectives from their experiences that enabled us to translate many of the elements of magic from theory to practice. Additional appreciation is owed to Jerry Richards, Dan Mulvenna, Nigel West, Michael Hasco, David Kahn, and Brian Latell, as well as Ben, Bill, and Paul for their insights and contributions. Susan Rowen served as our "hand model" and kept our spirits roused as the authors re-created each of Mulholland's original photographs as references for artist Phil Franke.

John McLaughlin, former deputy director and acting director of the CIA, reviewed the manuscript to validate our use of magic terminology, as well as contributing the book's preface and administering the "magician's oath" to the authors. John is an accomplished amateur magician and, by virtue of his distinguished career at the CIA, is uniquely qualified to understand the rich overlap between the tradecraft of the intelligence officer and the magician. As a senior research fellow and lecturer at Philip Merrill Center for Strategic Studies at the Paul H. Nitze School of Advanced International Studies in Washington, D.C., he often begins presentations on strategic deception with demonstrations from his repertoire of magic tricks.

FOREWORD

by John McLaughlin

Former Deputy Director, Central Intelligence

This is a book about an extraordinary American magician and the way his life intersected with American intelligence at a pivotal moment in its early history.

John Mulholland was never a household word, like the world famous escapologist Houdini or, more recently, the illusionist David Copperfield. But among professional magicians from the 1930s to the 1950s, he was seen as the very model of what a magician should be—urbane, highly skilled, inventive, and prolific. He was very successful professionally, entertaining mostly in New York City society circles. He published widely on magic, both for the general public and for the inner circle of magicians who subscribed to the professional journal he edited for decades, *The Sphinx.* His impact on the art of magic was enormous.

Mulholland's 1932 book, *Quicker Than the Eye,* was one of the first books I stumbled on as a magic-struck boy combing the public library in the 1950s. I fondly remember being transported by an author who seemed to have traveled the world and witnessed marvelous things I could only imagine.

That's what fascinated me about Mulholland then. As a lifelong amateur magician who spent a career in American intelligence, what fascinates me about Mulholland today is the way the story told here resonates with something I came to conclude in the course of my professional life: that magic and espionage are really kindred arts.

The manual that Mulholland wrote for the Central Intelligence Agency and that is reproduced here sought to apply to some aspects of espionage the techniques of stealth and misdirection used by the professional conjuror.

Many may ask what these two fields have to do with each other. But a cursory look at what intelligence officers do illustrates the convergence.

Just as a magician's methods must elude detection in front of a closely attentive audience, so an intelligence officer doing espionage work must elude close surveillance and pass messages and materiel without detection.

In another part of the profession, analysts must be as familiar as magicians with methods of deception, because analysts are almost always working with incomplete information and in circumstances where an adversary is seeking to mislead them—or in the magician's term, misdirect them.

Counterintelligence officers—people who specialize in catching spies—work in a part of the profession so labyrinthine that it is often referred to as a "wilderness of mirrors"—a phrase, of course, with magical overtones.

Finally, there are the covert-action specialists. In any intelligence service, these are the officers who seek at the direction of their national leaders to affect events or perceptions overseas, especially during wartime. Principles of misdirection familiar to magicians were evident in many of the great British covert operations of World War II—such as deceiving Hitler into thinking the 1943 Allied invasion from North Africa would target Greece rather than its true target, Sicily. This was the conjuror's stage management applied to a continent-sized theater.

The manual Mulholland produced for the CIA does not read the way a book for experienced magicians would read. He is clearly addressing an amateur audience and takes care to explain

things in the simplest of terms. Yet he draws on the underlying principles of magic to explain how intelligence officers could avoid detection in the midst of various clandestine acts.

A case can be made that Mulholland's instruction influenced the more mundane aspects of espionage tradecraft—how to surreptitiously acquire and conceal various materials, for example. As best we know, however, the methods he designed for more aggressive actions—clandestinely delivering pills and powders into an adversary's drink, for example—were never actually used.

The fact that he was asked to contemplate such things is emblematic of a unique moment in American history. American leaders during the early Cold War felt the nation existentially threatened by an adversary who appeared to have no scruples. Mulholland's writing on delivery of pills, potions, and powders was just one example of research carried out back then in fields as diverse as brainwashing and paranormal psychology. Many such efforts that seem bizarre today are understandable only in the context of those times—the formative years of the Cold War.

These were also the formative years for the American intelligence community. It is important to remember that this was a very new field for the United States. Most other countries had long before integrated espionage into the national security tool kit; the Chinese strategist Sun Tsu had written about it in sophisticated terms in the sixth century B.C., and older countries such as Britain, Russia, and France had been at it for centuries. While the United States had used intelligence episodically, it was not organized at a national-level effort until 1947, and our young country struggles still today with its proper place in our national security strategy.

I doubt many intelligence officers today would recognize John Mulholland's name. But the essence of his contribution had little

to do with notoriety or fame. It was, in effect, to help the nation's early intelligence officers think like magicians. Given the close kinship between these two ancient arts, that was a significant contribution indeed and one that continues—in stealthy ways that Mulholland would probably admire—to this very day.

THE OFFICIAL

CIA MANUAL
OF TRICKERY
AND DECEPTION

INTRODUCTION:
The Legacy of MKULTRA
and the Missing Magic Manuals

Magic and Intelligence are really kindred arts.

—JOHN MCLAUGHLIN,
FORMER DEPUTY DIRECTOR OF CENTRAL INTELLIGENCE

In 2007, the authors discovered a long-lost CIA file, once classified top secret, which revealed extraordinary details of the agency's connection to the world of magic decades earlier. The documents, part of project MKULTRA, shed light on a fascinating and little-known operation—the employment of John Mulholland as the CIA's first magician. An accomplished author and America's most respected conjurer of his day, Mulholland authored two illustrated manuals for teaching CIA field officers how to integrate elements of the magician's craft into clandestine operations. Due, in part, to the extraordinary levels of secrecy surrounding MKULTRA, the manuals were considered too sensitive to be distributed widely and all copies were believed to have been destroyed in 1973.[1] Nearly fifty years after they were written, rumors of the existence of a long-lost copy of the "magic" manuals continued to fly through the corridors at Langley, but many intelligence officers thought they were a myth.[2] To understand the CIA's first magician, and how his remarkable

manuals came to be, it is necessary to recall one of the most dangerous periods in U.S. history.

With its establishment in July 1947, the CIA received two primary missions—prevent surprise foreign attacks against the United States and counter the advance of Soviet communism into Europe and third-world nations. Officers of "the Agency," as the CIA became known, would be on the front lines of the Cold War for four tense decades fueled by nuclear stalemate, incompatible ideologies, and a Soviet government obsessed with secrecy. At home, the USSR's security and intelligence organizations, the KGB and its predecessors, cowed the internal population, and abroad they attempted to undermine foreign governments aligned with the West.

The Soviet Union's successful testing of a nuclear weapon in 1949 caught the United States by surprise and created two nuclear powers competing in an international atmosphere of fear and uncertainty. President Eisenhower received a startling top secret report in 1954 from a commission headed by retired general James H. Doolittle that concluded, "If the U.S. is to survive, long-standing American concepts of 'fair play' must be reconsidered. We must learn to subvert, sabotage, and destroy our enemies by cleverer, more sophisticated, and more effective methods than those used against us. It may become necessary that the American people become acquainted with, understand, and support this fundamentally repugnant philosophy."[3]

The report affirmed a threat to the Western democracies from Soviet-sponsored aggression and called for an American offensive and defensive intelligence posture unlike anything previously authorized in peacetime. As a result, the CIA's covert-action role expanded from Europe into the Middle East, Africa, Latin America, and the Far East. Reflecting on those years more than half a

century later, former U.S. secretary of state Henry Kissinger asserted that during the decade of the 1950s only the United States stood between Soviet-led communism and world freedom.[4]

The CIA had been engaged in covert programs since its creation and in 1951 formed a special unit, the Technical Services Staff (TSS), to exploit advances in U.S. technology in support of espionage operations. One of TSS's first employees was Dr. Sidney Gottlieb, whose degree in chemistry from the California Institute of Technology made him a logical choice to head the handful of chemists in the staff. Initially the chemistry branch created and tested formulas, or "special inks," for secret writing that enabled CIA spies to embed invisible messages in otherwise innocuous correspondence.[5] To conceal the liquid "disappearing inks," TSS reformulated the liquids into a solid form that looked like aspirin tablets and repackaged the tablets in pill bottles that would pass unnoticed in an agent's medicine cabinet. When a spy had information to convey, he would dissolve the tablet in water or alcohol to reconstitute the ink for his secret message.

TSS supported other activities of the Agency as well: forging travel and identity documents for agents who worked under alias names, printing propaganda leaflets, installing clandestine microphones and cameras, and building concealments for spy equipment in furniture, briefcases, and clothing. To those uninitiated in the craft of espionage, the secretive work of the TSS scientists and engineers at times appeared to accomplish the impossible. In reality, this handful of CIA scientists was demonstrating the third law of prediction advanced by science-fiction author Arthur C. Clarke: "Any sufficiently advanced technology is indistinguishable from magic."[6]

Dr. Sidney Gottlieb, Chief, CIA Technical Services Division, 1966–1973.

Dr. Gottlieb and his chemists expanded their research during 1953 to counter another unanticipated Soviet threat. The three-year-long Korean War had stalemated and the alliance of North Korea, China, and the Soviet Union seemed on the road to mastering the art of "mind control." Such a capability could render soldiers, and possibly entire populations, vulnerable to Communist propaganda and influence. Reports reached the CIA about Soviet clandestine successes with mind control and newly discovered capabilities to brainwash, recruit, and operate agents with the aid of drugs.[7]

Mind control appeared to allow the Communists, using a combination of psychological techniques and newly developed pharmacological compounds, to remotely alter a subject's mental capacities and control his "free will."[8] Despite limited research on similar topics during World War II and the early 1950s, the science underlying

the reported Soviet successes remained a mystery. America needed to understand the scientific basis of mind control and develop safeguards and, if necessary, applications for its own use.

In March 1953, Allen Dulles, Director of Central Intelligence, entrusted the thirty-four-year-old Gottlieb with one of America's most secret and sensitive Cold War programs, codenamed MKULTRA. Dulles authorized TSS and Dr. Gottlieb's chemical staff to begin work on multiple projects for "research and development of chemical, biological, and radiological materials capable of employment in clandestine operations to control human behavior."[9]

MKULTRA eventually encompassed 149 subprojects and remained one of the CIA's most carefully guarded secrets for over twenty years.[10] Its projects aimed to understand how drugs and alcohol altered human behavior and to protect American assets from Soviet psychological or psychopharmaceutical manipulation. The research included clandestine acquisition of drugs, clinical testing on and experimentation with humans, some of whom were unaware of said testing, and grant proposals and contracts with hospitals, companies, and individuals. The scientists investigated topics ranging from concocting truth serums to developing a humane way to incapacitate guard dogs using a powerful tranquilizer mixed into ground beef.[11] Several projects involved research on little-understood mind-altering drugs such as LSD and marijuana. In the end, the research produced an assortment of potential offensive capabilities involving incapacitating, lethal, and untraceable toxins.

However, the absence of scientific data in the early 1950s about the effective and safe dosage levels of the new drugs, including LSD, presented a problem for the MKULTRA researchers. As a result, Gottlieb and members of his team performed experiments on themselves that included ingesting drugs and

observing and recording their own reactions. In late 1953, an early LSD experiment involving several government scientists went horribly bad.

"Hush puppy" pills contained a harmless tranquilizer, which was mixed with ground beef and fed to the dog. To avoid suspicion, adrenaline-filled syrettes would reawaken the dog when the mission was concluded.

Dr. Frank Olson was working at the U.S. Army Special Operations Division (SOD) biological weapons facility at Ft. Detrick, Maryland, and assisting the CIA on MKULTRA projects. Along with half a dozen other scientists, he volunteered to attend a retreat during mid-November 1953 at the remote Deep Creek Lodge in western Maryland, organized by Gottlieb.[12] Together with seven other researchers from TSS and Ft. Detrick, Olson was served Cointreau liqueur that had secretly been spiked with seventy micrograms of LSD. After thirty minutes, the partici-

pants were told of the LSD and alerted to begin studying their reactions. Most reported little effect, but Olson had a "bad trip" that night. As his condition worsened in the following days, Gottlieb's deputy, Dr. Robert Lashbrook, escorted him to New York City for psychiatric counseling. This attention and treatment seemed to calm Olson temporarily, but later that evening on November 24, 1953, he jumped to his death from a tenth-floor window of his New York hotel room.

CIA executives, seeking to protect the secrecy of the MKUL-TRA program, did not fully reveal the circumstances of Olson's death to his family. No other fatalities from the MKULTRA experiments occurred, but two decades passed before Olson's widow received a delayed apology from President Gerald Ford and a financial settlement from the U.S. government.[13]

Soviet intelligence in the 1950s, however, was less averse to death, either from accident or from assassination. Nikita Khrushchev, the successor to dictator Joseph Stalin, continued the existing policy of "special actions" as a central tool for dealing with the leaders of anti-Soviet émigré groups.[14] The first target of the post-Stalinist era, Ukrainian nationalist Georgi Okolovich, was spared when the assassin, KGB officer Nikolai Khokhlov, confessed the plot to his victim and defected to the CIA. On April 20, 1954, Khokhlov gave a dramatic press conference and revealed both the assassination plot and his exotic weapon to the world.[15] The execution device was an electrically operated gun and silencer hidden inside a cigarette pack that shot cyanide-tipped bullets.[16] This failure was followed soon thereafter by the successful assassinations of Ukrainian leaders Lev Rebet in 1957 and Stephen Bandera in 1959. Both were killed by KGB assassin Bogdan Stashinsky, who defected in 1961 and revealed that he had disposed of his weapon, a cyanide gas gun concealed in a rolled-up newspaper, in a canal

near Bandera's residence in Munich, Germany.[17] An analysis of the KGB cigarette-pack gun and Stashinsky's cyanide weapon, recovered from the canal, stimulated accelerated U.S. efforts to create comparable weaponry for the United States.[18]

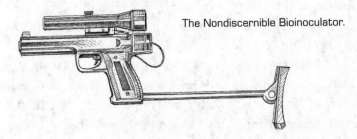

The Nondiscernible Bioinoculator.

From the beginning of MKULTRA, CIA scientists researched lethal chemical and biological substances, as well as "truth serums" and hallucinogens, as they continued work begun in the Office of Strategic Services during World War II. Under a joint project code-named MKNAOMI, TSS and the SOD cooperated on development of ingenious weapons and exotic poisons. One Army-produced handgun, called the "nondiscernible bioinoculator," resembled a .45-caliber Colt pistol that, fitted with a telescopic sight and detachable shoulder stock, fired a toxin-tipped dart silently and accurately up to 250 feet. The dart was so small—slightly wider than a human hair—it was nearly undetectable

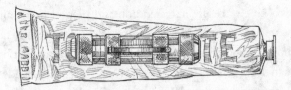

A toothpaste tube used as concealment for the CIA STINGER, a small .22-caliber single-shot firing device.

and left no traces in the target's body during an autopsy.[19] Other dart-firing launchers were developed and concealed inside fountain pens, walking canes, and umbrellas.[20]

Research was also conducted on a variety of exotic poisons including shellfish toxins, cobra venom, botulinium, and crocodile bile.[21] Under the MKULTRA program, the CIA stockpiled eight different lethal substances and another twenty-seven temporary incapacitates either for specific operations or as on-the-shelf capabilities for possible future use.[22] In one example, a tube of poison-laced toothpaste was prepared for insertion into the toiletry kit of President Patrice Lumumba in 1960. However, the CIA office chief in Leopoldville, Larry Devlin, rejected the plan and tossed the tube into the nearby river.[23] About the same time, CIA treated a handkerchief with an incapacitating agent, brucellosis, to be sent to a targeted Iraqi colonel,[24] but the man was shot by a firing squad before the handkerchief ever arrived.[25]

Illustration of original vials of lethal shellfish toxin created for MKULTRA.

Perhaps some of the most creative and almost whimsical CIA plots considered in the early 1960s were part of Operation Mongoose, meant to discredit or assassinate Cuban leader Fidel Castro using an assortment of incapacitating and deadly paraphernalia.[26]

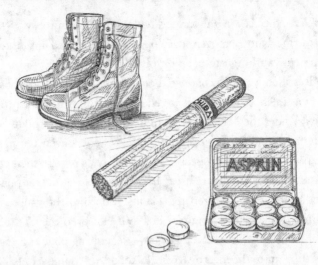

The CIA considered modifying various devices for assassinating Castro.

HALLUCINOGENIC SPRAYS AND CIGARS: One bioorganic chemist proposed spraying LSD inside Castro's broadcasting studio in Havana to cause him to hallucinate.[27] Since Castro famously smoked cigars, another idea suggested impregnating Castro's cigars with a special chemical to produce temporary disorientation during his rambling speeches during their live broadcast to the Cuban people.[28]

CONTAMINATED BOOTS: When Castro traveled abroad, he often left his boots outside the hotel room door at night to be shined. CIA considered dusting the insides of the boots with thallium salts, a strong depilatory, which would cause his beard to fall out. The chemical was procured and tested successfully on animals, but the plan scrapped when Castro canceled the targeted trip.[29]

DEPILATORY, POISONED, AND EXPLODING CIGARS: Similar to the dusted-boot concept, Castro's cigars could be treated with a powerful depilatory, causing loss of beard and corresponding damage to his "macho" image. A special box of

cigars was to be provided for Castro during an appearance on David Susskind's television talk show. However, after a senior CIA officer questioned how the operation could ensure that only Castro would smoke the cigars, the idea was abandoned.[30]

In another attempt, a Cuban double agent was recruited to offer Castro a cigar treated with botulin, a deadly toxin that would cause death within seconds. The cigars were passed to the agent in February 1961, but he failed to carry out the plan.[31] Cuban security officials eventually created a private cigar brand, the Cohiba, exclusively for Castro, to safeguard his supply against future assassination attempts.

A third concept involved planting a box of exploding cigars at a place where Castro would visit during a trip to the United Nations and "blow his head off." The plan was not carried out.[32]

In addition to cigars, Castro enjoyed Cuba's oceans and beaches, which offered an operational venue for:

EXPLODING SEASHELLS: TSD was asked in 1963 to construct a seashell filled with explosives. This device was to be planted near Cuba's Veradero Beach, a place where Castro commonly went skin diving. CIA discarded the idea as impractical when it failed an operational review.[33]

CONTAMINATED DIVING SUIT: A proposal was made for an intermediary to present Castro with a diving suit and breathing apparatus contaminated with tubercle bacillus (tuberculosis germ).[34] CIA obtained a diving suit and dusted it to produce Madura foot, a chronic skin disease. The plan failed when the intermediary chose to present a different diving suit.[35]

POISONED PEN: About the same time that President Kennedy was assassinated in Dallas—November 22, 1963—a CIA officer met secretly with Rolando Cubela, a Cuban agent in Paris,

A hypodermic syringe was concealed inside this modified Paper Mate pen for an operation to assassinate Castro.

and offered a *poisoned pen* to kill Castro. The device, a Paper Mate ballpoint, was modified to conceal a small hypodermic syringe for injecting Blackleaf-40 poison. Even the slightest prick would result in a certain death, though the agent would have time to escape before the effects were noticed. After learning of Kennedy's death, however, Cubela reconsidered the plan and disposed of the pen prior to returning to Cuba.[36] A decade later, in 1976, American policy governing lethal actions against foreign leaders was formalized when President Ford issued Executive Order 11905 prohibiting political assassinations.[37]

From the earliest days of MKULTRA, Dr. Sidney Gottlieb recognized that CIA's drugs and chemicals, regardless of their ultimate purpose, would be operationally useless unless field officers and agents could covertly administer them. During the same month MKULTRA was authorized, April 1953, Gottlieb contacted John Mulholland, then fifty-five years old and one of America's most respected magicians. Mulholland was an expert in sleight of hand or "close-up" magic, a style of conjuring that

appealed to Gottlieb because it was performed only a few feet from the audience.[38] Further, sleight-of-hand illusions required no elaborate props for support. If Mulholland could deceive a suspecting audience who was studying his every move in close proximity, it should be possible to use similar tricks for secretly administering a pill or potion to an unsuspecting target.

To do so, CIA field officers would need to be taught to perform their own tricks and John Mulholland, the author of several books about performing magic, appeared to be the ideal instructor.[39] When approached, Mulholland soon agreed to develop a "spy manual" for Gottlieb describing "the various aspects of the magician's art," which might be useful in covert operations. The instructions would provide information enabling a field case officer "to develop the skills to surreptitiously place a pill or other substance in drink or food to be consumed by a target."[40] Mulholland accepted $3,000 to write the manual and the CIA approved the expense as MKULTRA Subproject Number 4 on May 4, 1953.[41]

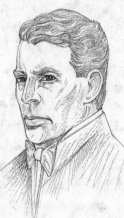

John Mulholland—world-renowned magician, "Deception that is art."

As part of the broader top-secret MKULTRA program, confidentiality regarding the CIA-Mulholland relationship and possible operational use of the techniques of magic was essential. Multiple layers of security included a formal secrecy agreement with Mulholland, "sterile" correspondence using alias names, cover companies, and nonattributable post office boxes. CIA used various covers for Dr. Gottlieb. Initially he communicated with Mulholland as Sherman C. Grifford of Chemrophyl Associates through a numbered post office box in Washington, D.C.[42] Subsequently the P.O. box number changed, as did the cover name, to Samuel A. Granger, president of the notional Granger Research Company.[43]

As an added measure, Mulholland's writing contained no reference to the CIA or clandestine operations. Field case officers were called "performers" or "tricksters" and the covert acts referred to as "tricks." Mulholland pledged never to divulge, publish, or reveal the information, methods, or persons involved.[44] Information compartmentation practices at the time make it unlikely that Mulholland was told about any of the other MKULTRA subprojects and there is no evidence that Mulholland designed the sleight-of-hand tricks for any specific operation.

By the winter of 1954, the manuscript, titled "Some Operational Applications of the Art of Deception," was complete.[45] Gottlieb, apparently pleased with the effort, then saw another area for the magician's skills: the CIA needed new methods for secret communication between officers and spies. Gottlieb invited Mulholland to suggest how the CIA might appropriate "techniques and principles employed by 'magicians,' 'mind readers' etc. to communicate information, and the development of new [nonelectrical communication] techniques."[46] For this new assignment, Mulholland produced another, but much shorter manual titled "Recognition Signals."

Office of

JOHN MULHOLLAND

130 WEST 42nd STREET, NEW YORK 18, N. Y.

WISCONSIN 7-2577

■

September 10,1957

Attached is a drawing of a toy which I am
submitting today, at 10:00 A.M., to Mr.
Hoover, President, Plakie Toy Company,
1350 Broadway, New York City.

John Mulholland

John Mulholland's stationery from 1953 to 1958.

In 1956, Gottlieb again expanded John Mulholland's role as a consultant to consider "the application of the magician's techniques to clandestine operations, such techniques to include surreptitious delivery of materials, deceptive movements and actions to cover normally prohibited activities, influencing choices and perceptions of other persons, various forms of disguise; covert signaling systems, etc."[47] Mulholland's work for TSS continued until 1958, when his failing health from constant smoking and advancing arthritis limited his ability to travel and consult.[48]

Mulholland's manuscripts, "Some Operational Applications of the Art of Deception" and "Recognition Signals," are among the few remaining documents to reveal MKULTRA's research. Virtually all of the program's reports and operational files on the "research and development of chemical, biological, and radiological materials capable of employment in clandestine operations to control

human behavior" were ordered destroyed by DCI Richard Helms in 1973, ten years after most of the research had ended.[49] According to a CIA officer in the 1970s, the Mulholland manual(s) "is the only product of MKULTRA known to have escaped destruction."[50] Gottlieb, MKULTRA's principal officer, had written in 1964, "It has become increasingly obvious over the last several years that the general area [of biological and chemical control of human behavior] had less and less relevance to current complex operations. On the scientific side these materials and techniques are too unpredictable in their effect on individual human beings to be operationally useful."[51]

But the destruction of the MKULTRA documents would itself become a problem for the Agency. In the wake of *New York Times* articles alleging CIA abuses and misconduct related to domestic spying in December 1974, a U.S. Senate Committee, headed by Senator Frank Church, launched an investigation. One sensational revelation from the hearings involved the discovery of nonoperational MKULTRA financial and administrative documents that had escaped destruction two years earlier. Senate scrutiny of the files revealed that drug experiments with provocative names such as Operation Midnight Climax had been run from CIA safe houses in California and New York. These experiments observed the effects of LSD on unwitting individuals or "clients" who were lured to the safe houses by prostitutes. Their reactions to drugs were surreptitiously monitored from behind one-way mirrors to judge the effectiveness of LSD, "truth serums," and other mind-control substances.[52]

Although he had been retired for two years, Gottlieb was called as a witness by the Senate committee and questioned for four consecutive days in October 1975. The questioning concentrated on the drug experiments and Gottlieb apparently was not asked about the John Mulholland contract. Subsequently,

following months of investigative work and thousands of hours of testimony, the Church Committee cited the CIA for a failure of "command and control" for only two drug experimentation projects including the 1953 event that had resulted in the death of Dr. Olson. The committee then concluded that none of the officers conducting MKULTRA had undertaken or participated in illegal or criminal activities.

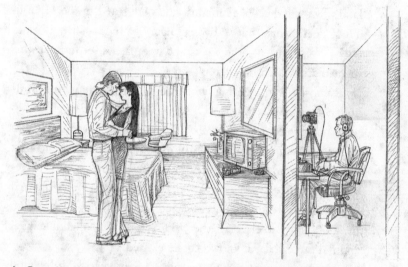

An Operation Midnight Climax researcher monitors the hotel room from behind a one-way mirror to secretly photograph and record events.

Keeping his promise of secrecy, Mulholland died in 1970 without revealing his clandestine role as "the CIA's magician."[53] The public learned of his covert relationship with the CIA, and the Agency's interest in drawing on the techniques of conjuring and magic for its espionage mission, only when the MKULTRA documents were declassified in 1977.[54] For nearly twenty-five years, the story was nearly forgotten until a well-researched article by magic historian Michael Edwards appeared in *Genii*

magazine in 2001, a follow-up August 2003 piece by Richard Kaufman in *Genii*, and a biography of Mulholland by magician Ben Robinson was published in late 2008 under the title, *Magi-CIAn: John Mulholland's Secret Life.*[55]

Declassified CIA documents, the *Genii* articles, and Robinson's book described an elusive, illustrated "manual" written by Mulholland detailing how to perform magic tricks for potential use by intelligence officers. The seven chapter titles of Mulholland's first hundred-page manuscript were listed in the MKULTRA documents, but Edwards noted, "Today—five decades after it was written—the tricks and approaches set forth in this manual are still classified 'top secret.'"[56]

Robinson, commenting about the secrecy surrounding Mulholland's manual, stated: "Of a one-hundred-and-twenty-one-page manual comprised of eight chapters, the government has allowed only fifty-six pages to be made public. Of the fifty-six pages seen, roughly two-thirds of the pages are visible; the remaining third has been redacted [blacked out]."[57] An internal history of the Technical Services Staff written by a CIA historian in 2000–2001 referred to the "top-secret" Mulholland manual and indicated that no known copies existed.

We now know that under his CIA contracts Mulholland produced at least two illustrated manuals. The first described and illustrated numerous "tricks," primarily sleight-of-hand and close-up deceptions for secretly hiding, transporting, and delivering small quantities of liquids, powders, or pills in the presence of unsuspecting targets. The second, much shorter manual revealed methods used by magicians and their assistants to pass information among one another without any appearance of communication. The manuals were written in the form of general training instructions rather than for support for specific operations. Only one copy of the original manuals is known to have survived.

For Gottlieb and his successors, the techniques of deception used by performing magicians, when added to the "magic" of technology, presented an intriguing potential to enhance the clandestine delivery of materials and secret communications. Mulholland's principles of magic were consistent with the CIA's doctrine of tradecraft, and in the ensuing decades talented consultants from the world of magic provided the CIA with innovative illusions to mask and obscure clandestine operations. Multiple elements of the magician's craft can be seen throughout the world of espionage, most notably in stage management, sleight of hand, disguise, identity transfer, escapology, and special concealment devices such as coins.

Stage Management and Misdirection

> The proper secret for a magician to use
> is the one indicated as best under the
> conditions and circumstances of the
> performance.
>
> —JOHN MULHOLLAND

John Mulholland instructed officers that their success, as opposed to that of magicians, depended upon the fact that they are not known to be, or even suspected of being, tricksters. The deceptive techniques he taught for delivering CIA pills, powders, and potions were to be performed clandestinely, yet in full view of audiences that, if aware of the nature of the activity, would immediately confront and arrest the spy. Awareness and "management" of the potentially hostile environment, where audiences are culturally diverse, uncontrolled, and sometimes unseen, is as critical to a spy's success as his special devices. Similarly, a successful stage magician understands that the execution of a trick

may not produce an effective illusion unless the stage and audience are consciously managed.

Mulholland, the master of "close magic," instructed his CIA "tricksters" that "the more of the performer that can be seen, the less his chance of doing anything without detection. As an example, a performer on the stage would be seen were he to put his hand into his pocket, but that action can be made without being seen while standing close to a person so the hand is outside of his range of vision."[58] This style of magic was ideal for the CIA-intended actions that needed to be performed in close proximity to the target.

Sight lines, limiting what the audience is allowed to see, are arranged so that the magician's trick may be executed without exposing secret equipment or maneuvers.[59] The placement of the magician's scenery, props, lighting, and even a distractingly beautiful assistant further protect and safeguard the illusion. Sufficient time is allocated for preparing complex illusions and an unlimited number of rehearsals may be conducted to tweak and perfect the performance. In contrast to espionage, where a single mistake can be deadly for the spy, slip-ups by a magician during a "live show" carry little consequence beyond momentary embarrassment.

To create an effective illusion, the spy and the magician employ similar craft and stage management techniques.[60] Plausible reasons are substituted for reality to conceal true purposes, and spectator attention is lulled and diverted. For both spies and magicians to be successful, execution must be carefully planned, exhaustively practiced, and skillfully performed.

Magicians plan performances by asking themselves "what is my stage?" and "who is my audience?" Mulholland taught that these questions should be supplemented by asking "what is my goal for the operation?" and "how can I carry out the operation secretly?" Only after these questions have been sufficiently answered can the likely stage and audience be assessed.

For the magician, the perfectly executed illusion is the ultimate goal. For the spy, illusion is only a means to divert attention from a clandestine act. To be successful, the espionage illusion must withstand both the direct observation of onlookers (casuals) and the scrutiny of professional counterintelligence officers (hostile surveillance), without exposing either the participation or identification of the agent. Typical clandestine acts of this type involve covert exchange of information, money, and supplies between the spy and intelligence officer.

Proper stage management techniques provide reasons for the magician's audience to believe their eyes instead of their reason. People have an almost infinite capability to self-rationalize and "know" that humans cannot levitate or survive being cut in half, yet both appear to occur on a well-managed stage. The CIA learned to exploit such tendencies in operations where the spy needed the hostile surveillance team to ignore direct visual observations and rationalize events as nonalerting. For example, an intelligence officer may always park his car at the curb directly in front of his house. This is observed by surveillance. On the day a dead drop is left for an agent, the car is parked across the street from the house.[61] The agent recognizes the different parking location as a signal, while surveillance sees no significance.

Strategic misdirection becomes even more effective when combined with camouflage and illusion. During World War II, stage magician Jasper Maskelyne used his skills for "deceiving the eye" to support the British Camouflage Directorate.[62] Inflatable rubber tanks were created to misdirect enemy attention away from real tanks that were disguised with plywood shells to appear as transport trucks. Operationally, an entire column of "trucks" could shed their artificial skins and reappear on the battlefield "out of thin air," as if by magic!

Such operations also had applications in naval deceptions. In

1915, "Q-boats," apparently harmless, worn-out steamers appearing to be easy prey, lured German submarines close in to finish them off with their deck gun. The Q-boats had been fitted with concealed guns disguised in collapsible deckhouses or lifeboats. Naval uniforms for the crew were exchanged for old secondhand uniforms to disguise their crew and captain, who remained hidden to portray a lightly manned and vulnerable vessel. Only when the submarine drew close enough "for the kill" would the trap be sprung, and the superstructure pivoted away to reveal the Q-boat's formidable weaponry.[63]

Reminiscent of the Q-boats' successful deception, in 1961 CIA officers acquired standard Chinese junks in Hong Kong for conversion with high-speed craft equipped with marine diesel engines, fifty-caliber machine guns, and a battery of camouflaged 3.5-inch rockets. The boats, which appeared externally unmodified, would patrol covertly off the Vietnamese coast above the DMZ, and, if necessary, be able to quickly discard their camouflaged junk superstructure and hull "like magic" before disappearing at high speed.[64]

For agent operations, a retired CIA technical officer, Tony Mendez, has described the elaborate stage management techniques used in Moscow against elite surveillance teams of the KGB's Seventh Directorate. By "lulling" the surveillance team with an unvarying pattern of daily commute in and around Moscow, the alertness of the watchers would eventually, and naturally, degrade. Then, after months of an unchanging travel pattern, the CIA officer would "disappear" during his "normal" commute for the brief time necessary for a clandestine act—usually filling a dead drop or posting a letter—before reappearing at his destination only minutes behind schedule.[65] The watchers were not alarmed by the short gap in a routine schedule.

Mendez explains that when using misdirection, "a larger

action covers a smaller action as long as the larger action itself does not attract suspicion."[66] A CIA officer stationed abroad once commented that having a dog was essential as a mask for secret communication with agents. Taking the dog out for long walks at night (the larger action) provided numerous opportunities to secretly mark signal sites and service dead drops (the smaller actions). Surveillance teams became used to the pattern of the late-night walks and were lulled into a false belief that no smaller-action clandestine activity would occur.

Both magicians and spies must effectively manage the stage and sight lines to create an illusion. CIA officer Haviland Smith, the former senior CIA officer in Czechoslovakia during the late 1950s, developed new operational techniques to exploit weaknesses in the sight lines of the surveillance teams working against him in Prague. He discovered that when he was walking in urban areas, on routes he used frequently, the trailing surveillance team was always behind him, and when he made a right-hand turn, he would be "in the gap" or clear of surveillance for a few seconds. Rather than acting suspiciously to evade surveillance, he managed the sight lines to operate "before their very eyes" while "in the gap." Smith repeated the technique during his next posting in East Berlin, and again it worked. By properly managing his stage, all of his operational activities could be conducted in these gaps, and out of sight.[67]

Smith continued to refine his techniques for working "in the gap" to covertly exchange information with spies and in 1965 consulted with a magician for tips on using misdirection.[68] Smith initiated each operational sequence employing an orthogonal approach—right angles or right-hand turns—to ensure he would be free from trailing observation. In a personal demonstration set up at Washington's Mayflower Hotel in front of his boss, the head of the East European Division, he added the new twist of

misdirection. Smith had another officer—Ron Estes—make a right-hand turn into the hotel carrying a small package in his right hand beneath his raincoat. Smith, posing as the agent, was waiting inside the door, standing next to a bank of pay phones. As Estes approached, he shifted his raincoat from his right hand and shook it briefly before letting it flop into his left hand. In that same instant he handed the package unnoticed to Smith with his right hand. The movement of the raincoat successfully diverted attention to the left of Estes and away from the package. Smith received it without notice and moved quickly away and down a stairway. The CIA observers were unaware of the technique and inquired impatiently when the activity would take place. It worked. Misdirection had compounded the effectiveness of stage management.[69]

Performing theaters can be artfully arranged for illusions that provide the stage magician with distinct advantages. Stage lighting assures the audience focus is drawn to visible details intended to enhance the illusion, masking those that are unwanted. Props and paraphernalia are arranged in advance. Access to the stage is controlled and restricted to avoid exposing the magician's secrets. The intelligence officer lacks such advantages, as the location or stage of his performance will be dictated by the requirements of the secret operation. As such, little assured control can be exercised over the audience, lighting, and sight lines. Regardless of how well designed and rehearsed clandestine "magic" may be, uncertainty always accompanies the real "performance." For the field officer and agent, unseen as well as unanticipated spectators or hidden surveillance can expose a clandestine operation with disastrous consequences. Thus special precautions are required.

Robert Hanssen, a trained FBI counterintelligence officer

who volunteered to spy for Soviet and Russian intelligence, selected the footbridges in the parks of northern Virginia for his stage. At night, he hid tightly wrapped and taped plastic trash bags crammed full of secret U.S. documents or retrieved sacks containing money or diamonds. Hanssen cleverly controlled the stage by choosing to "perform" when the parks were mostly unoccupied and at sites in heavily wooded and secluded park locations. He carefully selected each operational site to minimize his visibility to passersby while permitting him to detect possible surveillance prior to placing or removing bags from beneath the footbridge.[70] Under these circumstances, Hanssen exploited an advantage over even the magician's controlled stage since the absence of any audience virtually guaranteed his success.[71]

For the Central Intelligence Agency, few operations were more dangerous, or important, than the covert or "black" exfiltration of endangered officers, agents, and defectors from hostile countries or hostage situations. During the Cold War, the CIA and British intelligence, MI6, employed stage management techniques, frequently similar to those in the world of magic, for more than 150 secret operations to bring individuals and their extended families "out of the cold."[72]

Stage management by the British intelligence service saved one of its most important spies from certain death in 1985. KGB colonel Oleg Gordievsky, the senior KGB intelligence officer and acting *rezident* in London, who was working secretly for the British intelligence, was betrayed by CIA turncoat Aldrich Ames and recalled to Moscow under suspicion. KGB investigators had circumstantial evidence from Ames that pointed to Gordievsky, but lacked the proof necessary to arrest the senior KGB officer. Each day he was subjected to lengthy interrogations as the investigators built their case against him, but allowed to return at night to his apartment, which was rigged with hidden listening

devices. They hoped that overhearing a private confession to his wife, or an attempt to contact the British, would provide the final proof of his treason.[73] However, Gordievsky secretly activated an emergency escape plan provided to him by MI6, and after eluding surveillance while on his daily jog traveled by train and bus to the Finnish border.

Concurrent with Gordievsky's secret travel, a pregnant British diplomat was driven from Moscow to Helsinki for medical attention. As her car and driver neared the Finnish border, they rendezvoused with Gordievsky and concealed him in the trunk of their diplomatic vehicle. At the border, while KGB Border Guard officers were examining papers, their German shepherd guard dog began to sniff suspiciously at the area of the car concealing Gordievsky. Thinking quickly, the pregnant diplomat took a meat sandwich from her bag and offered it to the curious dog as a distraction. Her impromptu stage management, employing misdirection, saved the agent's life and Gordievsky became the only person known to have escaped Moscow while under the direct observation of the KGB's Seventh Directorate.[74]

A classic CIA example demanding exacting stage management for a secret exfiltration is the rescue of six U.S. diplomats stranded outside of the American embassy in Iran after the compound was overrun and seized by Iranian "students" in November of 1979. Mendez, then chief of the disguise section of the CIA's Office of Technical Service, adapted exfiltration techniques to the particular situation. With the assistance of Academy Award winner and Hollywood makeup specialist John Chambers, he created the deception necessary for their rescue. Mendez and his associates formed a notional Hollywood film company, "Studio Six Productions," to produce a science-fiction film titled *Argo*. Studio Six announced that the film would be shot in Iran and a team would be dispatched to scout potential locations out-

side Tehran. Fooled by this subterfuge, the Iranian government was expected to agree to cooperate with the Hollywood company as part of efforts to reverse the negative international publicity following the embassy takeover.

To prepare the world stage, Mendez opened Studio Six production offices on the Columbia Studio lot in Hollywood and established credibility by running a full-page business advertisement in the industry's most important trade paper, *Variety*. Mendez, posing as a European filmmaker, adopted an alias name, obtained visas from the Iranian embassy in Switzerland, and, accompanied by a colleague, traveled to Tehran in January of 1980. Once contact was established with the six diplomats hidden at the residence of a Canadian official, Mendez explained how their cover as filmmakers, combined with disguise and fabricated Canadian passports, could be used to exfiltrate them out of the Tehran airport. Mendez, a magic enthusiast as well as an accomplished "document validator" or forger, used a simple sleight-of-hand trick with wine-bottle corks to illustrate how deception and stage management would be used to overcome potential obstacles. His "magic and illusion" demonstration, called "The Impassable Corks," instilled confidence for the plan among the diplomats.[75]

Mendez and his colleague worked through the weekend to create "new" Canadian passports and forge the necessary Iranian exit visas. Each of the six diplomats received cosmetic "makeovers" using disguise materials that restyled their looks to appear "Hollywood." One conservative diplomat sported snow-white hair with a "mod" blow-dry. Mendez observed that after the transformation, "[the diplomat] was wearing tight trousers with no pockets and a blue silk shirt unbuttoned down the front with his chest hair cradling a gold chain and medallion. With his top-coat resting across his shoulders like a cape, he strolled around the room with the flair of a Hollywood dandy."[76]

Seats for the escaping diplomats posing as the film's "scouting team" were booked on a Swissair flight departing from Tehran's Mehrabad Airport early on January 28, 1980. Mendez and his CIA colleague arrived at 5:30 A.M. to "manage the stage" at a time when the departure officials would be sleepy and most of the potentially troublesome Revolutionary Guards were still in bed. The escapees' luggage was emblazoned with Canadian maple leaf stickers and Mendez hovered about his "stage," the airport departure lounge, impressing onlookers with "Hollywood-talk." The activity effectively supported the newly acquired manners and dress of the disguised diplomats, and by late afternoon, all reached Zurich, Switzerland, and freedom.

Illusionist Jim Steinmeyer, when commenting on the techniques of the escape, noted: "Mendez's improvisation was performed within carefully rehearsed scenes, meticulous paperwork, backstopped stories, and exhaustive research. If the six Americans seemed to saunter effortlessly through the Tehran airport, it was because the stage had been beautifully set and the scene masterfully presented. It was a demonstration of Kellar the Magician's famous boast that, once he had an audience under his spell, he could 'march an elephant across the stage and no one would notice.'"[77]

Dr. Gottlieb's TSS staff later became the CIA's Office of Technical Service and employed a new generation of magicians and illusionists.

Sleight of Hand

> As beginners, magicians love the colorful boxes they first saw on magic shop shelves—the trick props that seem able to do anything. As sophisticates, they learn that these mechanical props are no substitute for pure ability . . . sleight of hand.
>
> —JIM STEINMEYER, *HIDING THE ELEPHANT*

A common and incorrect belief is that the hand is quicker than the eye. Quick movement does not explain an effective illusion by either magicians or spies. In fact, the hand is much slower than the eye, and for deceptive purposes, neither should ever move quickly. An illusion is primarily mental, not visual; when magicians and spies fool the minds of audiences, eyes observe only what the performer intends.

Mulholland employed sleight of hand, the skilled manipulation of objects in a manner undetectable to the observer, in creating effective deceptions and illusions. He also recognized that such techniques could be learned by intelligence officers and applied in espionage. By replacing quick or clumsy movements that would attract the attention of hostile surveillance teams or an intended target, Mulholland described "sleights" that would appear to observers as natural and innocent, whether those be gestures, alterations in body posture, or changes in hand position.

Effective sleight of hand employs psychology, misdirection, and a natural sequence of steps to create an illusion. Magicians and spies use misdirection so that their audiences will look toward an intended direction and away from the covert act. Since the human mind can only focus on a single thought at a time,

controlling the target's visual perception of events unfolding around him can implant a false image and memory. For example, Mulholland instructed officers that the flaming of a match rising in one hand to light a target's cigarette would mask the discrete drop of a pill from the other hand. The target's eyes, focusing, as intended, on the match, were incapable of also noticing the pill, the covert action.

Mulholland realized that CIA officers needed small props to enhance their limited sleight-of-hand skills. He understood that spectators were less likely to suspect items with which they were already familiar. Commonly seen objects, such as cigarettes, matchbooks, pencils, and coins, appeared almost ubiquitous and inconsequential. Since most onlookers would not suspect that these items could be used as espionage devices, they could be concealments for hiding the pills, potions, and powders such as those produced by MKULTRA.

Intelligence officers employed other sleight-of-hand techniques using conjuring paraphernalia. "Flash paper," a staple for many magicians, was popular when cigarette smoking was common and acceptable. CIA officers employed it when taking secret notes in hostile and threatening environments; if the officer sensed danger or considered an operation compromised, touching the paper with a lit cigarette would result in its complete and instantaneous destruction. To the surveillance teams, none of the officer's movements appeared unusual and only the ash residue remained if searched.

In later years, as smoking became less acceptable, CIA officers preferred making written notes on water-soluble paper instead of flash paper. Covert communications and tasking instructions were printed on this special, water-soluble paper so they could be destroyed quickly and completely in a cup of coffee, splashed with water, or even swallowed. Ryszard Kuklinski, the CIA's

most valuable Cold War agent in Poland in the 1970s, kept his secret escape plan on water-soluble paper taped beneath a kitchen cabinet so it could be quickly destroyed in a nearby pan of water.[78]

A principal skill of intelligence officers is taking photographs without being detected. In the 1960s, the CIA needed an effective way to make a Minox subminiature camera "disappear" quickly after taking a secret photo. The solution employed sleight of hand and a device from the magician's repertoire of disappearing objects. In this case a "holdout," a simple piece of elastic for making a coin disappear from an outstretched hand and up the performer's sleeve, worked well. However, instead of elastic, CIA technicians used a retractable tape measure to fit the mechanism with thin black cord and mounted it on a leather armband.[79] The cord attached to the end of the Minox, and after the photo was taken, the officer had only to release his grip to allow the camera to retract and "disappear" up his sleeve.

Using sleight of hand can enhance a clandestine operation in other, less direct ways. For example, undercover officers often face difficulties infiltrating suspicious groups who are wary when approached by strangers. One solution was a simple trick, the "magic beer coaster," to attract attention and have the target "come to him."[80] A folded U.S. fifty-dollar bill was inserted into a Heineken beer coaster that had been sliced apart with a razor, then reglued and placed in a book press to flatten as it dried. The officer appeared several nights at the bar and drank alone while slowly tearing apart a stack of Heineken coasters. When the bartender eventually asked why he was doing this, the officer responded, "Heineken places fifty-dollar bills as a little-known promotion in unmarked beer coasters." An hour later, the officer

employed sleight of hand to introduce a gimmicked coaster into the stack in front of him. When he later tore apart the prepared coaster and "discovered" the fifty-dollar bill, he celebrated loudly and offered to buy a round of drinks. The onlookers came to him! Though the fifty-dollar coaster attracted attention, the full effectiveness of the illusion was dependent on the officer's stage performance and his sleight of hand.

Disguise and Identity Transfer

> Disguise is only a tool. . . . Before you
> use any tradecraft tool you have to set
> up the operation for the deception.
> —TONY MENDEZ, FORMER CIA "MASTER OF DISGUISE"[81]

Magicians regularly employ doubles, identical twins, full disguise, or disguise paraphernalia to create effective illusions. CIA disguise technicians employed skills learned in Hollywood to devise a variety of effective disguise solutions. As with stage disguises, the shorter the time the subject will be studied by observers, the less elaborate the disguise must be. A light disguise might include only a wig, glasses, mole, facial hair, dental appliance, and articles of clothing. One application of such disguises occurred during meetings with an unknown volunteer, called a "walk-in," who sought to meet with "someone in American intelligence."[82] In such cases, the CIA officer would put on a light disguise to provide limited protection against being later identified by terrorists or the local counterintelligence service. However, if the "volunteer" appeared to have valuable information and the attributes to become a future spy, his identity had to be protected, and a light disguise could effectively mask his appearance as he departed the meeting.

In the late 1970s, Hollywood makeup artist John Chambers worked with CIA technicians to create a new generation of face masks using techniques developed for the hit movie *Planet of the Apes.*[83] His masks blended articulated facial elements to appear "lifelike" when individuals talked or blinked their eyes. Illusions created with the new masks could withstand scrutiny for several hours or longer. More elaborate disguise could effect an ethnic or gender change as well.

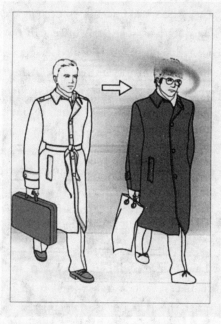

CIA field officers in Moscow frequently donned light disguises, such as that of a Russian worker, for meetings with agents; circa 1982.

Custom clothing altered body type and weight distribution and dental appliances altered facial features and speech tone. Hair could be dyed and makeup employed to give a younger or older appearance.

The FBI has used disguise techniques for years when pursuing evidence in counterintelligence investigations against U.S. traitors who spied for the Soviet Union and thought they had successfully retired. A disguised undercover officer, a special agent who spoke with a heavy East European accent, dressed in a poorly fitting suit tailored in the former Soviet Bloc, sought to "reestablish contact" with former agents.[84] Though the "retired" spies were initially

wary, the special agent's stage management, attire, and disarming questions such as "do we still owe you money?" eventually elicited replies and provided evidence. One notable catch from this operation was retired U.S. Army colonel George Trofimoff, who had been an important KGB spy for twenty-five years until his retirement in 1994. When recontacted by the undercover officer in 1997, he provided compromising details over the next two years before sufficient evidence was gathered for his arrest. His motivation in talking was to recover payments for information provided during his career as a spy, but for which, he alleged, no payment had been received. In 2001, Trofimoff, then age seventy-five, was convicted and received a life sentence.[85]

Disguises can also be used with greater speed and creativity than sometimes imagined. When, in less than a second, a magician's assistant is transported from one side of the stage to the other, there can be no other apparent explanation for the audience except "It's magic!" Illusionists perform similar feats nightly and Houdini's mysterious "disappearance through a newly constructed brick wall" act was one of his most famous illusions. R. D. Adams, the craftsman who constructed Houdini's magical apparatus, described the illusion: "A dozen or more bricklayers in overalls appeared before the audience and built a bona fide brick wall seven or eight feet high extending from the footlights to almost the rear of the stage. When it was completed, Houdini was ready to 'disappear.' After a few appropriate remarks, he stepped behind a small screen, something like a prompter's box, which the bricklayers pushed slowly to the center of the wall. The bricklayers moved over to the other side and adjusted a similar screen there opposite the first one. 'Here I am, here I am,' Houdini would shout, and waving arms thrust through holes in the screen gave evidence of the fact. Then the arms would disappear and Houdini would step forth from the screen on the other side of the wall."[86]

At the time, respected skeptics speculated that Houdini did this by using a trapdoor, which allowed secret passage from one side of the stage to the other. Such speculation was inaccurate, however, since the investigating committee that validated the integrity of each performance would have detected the trapdoor. To confound the audience in later performances, Houdini even placed a sheet of paper or a sheet of glass beneath the wall to demonstrate that a trapdoor was not used. The secret, Adams explained, was: "Houdini disappeared through the wall only in the minds of the exceedingly gullible. As a matter of fact while the first screen, behind which he had stepped, was being pushed back against the wall, he leaped into a pair of blue jumpers and

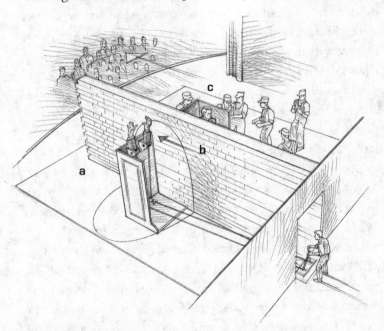

One of Houdini's most mystifying tricks. **a.** The brick wall was built on a glass plate. **b.** Mechanical hands were moved by ropes. **c.** Houdini, who was disguised as a bricklayer, changed sides and removed his overalls behind a screen before reappearing.

pulled a workman's cap down far over his face. When the screen touched the wall, he was one of the bricklayers as far as the audience was concerned. He got behind the second screen disguised as a bricklayer. From this point he did his calling to the audience. Mechanical arms and hands, operated by a hidden rope leading to the wings, furnished the gestures, which convinces Houdini was behind screen No. 1 instead of No. 2 completing the illusion."[87]

Such a baffling, and effective, illusion can also be accomplished employing an identical or disguised twin.[88] One assistant seems to vanish, and almost instantly reappears in another location, sometimes, for effect, even suspended above the stage. To deceive the audience, the lovely blond assistant, and her replacement, must be of similar body type, dressed in similar attire, using the same makeup and hair (wigs). To the audience, who never sees them together to form a comparison, they appear identical. The less time the audience has to scrutinize elements of the deception, such as details of the assistant's appearance, the more effective the illusion. The magician never announces the deception in advance, and the audience has no opportunity or reason to scrutinize any of the onstage participants.

At the CIA, the identical-twin illusion became known as "identity transfer." An officer would disappear from one location and reappear somewhere else as the same or a different person. When this was properly staged, surveillance teams were never aware of the switch and officers were able to evade hostile surveillance prior to performing operational acts. Successful CIA identity transfers involved an entire "little theater" presentation, which was performed for several hours before the swap took place. The actual transfer required only a few minutes at the most, and was nearly impossible for even a trained observer to detect. The staged scenario presented to surveillance was geared toward fooling their minds, rather than just fooling their eyes.

Disguise was critical, but only one element of the "magic" demanded by an identity-transfer illusion whether performed in an auditorium or on the street.

Moscow represented one of the CIA's most dangerous operational areas during the Cold War due to the effectiveness of the KGB's Seventh Directorate surveillance apparatus. CIA officers serving in Moscow were never publicly identified; they worked during the day in a variety of cover jobs and then at night and on weekends as intelligence officers. Though they were protected from prosecution by diplomatic immunity, their greater concern was that hostile surveillance of their clandestine activities might expose their agents, who were subject to arrest and execution. Therefore, it was imperative that an officer "go black"—become free of surveillance—before conducting an operational act and keep his agent safe. Different ruses, utilizing techniques similar to those developed by Houdini decades earlier, proved successful.

In one of the first successful identity-transfer performances in Moscow, an American intelligence officer planning a clandestine meeting with a top spy had to assure himself he would be free of surveillance. The officer carefully choreographed a performance with a similarly sized fellow worker during an official social function they both would attend.

On the appointed evening, the officer, accompanied by his wife, arrived at the reception dressed in his normal suit and tie. His partner in the operation, who was not under suspicion, arrived separately in garish, 1970s mod-style clothing. Both knew that their arrival and appearance would be noted by KGB surveillance posted around the official compound. Then a third official, driven by his spouse, arrived at the function on crutches wearing a leg cast, ski jacket, and cap, following an unfortunate

skiing accident the previous weekend. Once all were inside, the intelligence officer swapped clothing and "identity" with the garishly dressed man and left the reception in the company of the injured official, whose wife was driving the car.

The exit of the mod-dressed man accompanied by his friend on crutches would be observed by KGB surveillance who assumed the intelligence officer was still inside. Once away from the compound, the officer changed into nondescript clothing hidden in the vehicle and met safely with his agent. Before returning, he again changed into the garish outfit and, in the company of the injured skier, re-entered the compound they had earlier left. There a clothing and identity switch was made with the original partner. The normally dressed, suit-and-tie officer rejoined the function apologizing for being called away for a few minutes to "answer questions from another self-important bureaucrat in Washington." The successful performance, using identity-transfer techniques that fooled the KGB, would have made Houdini proud.[89]

Another identity-transfer technique permitted an intelligence officer to exit a car while being driven through the darkened streets of Moscow, yet appear to the trailing surveillance vehicle as if he were still inside. To set the stage, the intelligence officer and driver moved at normal speed through the nighttime streets knowing that KGB surveillance teams were following in their cars from behind at a discreet distance. Experience had taught them that when slowing for a right-hand turn on the dark streets, the car was out of sight of the trailing KGB vehicle for a few seconds. In this brief moment *in obscura,* which they called "the gap," the intelligence officer, riding in the passenger's seat, could roll unseen out of the slowed car. The challenge was to disguise his absence so that when the headlights of the trailing surveillance vehicle turned the corner, two silhouetted figures would still be seen in the car ahead.

The answer was the CIA's creation of a three-dimensional human torso sitting atop a spring-activated scissor-lift mechanism fitted with a rotating head, which collapsed into a small portable briefcase or duffel bag. This piece of equipment acquired the name "jack-in-the-box" or JIB. With one hand, the driver could unlatch the carrying case and lift the JIB instantly into place.

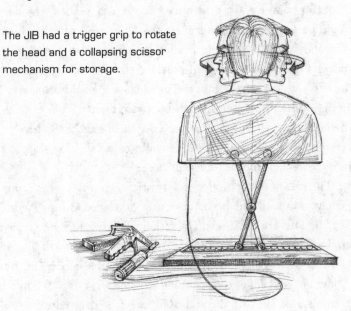

The JIB had a trigger grip to rotate the head and a collapsing scissor mechanism for storage.

Instead of using offstage ropes to manipulate artificial hands and legs as in Houdini's disappearance through a brick wall, the CIA used a trigger grip to rotate the JIB's artificial head and create an effective illusion for the KGB surveillance vehicles. When the officer was ready to reenter the car, the JIB could be pushed back into its resting position and the "briefcase" shoved to the floor.[90] The CIA understood that by controlling the location of the event (an empty street in Moscow), the lighting (an unlit

area), the audience (the trailing surveillance car), the timing (when the cars were a sufficient distance apart), and the sight line (visible only from the rear), they could stage-manage an effective illusion.

One of the CIA's most unusual plans for an identity transfer required a big dog. In the 1970s, a plan was conceived to post an officer abroad with an adult male Saint Bernard weighing more than 180 pounds. When identity transfer was needed, the dog would be swapped for an agent concealed in a full Saint Bernard skin and inside a portable kennel. A tape recorder and small speakers hidden in the kennel provided sound effects to enhance the effectiveness of the illusion. The agent-dog would be taken to a safe location for "examination by a veterinarian." Once inside the safe house, the agent could be safely debriefed, and when the "examination" was completed, he could redon the dog skin, get into the kennel, and be returned "home."[91]

The idea of swapping identities with an animal was not completely new and had been previously developed during World War II. The British Special Operations, Executive (SOE) created an innovative camouflage for parachutists secretly landing in German-occupied France. A two-piece, collapsible rubber cow was painted in advance of the operation to blend with livestock in the landing area. The plan then called for agents to parachute the rubber cow with them, land, and bury their parachutes. That done, they would climb into their respective half of the two-person cow, join up, and remain concealed until members of the local French Resistance units arrived and led them to safety. Tests showed the camouflage to be effective at night, and though rubber cows were produced, no record exists of their being used operationally.[92]

Escapology

> Anything that can be locked by one man
> can be unlocked by another.
>
> —ESCAPE ARTIST STERANKO

Danger is sometimes an unfortunate consequence of espionage and even the most skilled intelligence officers and spies may be caught and incarcerated. The art and practice of escaping from constrictions, be they ropes, handcuffs, straitjackets, jails, or even a country, is *escapology*. Magicians and performers have long employed such techniques to entertain audiences expecting to see an "impossible" escape. Spies have been equipped with similar tools and techniques for situations in which imprisonment could lead to death and escape is not expected.

Creative minds have continually devised special equipment and techniques to escape from virtually every type of restraint. Secret escape techniques developed by magicians over the last 150 years to amaze audiences have also been used by spies.

Escaping locks and chains requires special technical knowledge, a hidden key or tool, or a willing confederate. In the early 1900s, Harry Houdini employed all of these to become one of the most famous celebrities of his day. His creativity and innovation were exhibited during a 1903 visit to Moscow when he issued a challenge to the Russian secret police proclaiming his ability to escape from their dreaded "Siberian transport cell or carette," a large horse-drawn "safe on wheels" used for conveying prisoners to Siberia.[93]

The challenge was accepted and Houdini, stripped naked in freezing weather and searched thoroughly by three police officers, was manacled, shackled, chained to foot fetters, and locked inside the vault-shaped wagon. The lock controlling the door was

inaccessible from the inside and a small slit on the outside of the carette allowing access required a different key to open it from the one to lock it.[94] Nevertheless, minutes later, Houdini emerged to the amazement and fury of his wary hosts. How he had escaped was soon obvious to his jailers, but they remained puzzled about the trick he used to sneak his tools into the prison.

Houdini's preparations began the day before the escape, when his assistant, Franz Kukol, managed to glimpse the underside of the carriage. Kukol observed that the carriage's plain wooden floor was protected only by a thin layer of zinc. Kukol recognized that just two tools were needed for the escape: a flexible metal wire used by surgeons for cutting bone called a Gigli saw and a tiny cutting tool.[95] Houdini's plan was to completely avoid the heavy doors and locks, and cut through the floor to escape the carriage.[96] Houdini had managed to conceal his escape apparatus during the probing searches of his jailers in a small "sixth finger."[97] As the guards searched first his upper body, then his lower body, he switched the hollow finger between his trousers and hand. Once locked inside the carette, Houdini effected his escape in only a minute by cutting a slit in the zinc layer and sawing through the floorboards.[98] He credited his escape abilities to technical skills, physical ability, and trickery in concealing the equipment necessary for the act.

A few years earlier, in 1900, Houdini's escaping skills had attracted the attention of William Melville, the head of Britain's Scotland Yard Special Branch.[99] Dismissive of what he presumed were theatrical stage handcuffs, the chief encircled Houdini's arms around a pillar and snapped on regulation Scotland Yard handcuffs. Melville was amazed at Houdini's self-extrication within seconds and pronounced, "Scotland Yard won't forget you, young man."[100]

Melville fulfilled his own prediction. When British agents

began training in 1914 to operate against Germany during the buildup to World War I, those attending an MI5 spy school received lectures taught by Melville on "how to pick locks and burgle houses." Other presentations included the Technique of Lying, the Technique of Being Innocent, the Will to Kill, Sex as a Weapon in Intelligence, and (finally) Dr. McWhirter's Butchery Class, which taught one how to "top [kill] yourself if you were caught."[101]

The impact of Houdini's magical escape techniques influenced later generations of clandestine officers. Clayton Hutton, a pilot in the Royal Flying Corps during the First World War, volunteered his services to British military intelligence in the late 1930s.[102] None of Hutton's skills seemed of value until he mentioned his great interest in "magicians, illusionists, and escapologists." He described responding to a hundred-pound challenge from Houdini in 1913 for anyone who could construct a wooden box from which the magician could not escape. Hutton accepted the challenge and Houdini was handcuffed, put in a sack, and locked in Hutton's formidable wooden packing case. To Hutton's dismay, Houdini escaped within minutes.

Hutton said he learned years later that his own assistant, Ted Withers, a first-class carpenter, had been bribed by Houdini for three pounds before the performance. Withers gimmicked the case with false nails at the end to enable an easy escape.[103] Houdini cut the sack "using a small razor blade he had palmed when shaking hands with the last man to come up on stage—a confederate."[104] After hearing the story, the British intelligence officer conducting his interview, Major J. H. Russell, commented, "You may be the man we want. We're looking for a showman with an interest in escapology. You appear to fit the bill."[105] Hutton got the job.

• • •

MI9, a division of British military intelligence, was responsible for helping service personnel evade capture where possible, escape when necessary, collect intelligence, and distribute information.[106] Their efforts were centered at the secretive Intelligence School 9 (IS9), where Hutton worked to invent, design, and adapt aids for evasion, escape, and secret communication with prisoners of war.

Evading capture required small, easily carried, and hidden equipment for terrain and directional knowledge such as maps and compasses. Hutton remembered the methods Houdini had used thirty years earlier to conceal his escape aids and adapted them to hide MI9's gadgets from determined searches by German police and guards. Escape maps were concealed within false backs of playing cards or printed on silk or rice paper to be folded silently into tiny volumes. Miniature telescopes were hidden inside a cigarette holder, and smoking pipes, belt buckles, and even magnetized razor blades were used to hide compasses. The face of a standard brass uniform button unscrewed to reveal a hidden compass and was one of Hutton's most effective deceptions. In his first hidden compass design, the button was unscrewed with a standard left-hand thread. When German guards got wise to the concealment, Hutton quickly changed the design to utilize a right-hand thread on the buttons; the deception worked as planned, and the more the German guards tried to "open" the new buttons conventionally, with a counterclockwise rotation, the tighter they became.[107]

The imagination required for conceiving devices seemed to have no limits. One escape kit, fitted within a pocketknife, contained wire cutters, saw blades, and a lock breaker.[108] Another kit, concealed in a boot heel that was accessible through a hinged flap in the straight edge of the heel, contained a silk map, a compass, and a small file. The brother of magic dealer Will Gladstone had first created the hollow heel for the "Mokana shoe" in

1901, which Houdini used successfully to evade the invasive police searches that preceded his escapes.[109] Though stripped naked, he had requested shoes to ward off cold feet.[110]

During World War II, others from the world of magic applied their craft to support the British intelligence services. Onetime missionary Charles Fraser-Smith created gadgets and tricks for Britain's SOE and MI6 to deceive the Axis. Among these were pocket-size radio receivers, a device that seemed impossible at a time when home radios were so large that they were considered pieces of furniture. The radios allowed agents as well as prisoners to receive one-way communications. One set, designed for smuggling into POW camps, was purposefully manufactured crudely to appear as if it had been cobbled together by the prisoners.[111]

Tools such as the Gigli saw used by Houdini were capable of cutting through a one-inch steel bar and could be concealed within the shoelace of a British pilot "just in case."[112] Concealed knife blades for cutting ropes were fitted on the back of copper coins and passed unnoticed during a search. Other knife blades were concealed in a boot-heel reinforcement so even if the wearer was captured and hog-tied, the blade could be reached. Military uniforms were designed for "quick change" conversion into civilian clothes by use of dye concealed inside the ink bladders of standard-looking fountain pens.[113] "Cut down" and recolored, the uniforms provided a lower profile for escapees. Even military-issue leather flying boots were designed for instant conversion to civilian walking shoes by making a few cuts with a small, concealed blade.

The secret escape apparatus developed by Houdini and early twentieth-century magicians continued to influence spy gadgetry during the Cold War.[114] Houdini had hidden a small egg-shaped container holding a variety of small lock picks in the back of his throat while being searched. The concealment was safe from all

but a search by the most determined jailers.[115] The CIA, using a similar design, created an escape-and-evasion suppository as a portable "tool kit" packed within a waterproof black plastic shell. This "spy's Leatherman" featured nine escape tools, including wire cutters, pry bar, saw blades, drill, and reamer packed into the four-inch-long-by-one-inch-diameter kit.[116]

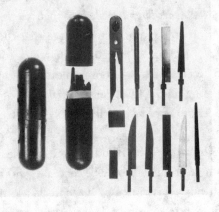

The CIA Escape and Evasion Rectal Suppository was a multipurpose tool kit packed within a smooth waterproof black plastic or aluminum shell; circa 1955 (actual size: 4" long x 1" diameter).

Lock picking, which even for Houdini was a last resort, has always been a useful skill for spies. Spies were taught the magician's principle to "beg, borrow, bribe, or steal" the master or original key, if possible, before attempting to break into or escape from a locked enclosure. Once obtained, the master key could be covertly impressioned using clay, wax, or even a small bar of soap, and returned. From this impression, an exact duplicate key could be cut and concealed.[117] The OSS, and later the CIA, issued key-impressioning kits using modeling clay in a pocketable aluminum mold for this purpose.[118] For actual lock picking, should that be necessary, the CIA improved on the design of a small concealable pocketknife designed first by the OSS that contained six small tools of the type Houdini employed seventy years earlier in his own concealed escape kits.[119]

Concealments

> The CIA concealment specialist combines the skills of a craftsman, the creativity of an artist, and the illusion of a magician.
>
> —CIA CONCEALMENT ENGINEER

Traditionally, conjurers must be smartly groomed and remain polished, refined, confident, and poised throughout the performance. Their clothing must be well tailored, yet incorporate special pockets for concealing performance paraphernalia, including tricked coins, cards, handkerchiefs, flowers, hollow thumbs, and even live animals![120] Spies also wear clothing designed specifically for their "performances."[121]

If the magician desires to produce a large rabbit, he might employ a "rabbit bag" under his arm. However, if his dress suit is cut too tightly, the bulge will be visible. Conversely, if the conjurer's attire is noticeably large to accommodate the bulk of the rabbit, suspicions will be raised. Author Dariel Fitzkee observed, "Any variation from the norm attracts undesirable attention from the viewpoint of the magic. The conjurer must remain natural at all times. When something unnatural is evident, a spectator becomes vigilant and alert to deception."[122] Whether one is a magician or a spy, specially tailored clothing must distribute both the weight and bulk of hidden items while keeping the items accessible for the performance or secret operation.[123]

CIA officer Richard Jacob was wearing a specially tailored raincoat when detained in Moscow in 1962 just after retrieving Minox film concealed in a matchbox, which had been hidden behind a radiator in a public hallway and placed there by the CIA's top Soviet spy, GRU colonel Oleg Penkovsky. Jacob's modified

raincoat included a slit inside a pocket. When Jacob saw he was about to be detained, he dropped the matchbox through the slit to the inside of the coat, letting it fall to the floor. Thanks to the accessibility of the flap within his special clothing, he was not apprehended with the stolen secrets in his hand or coat pocket.[124]

Other forms of attire, such as shoes, can be ideal concealment cavities for use by both conjurers and spies. The hollow Mokana shoe used by Houdini for hiding escape tools became a favorite for spies throughout the Cold War.[125] Concealment heels were used by East German agents to transport Minox film cassettes in both men's and women's shoes. In the 1960s Czechoslovakian intelligence (StB) technicians placed an entire eavesdropping transmitter in the heel of an unsuspecting U.S. ambassador's shoe.[126] When it was activated, the ambassador became a walking broadcasting station who was "bugging" his own secret meetings.[127]

Power's silver dollar with cutaway view revealing inner pin.

For a CIA application, the U.S. Army Special Operations Division at Ft. Detrick, Maryland, worked in the late 1950s with the Technical Services Staff to create a concealment coin for U2 pilots overflying the USSR.[128] The coin was a silver dol-

lar mounted inside a bezel with a loop on the end for holding a chain that could be worn around the neck. Inside the hollow shaft of a straight pin, a poison needle was concealed.[129] The pin fit into a small hole drilled into the edge of the coin and held in place by the silver bezel. When a small hole in the bezel was aligned with the hole in the coin, the straight pin was ejected by an internal spring. With a tiny prick of the skin by the needle, death would be nearly instantaneous.[130] On May 1, 1960, CIA pilot Francis Gary Powers was issued the modified coin as he prepared to depart from Peshawar, Pakistan, and overfly the Soviet Union.[131] After his U2 was shot down over Sverdlovsk, USSR, he parachuted safely into a farmer's field, hid the pin in his pocket, and discarded the coin. Both the coin and pin were recovered by the KGB and used as evidence against Powers at his subsequent trial for espionage.[132]

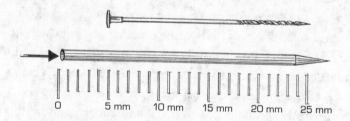

The needle was constructed using a tiny drill bit brazed to the head of a common straight pin. The sheath was built from a hypodermic syringe fitted to a machined metal tip.

Concealed devices can be made part of clothing or hidden inside body cavities to support clandestine operations. During the first half of the twentieth century, conjurers created the illusion of telepathy or "second sight" using only voice codes.[133] As new technologies became available in the 1970s, subminiature radios could be hidden inside the performer's clothing and connected by

small wires running from his neck to a concealed earpiece. The performer's stylishly long hair hid the wires. Later the telltale wires disappeared as hearing-aid-size radio receivers could be fitted directly into the ear canal.[134]

The problem then became one of hiding the earpiece rather than the wires.[135] The solution was a CIA-developed color-matched silicon covering that was camouflaged to replicate the inner ear's contours and shadows.[136] So effective was the illusion that the KGB missed the device during a search of CIA officer Martha Peterson after her detention at a dead drop in Moscow in 1977. Peterson's surveillance radio, attached to her bra with Velcro and concealed in her armpit, was discovered, but the absence of visible wires caused the KGB to ignore the concealed earpiece.[137]

Other body parts and orifices were useful for concealment as well. In the late 1960s, the CIA fielded a military request to provide a means of concealing a subminiature escape radio on a downed pilot who was likely to be captured and searched. Advances in miniature circuitry using transistors had produced a radio one-half the size of a cigarette pack, but it needed a hiding place. CIA engineers knew that guards were less likely to search another male's genitalia and created a false rubber scrotum that fit over the wearer's testicles. Matched to skin color, and incorporating full anatomical detail, the prosthesis was visually undetectable, but formed a cavity large enough to conceal the escape radio.[138]

Concealing larger objects presents a different set of problems. Magicians consider any object on the stage, from the performing table to the props themselves (including their bases or platforms), as a partial concealment cavity for the object, animal, or person to be hidden. Concealing the conjurer's "load" in a hidden cavity is a science that employs lighting, positioning, design, craftsman-

ship, and viewing angles to deceive the audience. The platform holding the woman about to be sawed in half appears impossibly small to conceal a second woman, and yet, by fooling the eye, the mind accepts the illusion as reality.

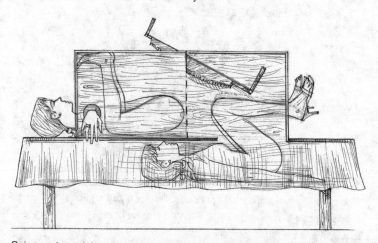

Spies and magicians employ concealment cavities to deceive their audiences. Concealing the second woman in the impossibly small cavity is essential for the success of the deception. Here, the magician uses a curtain to mask the size of the platform.

The CIA employed such a ruse during a Cold War operation to smuggle a spy concealed within a new Mercedes being driven out of Eastern Europe. The car's original fuel tank was redesigned to allow a person, though contorted, to fit inside it while to any observer the car looked factory-new.

Intelligence services have employed other concealments for illusions when faced with the challenge of moving a person unnoticed while under surveillance. Their creative solutions adapted the same principles of deception used by magicians. One was to construct a stack of luggage to be rolled on a hand dolly. The pieces of luggage appeared unmodified, but each contained

The modified fuel tank is only partially filled with gas and contains a cavity to conceal a person being exfiltrated from a hostile area. From the outside, the car appears normal.

hidden openings that allowed a person to sit inside. No single piece of luggage was large enough for the deception, but when they were stacked together, a person could fit inside.[139] A second technique involved stacking cases of bottled water side by side on a large rolling cart. Each case was wrapped in plastic, and to observers it appeared that light was passing through all of the cases. In actuality, however, the outer cases were only shells with Mylar inside the outer row of plastic bottles to reflect the light outward. Inside the stack of cases was a cavity large enough to hide a person. Each illusion had been constructed using the designs of a new generation of Hollywood illusionists brought to the CIA in the mid-1970s. The same principles of optical illusions that amazed audiences in Las Vegas stage performances paved the way for more daring and successful CIA clandestine operations.[140]

The illusion of light appearing to pass through the stacked cases of bottled water mask the person hidden inside.

A primary area for CIA concealment technology involved designing unsuspicious "hosts" for money, film cassettes, and other spy paraphernalia to be exchanged between agents and field case officers at dead drops.[141] The hosts might appear as innocuous tree branches, discarded soda cans, or even construction bricks left over at a building site.[142] Each item was left at an agreed on time and location for recovery a few minutes later. In the Cold War years before digital technology, such timed exchanges were a primary method of clandestine communications and still being used by Robert Hanssen at the time of his arrest in 2001.

Cold War operational requirements led the CIA to create a category of dead drop concealments using "host carcasses." Virtually any animal carcass could be configured with a cavity for exchanging spy gear. The more repugnant the host carcass,

the less likely it would be disturbed until collected. Pigeons and rodents, because they are small enough to be carried in a pocket and are found in almost every part of the world, were especially attractive hosts. Their eviscerated and preserved body cavities were large enough to hold money, instructions, subminiature cameras, film, notes, and codebooks.[143] The carcasses, filled with paraphernalia for the agent, could be tossed from a slow-moving vehicle at predetermined locations along the darkened streets of virtually any city. Who would disturb the carcass of a dead rat or rotting pigeon? That question had to be answered when deployed rats unexpectedly went missing. Hungry cats, unaware of the concealed treasure, had carried the rats off before the agents arrived. The solution to the problem was a liberal dousing of hot pepper sauce on the rodent before the operation.

When a magician pours water from a pitcher on the stage, the audience sees it as real. Yet the hidden compartment concealed by a mirror inside the pitcher is never observed as water is pouring out. The CIA used the same principle when designing "active" concealments for agents—each item retained its original function but masked a concealed cavity inside. The Cricket cigarette lighter concealing a tiny document camera was unlikely to be examined after demonstrating that it produced a flame. Likewise, a working fountain pen was dismissed by the KGB as a possible host for a suicide pill.[144] Less sophisticated "passive" concealments can be effective when a device needs to perform no function other than to conceal the cavity. For example, a large wooden storage cabinet in a basement mounted against a wall performs no function except to mask the entrance to a hidden crawl space for secretly entering or exiting the house.

A large piece of furniture with a concealed inner panel masked the entrance to an escape tunnel.

The concealments and tricks Mulholland envisioned for intelligence officers in his manual combined classic methods of the magician's art with the most nonsuspicious host objects available. Smaller packages attracted less attention and a concealment device had to fit naturally into the "act" being performed. Few props served this purpose better than the coins found in every pocket and purse.

Magic Coins

The best magicians come to understand
that these gimmicks are mere tools for

the presentation. Illusion, not mere
gimmicks, must be present in any real
magic performance.[145]

—JIM STEINMEYER

Coins provide objects for the tricks of magicians and spies that can easily deceive and confound audiences as well as espionage targets. The magician employs sleight of hand to make them appear, vanish, or change for amusement. A spy's coin can mask the presence of an attached pill, conceal a hidden powder, or contain a secret message.

"A trick becomes a piece of sheer incredibility in Mulholland's hands."
—Fulton Oursler

As mentioned previously, the magician plays to an audience that expects to be deceived, while the spy's trick occurs before an unwitting audience and unsuspecting target. Magicians refer to performances with coins as "close-up magic" because of the small size of the physical objects being manipulated and the short distance between the performer and the audience. The audience

must be close enough to the performer to see the effects; otherwise it will not be deceived or even be aware of the illusion. For the intelligence officer, performing the trick in close proximity to the target minimized exposure to onlookers and limited the target's sight lines as well.[146]

Coins are well suited for close magic, but manipulating them requires dexterity, skill, and grace.[147] For both magicians and spies, their universal presence offers great advantages. Coins create no suspicion, in contrast to other pieces of magical apparatus such as linking rings, wooden boxes, stage cabinets, and top hats, which, simply by being onstage, arouse curiosity and questions.[148] Most people do not assume that coins will be modified or used in deception. Such perceptions can be readily exploited to deceive an unwitting target.

Mulholland understood that maximum audience deception would occur when real coins were used to create espionage "magic." As a result, most of the coins used in his manual of deception for the CIA were unmodified. For example, in one trick a pill was affixed to the back of a real coin with a small dab of gum of Arabic or magician's wax. The coin would appear as just one of several others when held in the trickster's palm.

Professional coin manipulators employ a number of gimmicked coins that mirror the techniques used in "spy coins." These magic coins are constructed in ways that permit them to seemingly change denominations, multiply, pass through solid objects, and survive penetration. These and other gimmicked coins are designed for quick manipulation in performing an illusion.[149] They would not, however, survive close examination or, in most instances, satisfy the requirements of a professional intelligence service that primarily uses coins for clandestine communication—transporting and exchanging information. Hollow coins were employed by Soviet agents in the early 1930s

to conceal secret information on microdots, "soft film," or "one-time-pads," particularly while traveling or passing information between agent and handler.[150]

In the United States, attention was drawn to the Soviet use of spy coins for the first time in the early 1950s during the famous Hollow Nickel Case.[151] In 1935, a young Brooklyn newspaper boy dropped a nickel that was discovered to be modified when it was split open to reveal a tiny piece of film hidden inside an interior cavity. On the film was a ciphered message. The nickel was part of a sophisticated covert communication exchange between Soviet spy Rudolph Ivanovich Abel and his assistant, Reino Häyhänen, who had accidentally lost the spy coin.[152]

Russian spy coin machined to create a cavity for concealing soft film and ciphers. The coin opened by inserting a small tool (or needle) into the loop of the numeral 9 in the date, 1991, on the bottom face of the coin.

On June 26, 1953, the nickel was examined by the FBI and appeared unmodified, but had a tiny hole drilled in one side so that a fine needle could be inserted to force the sides apart. The examiner, Special Agent Robert J. Lamphere, examined the coin and correctly concluded that there was a Soviet "illegal" operating in New York City. However, the FBI was unable to identify the owner of the coin, or break the cipher.[153]

The mystery remained unresolved until Häyhänen defected in Paris in 1957 and revealed that Rudolph Ivanovich Abel had

received ciphered instructions from Moscow using the coin. A subsequent search of Häyhänen's apartment uncovered another spy coin of similar construction—a fifty-markka coin from Finland. It, too, had been hollowed out and had a small hole in the first *a* of the word *Tasavalta* appearing on the tail side of this coin. Abel was convicted of espionage in 1957 and served five years of a thirty-year sentence before being exchanged in 1962 for CIA pilot Gary Powers.[154]

The effectiveness of coins as hiding places also made them easy to lose. They were small, could easily be dropped, mistakenly spent, or become mixed in a handful of similar coins. In the early 1950s another Russian "illegal," Valeri Mikhaylovich Makayev, lost a hollow Swiss coin containing operational instructions on microfilm while returning to his post from leave in Moscow. The KGB recalled him to the Soviet Union and his career was ended.[155] There is no record of the coin being discovered and it may still be in circulation.

Intelligence services of the Soviet Union as well as Poland, Czechoslovakia, East Germany, and Hungary used concealment coins throughout the Cold War. The East German foreign intelligence service, the HVA, produced concealment coins with three different methods of opening. Each appeared externally unmodified, but required different techniques to access their contents.

The "pinhole coin" required a special tool or needle to force the sides apart. The design is very similar to KGB concealment coins.

The "screw-top coin" had an exterior shell with a second and smaller face of the obverse design of the original coin that fit within the milled edge of the shell. The pieces matched perfectly and only the lighter weight of the coin might give it away.[156] Placing the coin in the palm and using the opposing thumb to unscrew the inner face provided access to the concealment.

The "bang-ring coin," fitted with an obverse facing to appear unaltered, required that the agent also possess a fitted machined ring for opening.[157]

In 1966, the KGB sent Major Yuri Nikolayevich Loginov, posing as a Canadian businessman of Lithuanian heritage, to South Africa. Loginov established his cover business and began laying plans to immigrate to the United States. He carried a small coin concealing a tiny piece of soft film that contained his personal code, a list of radio frequencies, call signs, a listening schedule, a summary of instructions for meetings with other KGB agents, and a brief compendium of his legend.[158]

The concealment, an Indian rupee coin, had been machined at the Moscow workshops of the KGB's OTU—Operative Technical Unit.[159] This spy coin was constructed from two rupee coins machined to fit together. When the two sides were joined, the resulting coin appeared unaltered, a nearly perfect illusion. Identical in design and construction to the hollow nickel provided to the FBI in 1953, the coin could only be opened using a tiny needle, which was inserted into a small hole in the face of the coin near the milled edge of side one. The needle was used to separate the two sides, making access to the coin's secrets precise, but the opening process was slow. This type of spy coin worked perfectly for Russian spies, although it would not have allowed the quick access required in a magic performance.

Other intelligence services also machined concealment coins to be used covertly for storing or transporting cipher material and agent communication details. Most coins for clandestine operations employed threaded openings, which screwed together and were reusable by the agent. In rare circumstances, when the coin might be subjected to extra scrutiny, a "onetime," non-threaded coin was constructed, loaded, and sealed like a dead drop. Its weight, with the loaded microfilm, was identical to an

unmodified coin, but opening required special knowledge. For example, a temperature-sensitive coin seal required mild heating in a cup of coffee or tea to release the glue or low melting alloy that secured the two pieces together.[160]

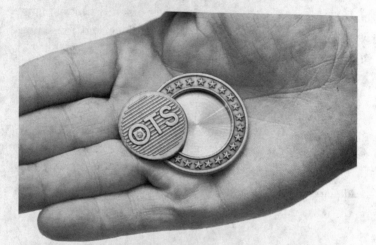

This example of a coin concealment was created by the authors from an OTS fiftieth-anniversary souvenir coin. The interior cavity can be accessed by unscrewing the inner face of the coin.

The process of creating threaded and screwed together coins required a machine shop lathe to mill out the inside of the coin and cut threads on the male and female sections. The face inside the rim would be hollowed out on one coin leaving the bottom and rim, and on the other coin the back side and rim would be removed for dead space and threads. While in theory only two coins are needed to make one modified coin, in reality at least six were usually required because of the difficulty in getting both sides to match up when screwed closed. Machinists preferred thicker coins with wide rims and an inside borderline since the

seam where the two sections fitted together would be invisible to the naked eye. Depending on space and what material was removed, weight was added to match the weight of the unmodified coin.

A threaded coin was opened by applying downward pressure on the face of the coin and turning right or left depending upon which type of thread was cut. When used by agents for storage or transport of microfilm, finely cut threads fit more snugly and were less likely to come loose during carrying or handling. The pieces fit together so well that some officers and their agents had difficulty applying sufficient finger pressure to open them. In that case, a piece of sticky tape placed on the bottom of the fingers made it possible to grasp the face of the coin and open it.

On display at the CIA Museum in its Langley, Virginia, headquarters is an Eisenhower silver dollar described as follows on the museum's Web site:[161]

> **"Silver Dollar" Hollow Container:** This coin may appear to be an Eisenhower silver dollar, but it is really a concealment device. It was used to hide messages or film so they could be sent secretly. Because it looks like ordinary pocket change, it is almost undetectable.[162]

The origin of the CIA's silver-dollar container is uncertain, but the method of quickly accessing its hidden cavity makes it an unlikely candidate for concealing messages.[163] The ability to open the coin by simply squeezing at spot near the edge makes it insecure for concealing secret messages because the sensitive contents might be revealed accidentally, or prematurely, and contrasts with other CIA concealments that require a planned effort for opening.[164]

The design of the CIA silver dollar, for example, employs a

feature that is more desirable to a magician—a large cavity that can be opened easily during a performance. In this case, it appears that Mulholland transferred the fruits of his magic to the CIA. Magician and author Ben Robinson's research into John Mulholland's papers discovered:

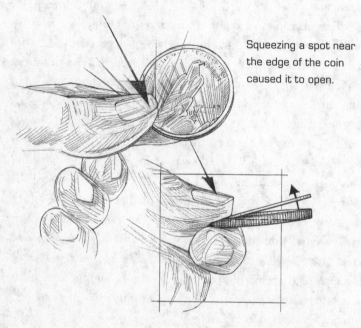

Squeezing a spot near the edge of the coin caused it to open.

The clever "dope coin" that Mulholland machined for the Agency in 1953 is made from a 1921 Silver Dollar and opens when the word "peace" is gently pushed between thumb and forefinger. Mulholland charged fifteen dollars in machine fees when he submitted his bill for the presentation of this highly secret tool. Apparently Mulholland was no stranger to this device. He had been working on such a prop since his early 20s.[165]

The method described by Robinson for opening the Mulholland "dope" coin is identical to that for opening the CIA silver-dollar hollow container. If usable at all, the coin's large cavity and quick accessibility would have been better suited for the covert delivery of powders—one of the major topics in Mulholland's manual.

The principles of magic learned from Mulholland and his follow conjurers like Houdini and Maskelyne combined with twentieth-first-century technology will continue to influence espionage "tricks." Even the ultimate tool for both magicians and intelligence operations, an "invisibility cloak," now appears possible. Scientific experiments have confirmed that light waves can be bent to make objects invisible to the naked eye or appear to be something else.[166] The concept of invisibility is not new and was popularized in 1897 by H. G. Wells's science-fiction novella *The Invisible Man*.[167] Stage magicians in the twentieth century regularly made objects, people, and even elephants disappear, as illusionist Jim Steinmeyer chronicled in *Hiding the Elephant: How Magicians Invented the Impossible and Learned to Disappear*.[168] Because such techniques employed mirrors and other special apparatuses and were performed only onstage, the illusions had limited application to espionage.

The effect of an electronic cloak of invisibility on clandestine operations would be sweeping. Sensors, listening devices, cameras, and data intercept devices could be hidden in plain sight. Dead drops could be serviced with impunity and electronic identity transfers performed on command. New technologies, however amazing, provide only additional methods for creating deceptions and illusions; the goals and objectives of both the spies and magicians remain unchanged.[169]

A copy of the only known example of Mulholland's two original manuals overlooked during the destruction of MKULTRA files in 1973, was discovered by the authors in 2007. Subsequently, master illustrator Phil Franke used the poor-quality photocopies of Mulholland's original photographs as the basis for painstakingly redrawing the illustrations. Each image details the exacting movements and techniques used by Mulholland to teach the CIA's "tricksters." These images, along with the retyped original manuals' text, are reprinted together here for the first time.

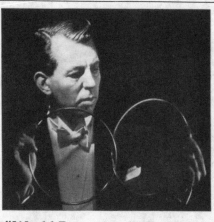

"World Renowned Magician"
John Mulholland

John Mulholland was a master magician and showman.

"Magic is the art of creating illusions agreeably." Crest from *Mulholland's Book of Magic*, 1963.

SOME OPERATIONAL APPLICATIONS OF THE ART OF DECEPTION

TABLE OF CONTENTS

I. Introduction and General Comments on The Art of Deception

The purpose of this paper is to instruct the reader so he may learn to perform a variety of acts secretly and undetectably. In short, here are instructions in deception.

There are few subjects about which so little generally is known as that of deft deception. As the American humorist Josh Billings said, "It ain't so much ignorance that ails mankind as it is knowing so much that ain't so." Practically every popularly held opinion on how to deceive, as well as how to safeguard one's self from being deceived, is wrong in fact as well as premise. Therefore, prior to explaining either theories or methods, an effort will be made to uncover that which "ain't." This is particularly important because successful deception depends so much on attitude of mind, and holding even one erroneous belief will make it difficult to attain the proper mental approach.

Parenthetically, the writer is assured that the reader is a person of unquestionable integrity, possessing more than average intelligence and schooling. In other words, this is a person to whom the practice of deception is quite foreign. However, the reader's admirable attributes of honesty and learning do not make his present task easier, for it takes practice to tell a convincing lie. Even more practice is needed to act a lie skillfully than is required to tell one. Though practice is essential to successful deception,

much less practice is needed than might be imag-
ined provided a person knows exactly what he is to
do, how he is to do it, and why it is to be done
in that way. The success of the act becomes more a
matter of memorization of details than of physical
repetition.

As examples of those who deceive by physi-
cal trickery, i.e. doing something in addition to
talking, may be named magicians, crooked gamblers,
pickpockets, and confidence men. To cite fallacious
beliefs regarding the methods of each of these ex-
amples will show how wrong popular opinion is.

"The hand is quicker than the eye" generally
is given as the reason for a magician's success in
mystifying his audience with any trick of small
size. In large tricks, for instance where a person
is caused to disappear, the secret is generally at-
tributed to the use of mirrors. There are a number
of other equally wrong "solutions" used to explain
the methods of magicians, but the two given will
show how basically wrong is uninformed opinion.

Stating that the hand can move more rapidly
than the eye can follow suggests that a movement
can be made and the hand returned to its original
position so quickly that no motion at all is dis-
cernible. This is not possible.

The most rapid coordinated movement man has
ever learned to make is done by a few of the lead-
ing pianists. Some of these highly trained musi-
cians have gone as high as eight to nine strokes
on a key per second, with one finger of one hand.
It was discovered through mechanical tests with

player pianos that the mechanism had to be in very good order to have one key function at the rate of ten times per second. It may be assumed that some pianist could develop the manual speed of ten strokes per second. However, even at such a rate, the movement would not be invisible because the normal eye can catch movement at the speed of one-one-thousandth of a second. The sight of the average person therefore is one hundred times faster than the most highly trained person can move one finger.

The mind may not register exactly what is accomplished in a very rapid motion of the hand but that a motion has been made will be quite obvious. It should be noted that a magician, unlike all other tricksters, acknowledges that he intends to deceive. His performance, because trickery is expected, can have no unexplained or, at least, unacceptable movements of the hands. A magician may not be seen to make any false motions and he should realize that he should perform all his secret movements with deliberation. Movement of any kind attracts attention—hence moving signs—and trickery depends upon not attracting attention to the method of performance. Magicians do not use speed in their actions.

Mirrors have been used by magicians in a few feats but their effective use is limited. A mirror can hide only one object by giving the reflection of another as a substitute. A mirror cannot make an object invisible. A mirror's single function is to reflect something. A mirror cannot reflect

nothing—and when a mirror is given nothing to reflect, the mirror itself becomes visible. Further, a mirror only can be used in trickery where it is possible to have every edge abutting some visible solid object, for otherwise the edges can be seen. Another detail which precludes the general use of mirrors in magic is that the larger the audience the closer the object to be reflected has to be to the mirror because of the angle of reflection. In large modern theaters this fact makes mirrors of no use to magicians. Traveling magicians, and these are the vast majority, find it utterly impossible to transport large mirrors due to their weight and fragility.

In short, while there is a slight basis for the public to believe that magicians use mirrors to achieve their mystification, the public is wrong in its understanding of the functions of the mirror in optical trickery and wrong in believing that mirrors generally are used in magic.

These two examples, 1. the totally wrong general belief that magicians depend upon rapidity of action, and 2. the misconception of how and when mirrors are used in magic, are typical of the wrongness of popular beliefs regarding magic. That magicians depend upon hypnotism and that magicians generally use confederates are among the other fallacies to which the public clings. None of these have any more validity than the one occasionally heard that magicians make objects invisible by painting them air color.

The great misconception about all trickery is

that there is a single secret which will explain
how each type of trick is performed. For instance,
consider the feat of causing a rabbit to appear in
a hat that had just been shown to be quite empty.
It generally is thought that there is a specific
method of getting the rabbit secretly into the hat.
The fact is that there are several score of dif-
ferent methods for performing this feat and a per-
son conversant with the majority of methods may be
mystified (and most probably will be) upon seeing
the trick performed by a method he does not know.
As another example, people still wonder about the
secret which permitted Houdini to escape from
any type of physical restraint. The fact is that
he released himself by a different secret method
for each way in which he was confined. He had at
least one method for escaping from each type of
handcuff, shackle, and box, and each way of being
tied with rope, cord, bandages, or straitjacket.
There is no overall secret to magic, or any part
of magic. It is the multiplicity of secrets and
the variety of methods which makes magic possible.
The proper secret for a magician to use is the one
indicated as best under the conditions and circum-
stances of the performance.

All tricksters, other than magicians, depend
to a great extent upon the fact that they are not
known to be, or even suspected of being, trick-
sters. Therein lies their great advantage, for they
need only do their trickery when it is to their
advantage and when they have conditions favorable
for success. Further, having made no commitment

as to what they are going to do, they can utilize that trick which is most suitable under the conditions of the moment.

The main error in public thinking about the tricks of gamblers is in believing that the tricks are designed to make winning a certainty. Actually these tricks are intended only to give the gambler enough advantage to increase the probability of his winning above that of the chance expectation. Working on this basis also minimizes the possibility of the gambler's tricks being discovered.

It generally is believed that a skilled card shark can deal to himself any card he wishes and whenever he has such desire. This can't be done, although a skilled manipulator of cards can, now and again, arrange to give himself a good hand. Even such skill may not ensure winning, for chance may give his opponent a better hand. The professional gambler depends largely upon a thorough knowledge of the game played, his memory of the cards played, and a full understanding of the mathematical probabilities of winning in any situation. This is not suggesting that the gambler will not take advantage of any means which he can use to his own aid but merely that he doesn't, and usually cannot, do the things which people generally believe.

The opposite situation also exists in the common belief about gambling that demanding a new deck at the start of a game will ensure that the cards do not have secret marks upon their backs. The new deck may have such marks, or it is not at

all difficult to substitute a marked deck for an unmarked one. Also it is quite possible to mark cards while the game is being played.

Pickpockets are very generally accredited with such delicacy of touch, brought about through long practice, as to be able to put a hand into a person's pocket and remove it, along with some valuable, without the person feeling the action. This is easily possible with a sleeping or intoxicated person, but for the sober, as well as awake, individual, deftness is not enough on the part of the pickpocket. The method generally used is to accustom the victim to being touched (usually done in a crowd) so that he is not aware of the extra touch at the time the theft is made. The public has been told about pickpockets having jostling confederates. At times confederates are used but they seldom are as rough as the word *jostling* would indicate. While the confederate may assist in preparing the victim by accustoming the victim to being touched, his chief task is to accept the loot and leave the vicinity so that the pickpocket is free of incriminating evidence.

Sellers of goldbricks (also confidence men and others of like ilk) rely in the main on the cupidity of their dupes. The only person who can be sold a goldbrick must have such avarice that he ignores the obvious fact that the "bargain" he is offered must be untrue or illegal. The chief skill of the seller is in discovering properly greedy victims. However, trickery frequently is used to clinch the sale by substituting false gold for

real, or substituting other bad merchandise for good. The world has the opinion that the goldbrick seller is one who has the ability to give a super sales talk. Actually he is merely a trickster with knowledge of the weaknesses of human nature.

To summarize from these few typical examples, the public holds wholly, or largely, untrue beliefs about how all trickery is accomplished. The public is satisfied that these false beliefs explain every deception, while actually the public has almost no factual knowledge of the methods used to deceive. One not aware that these generally accepted beliefs are false will be bothered subconsciously and can never learn to perform any false action smoothly and easily.

It is as essential to point out the facts as to point out what are not facts. As has been noted, there never is a single secret for any trick. The sole criterion is that the method to be used is the one to ensure the trick's success. There are two chief reasons for choosing a particular method. One is that it fits the physique, mannerisms, and personality of the performer better than any other method. The other is that conditions at the time of performance favor a particular method. Of course, this latter reason sometimes, as in a theater, can be ignored because conditions of performance are under the control of the performer.

The basic principle in performing a trick is to do it so that the secret actions are not observed. As Alphonse Bertillon said, "One can only see what one observes, and one observes only things which

are already in the mind." A trick does not fool the eye but fools the brain. In order to do that, it must be performed so that the secret parts are not noticed. This is possible because the trick is merely one or more actions which are added to other actions done for legitimate and obvious reasons. The added motions are not noticed because of the great variation in which people perform any given task and because it is not in the observer's mind to suspect such motions. The added motions must be minor ones, or at least they must not be emphasized more than the other actions. Further, the "secret" actions must fit in with the actions which are done openly.

Here is an example to clarify the generalities. A person, seated at a table in a restaurant, wants to obtain a teaspoon full of salt and put the salt into his left coat pocket, and wishes to do this without being observed.

The trickster picks up the saltcellar and shakes salt on to his food, or into his beer. He does this with the top of the saltcellar held toward himself so that the others at the table cannot see the quantity of salt coming out of the shaker. Seemingly not satisfied, the trickster raps the bottom of the saltcellar on the table. At this point circumstances dictate the performance, for the salt may, or may not, run freely from the cellar. If the salt runs freely, the performer, as if to try out the shaker after he has tapped it on the table, shakes a quantity of salt into his left hand, which is held at the edge of the table. If

the salt actually is bound up in the cellar, he unscrews the top and pours a quantity of salt into his left hand. In the first instance, as if satisfied by the test that the salt is coming out properly, he salts his food, or beer, by using the shaker. He drops his left hand to his lap or by his side. In the second instance, he takes pinches of salt from his left hand, with the fingers of the right hand, and salts his food. As soon as he has taken enough salt for his needs, he drops the left hand as was done in the other case. Naturally, when the left hand is dropped below the table, the fingers are closed so that the salt is held in the hand. The left hand is held at the side, or in the lap, for as much as a minute before the salt is put into the pocket. This wait is to ensure that there will be no obvious connection between the salt going into the hand and the hand going into the pocket. While this illustrates how something can be done which will not be observed although it can be seen, it also illustrates another point: not everyone can do a trick in the same way. A person with very moist hands would have to use another method because all the salt would adhere to his hand and could not be left in his pocket.

Timing also is most important. Timing has two elements. One has to do with when the trick is done. For instance, it obviously would be wrong, in the example above, to handle the saltcellar immediately after another person has used is successfully. The other point in timing is the cadence in a series of actions. The accent is given

78

to what is wished to be noticed. There will be little attention paid to those actions which are not stressed.

The example makes it obvious that what is essential to the success of the trick is the naturalness with which the performer acts the part of wanting salt, has trouble getting salt, doesn't let it bother him, and gets the salt he wants. It should be performed as if it were one of those minor bothers which beset mankind. He should go through all the actions as if no thought were needed (which it isn't) and is just one of those automatic actions one does regularly. Above all the trickster does not try to make any action slyly. The salt openly goes into the left hand and then the hand is dropped. He calls no attention to dropping the hand and thereby attracts no attention to the action. As with most tricks, it will be seen that it is not a matter of digital dexterity that is required for the success of the trick, but instead, a carefully thought out sequence of actions, naturalness in performance, and the ability to fit oneself to circumstances.

In planning a trick, the first consideration is to determine exactly what is to be accomplished. This would seem to be so obvious a fact that there would be no need to mention it at all. But, unless one is reminded that he must know fully and exactly what is his aim, one will begin with generalities. The invariable result of planning, when working from generalities, is complication of method. A trick to be good must be simple in its



of relying only upon simple pantomime is that the actions can further be minimized by talking on a totally unrelated subject as the actions are made.

Primarily, trickery depends upon a manner of thinking. It is a lie acted. More thought and care are needed to act out a lie than to tell one, for false actions are more obvious in their incongruity than are words. It is easier, for example, to claim to be an automobile mechanic than it is to act the part of one. It is easy for a phlegmatic person to state that he is nervous but exceedingly difficult to act for any appreciable length of time as if he were nervous.

Stating that trickery basically depends upon a manner of thinking needs considerable amplification, for the oblique thinking of the trickster must be acceptable to the spectators. This means that it cannot violate the manners and customs of the spectators nor, in any other way, can be the cause of attracting special attention. Anything unusual in action or speech (unusual to the one watching or listening) will attract attention and should be avoided. Even if a spectator's attention is focused on the actions during a trick and he does not discover that a trick is being done, he may later recall that the trickster acted oddly and possibly have his suspicions aroused.

Before a trickster can plan a trick, he must know who the spectators are to be. This does not mean knowing their names and addresses. It means knowing the kind of people that they are and their nationality. For instance, one might base a trick

on the action of borrowing a watch and then find that none of the spectators carried watches. Or the trick might require the trickster to slap a spectator on the back only to discover that all the spectators were Hindu, who would resent being touched. These are examples of actual cases where the trickster's lack of knowledge of who the spectators were precluded the performance of the trick which had been planned. The more the trickster knows about the spectators the better he can plan the trick to assure that it will succeed.

The "at-a-tangent thinking" is quite a descriptive phrase of the manner in which a trickster plans his work. He must think of something to do or say which, while it touches the subject, actually shoots off from it. Because the comment touches the subject, it will not be noticed that it actually is going away from the subject rather than around it. Again refer to the saltshaker trick. Attention is called so obviously to the "faulty" shaker that the spectators pay no attention to the perfectly open action of putting salt in the left hand. It should be stressed again that the false action must be so natural as to be acceptable.

There are several points which should be known about the things spectators will notice and those things they will not notice and about some of the spectators' thinking processes which can be depended upon. These are things which are true of all people irrespective of their nationality, educational background, or station in life.

No action which is expected will be noticed, but all actions which are surprising to a spectator will be noticed by him. However, while all surprising actions will be noticed, many will immediately be forgotten when followed at once by a rational explanation. For instance, pouring a beverage from a bottle into a glass, or tea or coffee from a pot into a cup, will not attract attention. However, pouring the liquid over the food on one's plate will be noticed. It will be noticed but not remembered if, when the liquid is poured on the food, it seems accidental because the body is twitched as if in pain and the statement is made, "There must be a pin on the chair." It will be all the stronger if, upon reaching down, a pin is produced, shown, and discarded. In other words, natural and normal actions excite no interest and, therefore, are not observed, while unnatural and unusual actions will attract attention unless a simple but satisfactory explanation is given at once.

A person who seems to be interested in what it is he is doing will not be noticed but one whose interest is directed toward what others are doing will attract attention. For instance, little attention will be paid to the individual who, when alone, seems absorbed in the book or newspaper he is reading, and when with others devotes his interest to his companions and has but casual interest in his surroundings. One who seems interested in everything except his paper, or his companions, or seemingly is looking for someone who hasn't yet arrived, always will attract attention.

Posture is important in avoiding being con-
spicuous. That person attracts little attention
who when either seated, or standing, appears to be
at his ease; that is, showing no physical effort
and with the manner of being confident of having a
right to be where he is. He will be noticed if he
stands stiffly as if he were a soldier reporting to
a high-ranking officer, or slouches as if death were
imminent. Noticeable, too, is the person who sits
as if he expects the chair to explode, or the one
who sits slouched awkwardly in a chair as though
he were a rag doll tossed into that position.

Possibly nothing attracts attention as quickly
as fidgeting. Constantly shifting position either
while standing or seated; repeatedly putting hands
in and out of pockets; tapping on a chair area
or table with the fingers; or playing with a watch
chain, keys, coins, table silver, etc are all to be
avoided by the person who wishes to do something
secretly.

Summarizing these points: the calm, quiet, re-
laxed (though not to the point of seeming dis-
jointed) person does not attract attention. This
assumes, of course, that he is a normal indi-
vidual. The person who is exceptionally tall, or
short, or crippled, or deformed will be noticed,
but once the observer notes the way in which he is
unusual, little further notice is paid.

On the subject of being noticed, there is an
inverse point that should be noted. At times
tricksters have reason to credit, or accuse, some
imaginary person with what has been done. A natu-

ral mistake is to describe someone of a form, and of actions, which are unusual and striking. It usually is easy to ascertain that no such person has been in the vicinity. The proper description will be of a person average in size and coloring and normal in features, but—and this is a very essential point—having some minor oddity such as the first joint missing of the little finger of the left hand, or a large mole close behind his right ear. The description, in short, of almost anyone but mentioning some unlikely, but easily noticed, minor oddity which would identify him if found. Such a description will be acceptable to listeners and at the same time be one most difficult to disprove.

Resuming the description of the attributes of a successful trickster, let it be repeated that he should be so normal in manner, and his actions so natural, that nothing about him excites suspicion. This does not mean that he has to be of any particular size or shape, or that he has to make gestures when he talks, or refrain from making them. It means only that he has to be himself—as he is at his calmest moments. That person who naturally speaks and acts rapidly will do well to learn to make both speech and actions more slowly. Tricks never are done rapidly and slowing up at the time the trick is done becomes noticeable. The big point is to be comfortably natural or, at least, to give that appearance. If one can be natural even in a difficult situation, he will make his work less arduous, for it is very difficult to act the role of one who is at ease and, at the same time, think of

trickery. The chief cause of stilted actions and lack of poise is due to worry brought about through lack of preparation. When confident that he can do it, he will have a natural manner. There is nothing more important to the performance of a trick than confidence on the part of the performer. Confidence is a direct result of preparation. Confidence is nothing to be exhibited and it is not cockiness. Confidence is merely the feeling of certainty of being prepared to do the job—an awareness of being ready.

Some people, as a matter of fact almost everyone, become nervous and tense when appearing before a large audience. The trained actor realizes, and the novice senses, that due to distance, his natural manner seems false. Because distance both minimizes and otherwise alters, the stage actor makes gestures both broader and slower than he would do intimately. Because doing a trick is a form of acting, beginners tend to be nervous and assume an unusual manner and stilted gestures. Those who do their tricks before only a few should not worry, for they have no need to alter their actions or manner. Not only is there no need, but it should not be done. The popular belief that it is more difficult to perform a trick "right up close" is completely erroneous. The performance on the stage is sufficiently distant so that the spectator's eye sees the entire man. When close by, only part of the performer is within the spectator's range of vision. The more of the performer that can be seen, the less his chance of doing anything

without detection. As examples: a performer on the stage would be seen were he to put his hand into his pocket, but that action can be made without being seen while standing close to a person so the hand is outside of his range of vision.

Simple tricks, and the reader will never need to do any others, are easy to do, for they require only knowledge, understanding, confidence, and a small amount of ingenuity. And the ingenuity will be needed only in the event of having to combine or alter methods hereinafter set down in order to fill some particular circumstance of which the writer could not be aware. The reader will not find it necessary to develop any manual skills for any of the tricks. He never will be asked to do any action that he does not now do regularly, even though he may need to make the action for a new purpose. There will be no lessons in intricate sleight of hand. All tricks will be simple to do physically. But take this bit of warning—the easier the manipulation in a trick the more essential it becomes for the performer to have every detail clearly in mind. This is because, while expert manipulation can in itself become mystifying, simple trickery depends entirely upon an idea and a routine. However, with your mind and my methods, there should be no real difficulty.

Prior to going on with details of how to do particular tricks, it may be well to review what has been written. First, in order to approach the subject properly, one must have a mind completely free of all the various commonly held, though erroneous, ideas about how tricksters operate. It is

wise for a beginner to have his mind completely devoid of convictions of any sort about trickery. Starting with a clear mind eliminates 75 percent of the difficulty of learning to do tricks.

Next, it is necessary to restate that trickery depends basically upon elementary psychology. One who expects to perform trickery must understand that the objective of the trickster is to deceive the mind rather than the eye. This understanding will make him ready to accept that the trickster depends upon a form of thinking which will mislead the spectators rather than upon quickness and ma- nipulative ability. To make a positive statement, the trickster relies upon confusing, and thereby deceiving, the minds rather than the eyes of the spectators. Even when eyes are misled, the memory may hold something that will permit working out how the mystery was accomplished after it is over. When the mind has been deceived, it is almost impossible to work backward and discover the deception.

Were it possible for the writer to be with the reader, it would be very easy to demonstrate how readily the mind may be fooled even when what is done is seen by the eyes. It would be very easy be- cause the personal element plays such a large part in the performance. As this is not possible, all that can be done is to set down a couple of tricks on paper.

1. Two farmers live a mile apart and each put a fence of the same length, height, and material in front of his house. The

eye can see (in the design below) that one farmer is a better fence builder than the other, but unless attention is called to the matter, the mind does not realize the difference.

(-0-0-0-0-0-0-) (-0 -0—0- 0-0 -)

2. A man had been studying Esperanto and other universal languages. As he sat at his desk thinking about the matter of universal languages, he absentmindedly wrote these letters:

LUANSIRVEEVRISNAUL

The eye sees the letters, but even with the reader's mind cued twice in the story above, it takes some study to see what was in the man's mind. Without the story, and the study, the mind would register only that a number of letters, making no word or words, had been written. It is not immediately apparent that beginning with the second letter and reading every other letter spells out the word universal. And beginning with the next to the last letter and reading backward, every alternate letter spells out the same word.

Now a description of the performer. He must be natural and at ease. He must know in such complete

detail what he is to do and how he is to do it
that he is completely assured and so has full con-
fidence in himself. He has such complete confidence
that he not only does not fidget but has no incli-
nation to do so.

Then the performer must have a realization of
the element of time. He must know the proper time
to start his trickery. He must know the importance
of time in each detail of his performance.

Finally, the performer must accept to the full
extent the fact that he cannot know too much about
what he plans to do. Every detail he knows, be-
yond the bare essentials to ensure success, adds
just that much more to eliminating the possibility
of failure. The more details a trickster has in
mind in connection with a trick the more certain
he will be of his ability to do what is required.
To state this in other words, worry, the possibil-
ity of error, and the chance of detection can all
be eliminated by thoughtful, careful preparation.
The situation recalls the occasion when a reporter
asked the scientist Dr. Roy Chapman Andrews, on
his return from a year in Inner Mongolia, to tell
about his adventures. "My dear man," said the doc-
tor, "we had no adventures. We had a scientific
expedition. Adventures come only through lack of
preparation and we were properly prepared." Such
is the case with trickery, for proper preparation
ensures success.

The performer's knowledge must be so complete
that he knows each detail of how and why each
point in the trick is done. He must know, as well,

when conditions of the moment demand a change in the prepared procedure and how to make such change without being disturbed. Such changes will not be manipulative and never require anything but a flexibility of mind coupled with knowledge.

At this point (very possibly at an earlier paragraph) the reader comes to the conclusion that the writer is extremely verbose in explaining a few simple points. Such feeling is not at all objectionable as long as the reader has grasped that the points are simple. The writer's aim is to have the reader successful whenever he performs a trick. The writer is quite willing to acknowledge being both wordy and obvious provided the reader, thereby, invariably has success in his work.

II. Handling of Tablets

In an earlier paragraph it was noted that the reader in performing his tricks need never make any action that he does not now do regularly. This is because he should be able to have his entire mind concentrated upon the performance rather than being diverted by the necessity of having to consider a new manipulative technique. The first illustration will be found to be entirely natural for any person who smokes. Even if the reader is a nonsmoker, he will, most probably, find it to be quite natural. Whether the reader does or does not smoke, he should follow the instructions and actually do the action indicated.

In order that the reader may find exactly what

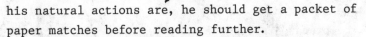

his natural actions are, he should get a packet of paper matches before reading further.

Take the paper matches, open the cover, tear off one match, and close the cover. Then light the match and blow it out.

You will have found that it is natural to do these several actions entirely without using the third or little fingers of either hand. Assuming that the reader is right-handed, he will have held the packet of matches in the left hand and between the thumb, on one edge, and the first and second fingers, on the opposite edge. (If the reader naturally is left-handed, he will find all details are the same in all instructions hereinafter set down and quite usable provided he read "left hand" whenever "right hand" is set down and vice versa.)

Whereas the reader will find that he will use only the thumb and the first and second fingers of the left hand in holding the paper of matches, he may not automatically hold the packet exactly as is required for this first trick. However, he will find that the position of the packet is all that has to be changed and that does not change the grip he naturally uses. Properly held, the thumb is on one side of the edge of the back of the paper cover and the first and second fingers are on the opposite edge. Held in this way, the back of the cover is facing the palm of the hand. This grip makes it possible for the fingers of the right hand to open the front cover, to tear off a match, and to close the front cover,

without releasing the grip of the left fingers or changing their position.

To continue the experiment, the reader should insert an ordinary straight pin into the back of the packet of matches. The pin is stuck through the lower-right-hand corner (this assumes that the back of the packet is uppermost), a quarter of an inch from the right side and the same distance from the bottom. The pinpoint should be pointed toward the top of the packet and right along the inside of the back and behind the matches. The pin should be pushed all the way in so that only the head protrudes at the back.

Again the packet of matches should be taken, held as described above, opened, one match torn off, the cover closed, and the match lighted. It will be found in doing these actions that the head of the pin never is touched. It also will be found that it is easy, and not at all noticeable, to rub the tip of the third finger of the left hand over the head of the pin. If the nail of the third finger is used, it will be found easy even to pull the pin out of the paper.

Having tried this experiment, it will be obvious how simple it would be to knock off a small pill which had been stuck to the packet at the position of the pinhead. In handling the matches, it will be seen that it is natural, and easy, always to keep the back of the matches pointing toward the inside of the hand or down toward the floor. In either instance the pinhead (or the pill) always will be kept hidden from the sight of both performer and all spectators.

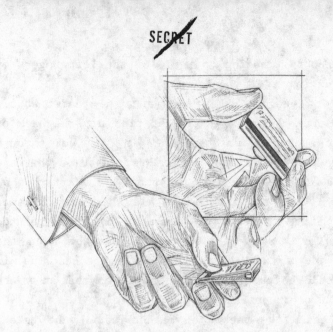

Showing pill attachment and way matchbook is held to easily release pill.

The above describes how a small pill may easily
be carried and handled (though it is minute) and
yet is quickly released indiscernibly and with no
effort. Such is the secret and the following are the
details of performance. The plot of the trick is to
put the pill into the beverage of one particular
spectator without his, or any other spectator's,
knowledge. In the situation where there is but one
spectator, the trick is extremely simple. The per-
former should either be facing the spectator or at
his left (again these are instructions for a right-
handed person). It makes little difference whether
both are standing at a bar or are seated at a table.
If the table, however, is so wide that the performer

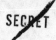

cannot easily reach across it, the trick cannot be done when the performer faces the spectator. If, by half rising from his chair, the performer can reach across the table, then it is suitable. The reason for the respective positions of performer and spectator is that the trick is done with the left hand and therefore requires ample space for the movement of the left arm.

This trick, by the way, only can be done for a spectator who is a smoker. Another method will be described for performing for a spectator who does not smoke. If, prior to performance, the performer knows whether the spectator does or does not smoke, he need only be prepared to use one method. If that fact is not known, it will be necessary to be prepared to perform either method.

This is the routine for the spectator who smokes. The instant the performer sees the spectator take a cigarette, cigar, or pipe, he takes the packet of matches from his pocket, tears off one match, and holds packet and match ready to ignite the match. He does these things openly because what he does can only be looked upon as a friendly and courteous gesture. As soon as the spectator is ready to light up, the performer should hold the matches close to the spectator and strike the one match. The matches should be held only as close to the spectator as politeness allows but should, if possible, be closer to the spectator than is the mouth of the glass, or cup, into which the pill is to be dropped.

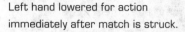

Left hand lowered for action
immediately after match is struck.

The performer should hold the flame of the
match so that the spectator best can use it, and,
of course, the performer must look at what he is
doing. As soon as the spectator has a proper light,
the performer should begin to lean backward into
his previous position. In doing this, the left
hand, which has been held still since the match was
struck, is brought over the mouth of the glass or
cup, and the pill dropped into the liquid. Three
points should be stressed. First, the left hand must

be withdrawn with a continuous motion. There can be no hesitation over the liquid. It should be obvious that the slower the left hand is moved the easier it will be to aim accurately. Second, while the left hand is being withdrawn the performer may drop his eyes from the face of the spectator and thereby see the table, but he should not obviously follow the movements of the left hand. Third, the left hand should come as close to the mouth of the glass as possible. This not only ensures the pill going into the liquid but also lessens the chance of the pill making a splash which could be seen or heard.

It will be noticed that the pill is dropped as the arm is brought back to the body rather than at the time the arm is extended. This, chiefly, is because any secret move which is performed as a part of a broader action usually can be made less obvious when done as the arm is brought back to the body. This is because once the obvious action has been completed, the spectator's mind no longer takes an interest in the movement of that arm.

The psychological basis for this routine is that a small action will not be noticed when it is done while making a broader gesture for which there is an obvious reason. The reason for the broad gesture must, however, be an essential part of a thought entirely disassociated from the purpose of the small action. Again it should be stressed that the obvious action must be completely natural.

In the circumstances that the performer is standing with the spectator at a bar, the trick is done exactly as if at a table except for the

movement of the performer's body. At the bar the performer makes a quarter turn of his body to the right so that he is facing the spectator rather than facing the bar. Otherwise the movements are done entirely with the arms. When at the table, if seated at the left of the spectator, the performer turns at his waist rather than moving his feet, so as to face the spectator.

If the spectator is a nonsmoker, this is the routine suggested. Affix the pill to the back of a wallet, notebook, or small paper pad which would be natural for a person of the character of the performer to carry. Have loosely in the pocket of the wallet, or among the pages of the notebook or pad, a paper with something written on it about which you wish to question the spectator. The writing may be an address, or name, or anything on any subject. Whatever is written only has to be something about which a legitimate question may be asked.

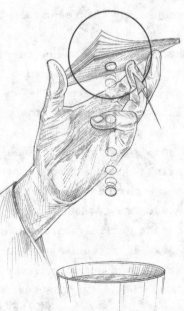

There is an alternative possibility, which is to show something

commonly seen about which a remark can be made on a point which it is unlikely the spectator is aware, such as a piece of paper money.

A few minutes' study with any piece of paper money ever made will find some oddity about which a remark may be made with the assurance that the spectator never had noticed the detail. Such a detail is the fact that on the U.S. dollar bills issued during the time John W. Snyder was secretary of the treasury there was no period after the *W* in his signature. The detail need have no importance whatsoever. It need only be something which may be shown and talked about. It is best not to use a detail which may be something the spectator has been asked before, such as, "How many times does the figure 1 and the word one appear on a dollar bill?"

The preparation for using the paper is exactly the same as with the matches. The point at which the pill is affixed to the back of the wallet, notebook, or pad depends upon the size of the object. It is to be stuck at a point where the third finger of the left hand can pick it off easily when the object is held between the thumb on one edge and the first and second fingers on the opposite edge. Naturally, the object used must be of such a size that it may be held in this manner and as if it were a natural way to hold it.

The performance, using the paper, is almost the same as the trick with the matches. These are the details of the routine of the performance. First, something is said about the subject mentioned on the paper. Then the wallet, notebook or pad is

taken from the pocket. It is brought in front of, and close to, the spectator as it is opened and the paper is taken out. The majority of people in doing this action would open the wallet and extract the paper while the wallet was held close to their own bodies and then reach out only with the hand holding the paper. The point is that there are some people who naturally would do the action the other way. That fact makes it possible for the performer to do it in such manner. He need only remember that it is a perfectly natural action even though it might not be the way he normally would do it. It does not in the least change the manipulations he normally uses. By holding that thought in mind and then going ahead and opening the wallet close to the spectator, the performer will find that the action seems natural even for him.

The psychological point here is that all that is required is, no matter what the action, that action must be a natural one and appear so. It is not necessary that the action be the one customarily followed by the performer. Any action natural for one person can be performed easily by another person provided no new techniques are involved.

Once the paper has been taken with the right hand and handed to the spectator, the left hand is brought back to the body. In the motion the left hand is brought over the mouth of the glass or cup, and the pill is dropped in.

The character of the performer, or the character he has assumed, plays a major part in this trick and its performance. For instance, if it is in

character for the performer to carry a cigarette case, the pill may be stuck to it. After offering a cigarette to the spectator the pill is picked off as the performer brings back the case prior to returning it to his pocket.

If the performance is to take place in a country where paper matches are not commonly used, the trick may be done quite as readily with any size box of matches which may be carried in the pocket. One accustomed to performing tricks could do the trick by using a lighter but, due to the fact that only one hand is needed to operate a lighter, the trick becomes more difficult to do. It is more than twice as hard for a spectator to observe the simultaneous, though varied, actions of two hands as it is to follow the movements of one hand. This is a factor of which it is advisable to take advantage.

No matter what the object to which the pill is attached, precaution has to be taken that the pill is not scraped off the object during the time it is in the performer's pocket. The most certain way to prevent having the pill accidentally loosened in the pocket is to have a stiff box in the pocket in which the object may be put. The box must be open at the top in order that there will be no fumbling in extracting the object. The box must be shallow enough so that part of the object will extend above the edges and will be easy to grasp. The box should be only so long and so wide as to ensure that the object goes in and can be withdrawn easily. Such a box often can be made from some small container by

cutting away a part. A proper box can also be made by cutting and folding a piece of cardboard and pasting paper around the outside.

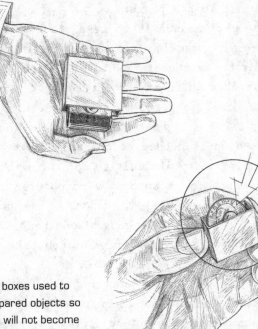

Types of boxes used to hold prepared objects so that pills will not become dislodged while objects are carried in pockets.

The above trick, even with its variations, is intended for use only in connection with a solid pill no more than 2.5 mm in diameter. Other methods are more practical when using objects of larger size, or objects in other form. Methods for achieving the same objective but using pills of larger size, a powder, or a liquid will be described later. It is not the task of the writer, nor is it within his

knowledge, to indicate whether a solid or a liquid form should be used, nor the size or quantity of either. Such information will be given the reader by other sources. The writer's single job is to supply the tricks by which the object may be handled. The writer does not recommend one method above another. The method indicated for a specific performance is the one having details most suitable in the situation and which will appear most natural.

Left: Normal expression of face. Right: Exaggerated expression of dumbness. The more facial muscles are relaxed and eyes thrown out of focus, the greater the effect. Doing these actions to a mild degree merely shows a lack of alertness or disinterest.

A psychological-physical fact which applies to the performance of the above trick in all its variations, as well as in the performance of all other tricks, must be noted because of its great importance. The fact is that physically, at the moment of doing any action requiring concentrated thought,

there is an alertness of appearance which is very noticeable.

A sudden alertness on the part of the performer causes wariness on the part of the spectator. The opposite of an alert appearance is a stupid one. Assuming a mildly stupid appearance during a trick will give the appearance of disinterest. Naturally this should be done to a mild degree, for suddenly having an imbecilic expression also is warranted to attract attention. Stupidity in appearance is affected by relaxing the facial muscles and throwing the eyes out of focus. To learn to relax the facial muscles one should practice in front of a mirror. When one finds, in this manner, which muscle controls which part of the face, it becomes a matter of very little practice to relax the indicated muscles when away from a mirror. To learn to throw the eyes out of focus, look at some object about a foot distant and then hold that focus when looking at a person several feet away. This skill, too, requires only a little practice. When, earlier, the writer promised the reader that he never would be asked to do any action he did not regularly perform, it escaped the writer's memory that the reader would at times need to appear stupid. This is the single exception and the writer apologizes to the reader. However, to be able to appear stupid purposely in order to enhance one's work shows a considerable degree of intelligence as well as an appreciation of the art of acting. In such cases it is quite a different matter than it is with that individual to whom such an expression is not only uncontrollable but usual.

The instructions above are for performing a trick in which a small pill is used. Whereas the method was devised for pills ranging in size from one-sixteenth of an inch in diameter to a pill as large as three-sixteenths of an inch in diameter, it will be found that the method is suitable for pills of greater size. In doing the trick with larger pills (up to three-eighths of an inch and even more) extra care must be taken in sticking the pill to its carrier. First, the position on the object at which the pill is attached must be such that the pill can be removed with ease. Second, its position must be such that the pill is masked from the sight of the spectators. This means that the pill must be far enough away from the edges of the object that it does not stick out where it may be seen—even when the object is held as has been described. A little experimenting will show the spot at which the pill is to be attached. Third, extra care must be taken in using the exact amount of paste in sticking the larger pill to the carrier. Due to the greater weight of a large pill, more paste will be needed than for a small pill. Experimenting, here, too, will show just how much paste to use.

The paste used must fulfill several requirements. It must be simple to apply, hold firmly, dissolve quickly in any beverage and without leaving a noticeable residue, and it should be easily obtained. Powdered gum arabic (available in any drugstore) makes an excellent adhesive when mixed with water and fulfills all the requirements. A drop of water and a minute quantity of the powder, mixed together

with a toothpick, will make enough paste to hold
even a large pill. When mixed to the consistency of
a fairly thick gruel, a small quantity of the paste
is taken on the point of the toothpick and put on
the proper position on the carrier. The pill then
is pressed onto the paste.

In using a large pill (three-eighths of an inch
in diameter and over), it probably will be found as
easy, if not easier, to hold the pill in the fingers
and merely drop it at the proper time rather than
carrying it on an object from which it has to be
picked off.

The easiest and most natural way secretly to hold
a pill is at the base of the third and little fingers
and curling those fingers so that the tips touch the
palm of the hand. It will be found, even with those
two fingers held in that manner, that there is no lack
of freedom of movement of the thumb and the first and
second fingers. When the third and little fingers are
curled as described, there is a crease between the
base of the fingers and the palm. The pill is held by
the fold of flesh which forms the crease. The center
of the pill should be at the crack between the two
fingers. In this position there is enough flesh on all
sides of the pill so that it is completely masked
from sight. Some individuals, because of the forma-
tion of their hands, have a space between the fingers
which is impossible to close and, therefore, cannot
hold anything in this manner so that it cannot be
seen. However, even they will find it is possible to
adjust the position of the pill so that it will be
hidden.

Position in hand for holding large pill in fingers. This action can be masked by holding some object such as a paper of matches. Object held is immaterial.

In using this "grip" method, all the details of performance are identical with the methods described above with two exceptions. The pill is released by opening the fingers instead of picking it off the carrier as is done in the other method. The second difference is that the pill has to be in position in the fingers before the packet of matches (or whatever other object is used) is taken in the hand. It is advisable to have some small container with an open end to carry the pill when it is in the pocket. Using a container ensures that there is no chance of having the pill crushed, or chipped, and thereby rendering the

pill so that it is entirely useless or lacking its full strength. The container also keeps the pill from picking up any lint, etc., in the pocket.

The pill is tipped from the container into the hand and pushed into position by the thumb. This action takes place in the performer's pocket. The fingers then are curled to hold the pill. When the pill is gripped firmly, the matches or other object is taken by the thumb and first two fingers.

It is possible that the reader will find this method to be so easy and natural that he will wonder why the other method was suggested. Holding the pill in the fingers only is indicated for use with the larger pills. The reasons for this statement are: 1. Few men have hands with flesh so soft as to be able properly to feel a small pill and to be certain that they are holding it. 2. The natural moisture of the hands is apt to make a small pill adhere to the flesh and not be released when the fingers are opened. 3. The fingers have to be closed so tightly to hold a small pill that the hand is noticeably cramped and unnatural.

One additional suggestion for a way secretly to handle a pill is set down only because circumstances in a particular situation may make it more suitable. In this method the pill is stuck to the center of one side of a coin. This coin is taken by the performer from his pocket along with two or three other coins. The "loaded" coin, however, in being brought out of the pocket is held between the thumb and first finger and the other coins are gripped between the rest of the fingers and the

palm. The loaded coin is so held that the pill is kept from the sight of the spectators.

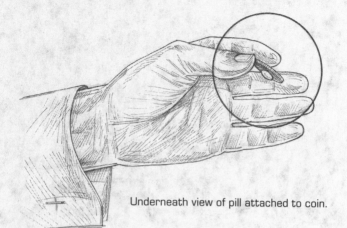

Underneath view of pill attached to coin.

The loaded coin is placed on the center of the palm of the other hand (pill side down) and the rest of the coins dropped upon it. Due to the concave shape of the palm of the hand, the pill will be completely hidden from sight.

The purpose of taking the coins from the pocket is, ostensibly, to make some minor purchase such as a package of cigarettes. There should be enough coins left on the hand after making the purchase so that two or more may be put on the bar or table and yet still have two of the same size left on the hand. One of these two coins is the one to which the pill is attached. One of these coins is taken in each hand and held, with one flat surface facing the ceiling, between the thumb and first finger. The second finger of the hand holding the

loaded coin will readily and naturally hide the
pill from being seen from the side, and also is in
position to pick off the pill.

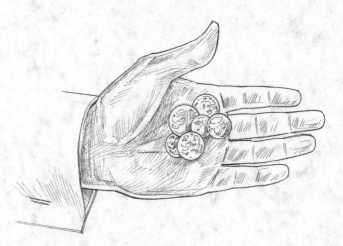

The coins are held in front of the spectator and
some remark made as to how much, or how little,
the coins have worn, or that one is worn far more
than the other. The remark is unimportant as to
substance. It has only to express a reason, seem-
ingly of interest or amusement to the performer,
which makes it natural to show the coins. As soon
as the remark is made the extra coin is handed to
the spectator or dropped on the table or bar. Ac-
cording to what has first been said, the performer
asks the spectator to feel the surface of the
coin, or its weight, or to listen to its "ring."

As these things are done and said, the loaded
coin is brought back to the performer's body. In

the movement the coin is carried over the specta-
tor's drink and the pill is released.

As was the case with the paper of matches, the
coin to which the pill is attached is carried edge-
wise in a box in the performer's pocket. The box is
so made that the coin may easily be taken out.

While several variations have been given in the
mechanics of carrying and disposing of the pill,
it will be apparent that the psychological back-
ground for the performance does not change. There
is no change in the thinking behind the actions
of the performer, nor in the way in which the mind
of the spectator is led to thoughts apart from the
secret action. What the performer says and what he
handles may be varied from the suggested topics
and articles as long as no change is made in the
psychological pattern of the performance.

An important point is that these tricks, as is
true with almost everything one does well, must
be practiced. That does not mean countless rep-
etitions such as a pianist does in learning the
scales. It means slowly going through all the de-
tails of performance, physically as well as men-
tally, until confidence comes so that there will be
nothing awkward nor hesitant in word or action.
The first few times the routine is gone through,
it should be done extremely slowly in the manner
of the movement in slowed-action moving pictures.
Rehearsing slowly at the beginning ensures that no
detail will be overlooked. As soon as the routine
can be done smoothly and evenly, it may be prac-

ticed at a natural tempo. Learning the details of performance by practicing slowly at the beginning reduces the overall rehearsal time materially.

If a matter of weeks, or longer, occurs between rehearsals and the time of performance, it is advisable to run through the routine prior to attempting it. Provided it had been thoroughly learned during the original rehearsals, it is not absolutely necessary to do the trick at later rehearsals if one is able mentally slowly to go through each detail of speech and action that the performance requires. If there is any hesitancy in recalling details, the trick should be practiced further. Forgetting details is more apt to be caused by not having learned the trick thoroughly in the beginning than from being possessed of a faulty memory.

III. Handling of Powders

Loose material, saltlike in form, can be handled only when it is in some type of container. The container has to have three requisites. 1. The container must safely hold the loose material without the possibility of loss of quantity. 2. It must be constructed so the material can be instantly released. 3. It must not appear to be a container and it must have some common use which makes it an object anyone might be expected to carry. The writer's instructions were to design tricks in connection with using amounts of a loose solid varying from the volume of one grain of table salt to one teaspoonful.

In order to simplify the instructions, all tricks in which powdered solids are used are based upon using a pencil as the container. Normally, common wooden pencils are not considered as containers and for that very reason excite no suspicion when used for writing in the customary way.

Common objects are not apt to be suspected, especially if the object is not new. This is a psychological point which holds true with things a man ordinarily carries in his pockets. Crumpled and worn paper money (unless the value is so high as to be of interest because such bills are not usually carried) attracts less notice than do crisp new bills. A shiny new penny will be the only coin noticed in a handful of dull worn coins. Taking a cigarette from a partially used pack will pass unheeded while taking a new packet from the pocket is apt to be noticed. A new billfold, watch, etc. will be noticed, while the actions connected with using similar but old objects will not be observed. Therefore, since it is necessary that it attract no attention, the "loaded" pencil should not be new. The difference in appearance between an old and a new pencil is largely a matter of length. A pencil from four to five inches long, seemingly having been sharpened and resharpened, will not attract attention. As in most such rules, this rule against newness can be overdone. A stub of a pencil, only an inch or two long, is noticed because it is awkward to handle so short a writing tool. A torn and ragged wallet, a twisted and crushed pack of cigarettes, or anything so obviously dirty no normal

person would carry it are other examples of the overdoing of the lack of newness.

There is a further exception to the above rule. A worried and suspicious person will more readily accept a cigarette from a new package he has just seen purchased than he will from a partially used package taken from someone's pocket. While it is not the safeguard the suspicious person assumes, it is one of those commonly held beliefs, such as the trust in a newly opened deck of cards, previously mentioned.

According to the amount of loose solid needed to be carried, there are three ways of preparing a pencil. Although it does not make a great deal of difference in two of the methods, a round, rather than a hexagonal, pencil is easier to handle. In the third method a round pencil only can be used. The pencil should be of the usual style, which has a metal band at one end to hold a rubber eraser. Because the performance is the same no matter which pencil is used, descriptions first will be given of the three ways to convert a pencil into a container.

1. Container for from one to fifteen grains.

It will be found fairly easy to take the rubber out of the metal tube. Most pencil manufacturers run the metal cap through a machine after the rubber has been inserted. The machine stamps small prongs of metal into the rubber in order to clamp it firmly in the metal. During the same operation, the metal tube similarly

SECRET

is clamped to the wood of the pencil. Usually the rubber can be twisted out of its metal casing so that the rubber remains quite intact. At times the rubber will tear and part of it will be left inside the metal band. In the event of the rubber tearing when it is taken out of the metal, such rubber as remains has to be dug out completely. The rubber, if taken out whole, should have one-eighth of an inch cut off the end so that it is from one to three-eights of an inch less than its original length. If more than that amount of rubber is missing, it is advisable to use another pencil. The eighth-of-an-inch cut off the rubber allows space inside the metal band for a small quantity of powder when the rubber is replaced in the pencil. Prior to pushing the rubber back into the tube, the sides of the rubber should be rubbed lightly with very fine (00 or 000) sandpaper so that it will go easily into the tube and yet still be large enough to stay firmly in place.

2. **Container for up to a cubic centimeter of a powder.**

In this instance the rubber is taken out as before. Then the center of the pencil is drilled out to a depth of an inch or more depending upon the amount of powder to be used. Such drilling should be done in a shop having a small drill press having a

clamp with which the pencil can be held firmly. Due to the graphite being harder than the wood of the pencil, it is almost impossible to drill down into the center of a pencil by using a hand drill. Even with the proper drill press, the job of drilling such a hole has to be handled with great care. The amount of powder which such a hole will hold depends, of course, upon the length and the diameter of the hole. It is possible to drill a three-sixteenths-inch hole in a pencil to a depth of two inches and such a size hole will hold a cubic centimeter of a fine-grain loose solid. The rubber is sanded as in the other case and used as a stopper for the container. It is not necessary to shorten the rubber unless more space is needed for the powder.

Removal of eraser from a wooden pencil can create a secret cavity for powders.

3. **Container for up to a half teaspoonful of powder.**

To make a really sizable container out of a pencil requires using a glazed colored paper. Such paper is sold for a variety of purposes such as gift wrappings, shelf paper, and children's pinwheels—years ago the usual name for such paper was "pinwheel paper." Pencils commonly are orange, yellow, blue, green, or red and such paper generally is to be found in these colors. To prepare the pencil, the wood just below the metal band (which holds the rubber) is cut through so that the band is separated from the pencil. The wood and graphite remaining in the metal tube are drilled. Care must be taken not to drill into the rubber, which must be pushed intact out of the metal tube. This is done from the inside of the tube. Next the metal prongs on the inside of the tube are flattened and the metal of the tube stretched a very slight amount. These things are done by using a drill whose shank is a little (but no greater than one-sixty-fourth of an inch) larger than the diameter of the inside of the tube. The drill is reversed in the drill stock so that the shank protrudes. As the end of the shank of the drill is somewhat rounded, it makes an excellent tool for the purpose.

Having prepared the metal band, the next step is to make a tube of the paper. This is done by rolling the paper around the pencil tightly in order to measure the exact amount of paper needed. A mark is made on the paper allowing one-eighth of an inch of overlap. The paper is unrolled and carefully cut so as to have straight and true edges. Glue is brushed along the inside of the paper but only on the portion which will overlap. The paper is rerolled tightly around the pencil and the glued part pressed down. The paper is held in place by winding soft string tightly along the entire length of the paper. The string is tied and the pencil put aside until the glue has had a chance to dry. Most glue used on paper will harden in less than an hour. The string then is taken off the paper and the pencil pushed out of the tube. There should be no difficulty in removing either string or pencil provided the glue had been carefully applied so that none had squeezed out of the edges of the paper.

The pencil then is cut off two inches above the point. This piece of pencil, after having been lightly brushed with glue from the blunt end down almost to the taper, is pushed into the paper tube. The stub of pencil should be pushed into the tube until only the point and the taper protrude. Measuring four and a half inches from the point of the pencil, the paper tube should be cut off. That end should be inserted into the metal band. Glue should be brushed around the end of the paper tube prior to pushing it into the metal band. The

rubber eraser will have to be rubbed with fine sandpaper in order to make it fit properly in the metal tube, which now is lined with the paper. While the rubber should go easily into the tube, it should be large enough to stay in and hold the weight of the powdered solid. The reason for the rubber being its original length is to give more surface to hold the rubber more firmly in the tube. The rubber has to stay in place, yet it must not fit so tightly as to cause difficulty in taking it out. This pencil will hold up to 2.5 cc of a powdered solid.

It will be seen that each of the pencils described has a secret compartment and that each compartment is stoppered with an eraser. For each of these pencils there should be a duplicate in outward appearance and lacking the secret compartments. Actually, a duplicate of the first pencil described (with the capacity of fifteen grains) is not essential, although having one may help the confidence of the performer. Each duplicate pencil should have a tiny notch cut in the taper of the wood near the point of the pencil so that by touch it can be distinguished from the matching prepared pencil. This notch should run partway around the circumference of the pencil and cut so that it appears to have been accidentally made when the pencil was sharpened. While the notch should be so small that it never would be noticed by anyone handling the pencil in the ordinary manner, the notch should be deep enough so that it can readily be felt by anyone aware of its existence.

The best place to carry the pencils (a prepared one and its duplicate) is in the right, outside pocket of the coat. In that pocket the pencils can be carried in a horizontal position. However, when a coat is not worn, the pencils may be carried in any pocket which will make them instantly available. The pocket should be large enough to permit the entire pencil to go inside. Were the pencils to protrude, it would be obvious that two were carried.

In performance, the routine is very much like that with the pills. Again it is assumed that the action takes place either at a bar or at a table. Again the purpose is secretly to put something into the beverage of a particular spectator. The respective positions of performer and spectator are changed when at a bar. In this trick the performer stands at the right of the spectator.

The best way to introduce the pencil (and at the beginning the duplicate is used) is to bring into the conversation some subject which becomes clearer, or less confusing, using a diagram, for example the streets to follow and the turns to be made in order to get from here to there. If the performer has the ability to sketch, the subjects which may be brought up are limitless. If he cannot draw recognizable pictures, he will find many subjects in connection with which he can draw simple diagrams.

While the performer should have some piece of paper with him in case it is needed, it is better to use something for the drawing which is picked up

at the moment. Menus, beer coasters, etc. are all good for the purpose. Anything at all may be used which readily will take pencil marking and may be passed to the spectator. Because its position cannot be changed, a tablecloth cannot be used.

The routine in sequence is: first, the subject is brought up about which the diagram or picture may be used. It is preferable if a picture can be thought of in connection with some subject which the spectator has introduced. Then the paper, or whatever, is located and the performer places it on the table or bar in position to make his sketch. He takes the pencil from his pocket and makes his drawing. If, when the performer first sits at the table or stands at the bar, he makes certain (by touch) of the respective positions of the two pencils in his pocket, he will avoid either fumbling or error when it is time to draw.

During the drawing, the performer acts as if he were concentrating upon his picture—which may well not call for any acting. At any rate, during the drawing, he says nothing. When the sketch has been completed, he places it on the table or bar in position for the spectator best to see it. He replaces the pencil in his pocket and lets his hand remain in the pocket as he starts to describe the details of the sketch. It not only is natural, but far easier, to point to the details as they are mentioned. So the pencil again is taken from the pocket and the details of the sketch indicated with the point of the pencil.

"The pencil again is taken" is what the very

close observer will believe. Very few people would notice that the pencil had gone back in the pocket at all. No one will suspect the existence of a second pencil. The pencil makes an excellent pointer and its use is so natural that no thought is given to its being used in that manner. The eraser is left in the "loaded" pencil while the pointing is going on.

An easy and natural way to hold the pencil while using it as a pointer is between the first and second fingers as a cigarette is held. That is, the pencil goes on top of the side of the second finger right at the first joint, and the first finger goes on the pencil. There is this difference: the ball of the thumb is pressed against the rubber at the end of the pencil. The thumb on the end of the pencil will be found to be necessary in order properly to point with the pencil. While at the beginning of using the pencil as a pointer, holding the pencil in that manner is not essential, it is best to hold it so, for later it must be held that way.

After two, or more, details have been indicated with the pencil point, the performer brings his hands back to his body and, without releasing the grip on the pencil with the first and second fingers, moves his thumb away from the rubber. As the thumb leaves the rubber, the thumb and first finger of the left hand grasp the eraser. This appears to be, as it actually is, a very natural thing to do. Because it is so natural a thing to do, there is very small chance of anyone noticing the action and, even if it should be observed, there is noth-

ing out of the way to see. The performer should continue talking about the subject and either look directly at the face of the spectator, or at the sketch, as would be natural in the circumstance. He should not look at the pencil he holds and, of course, there is no reason to do so.

While the pencil is held between the two hands, the sides of the hands should be resting on the table or bar. A few trials will show whether it is more natural for the reader to twist the rubber out of the pencil in one move, or to loosen it gradually. Most people find the first move easier. Whichever way it is done, the pencil must be held so that the point is lower than the rubber. The pencil need be held only enough off the horizontal so that the contents will not be lost. The instant the rubber is out of the band, the right thumb goes back to its previous position, but this time it acts as a stopper as well as holding the pencil more firmly.

This is an important point: the right hand moves away from the left hand which holds the rubber. The left hand does not move. As has been mentioned, movement attracts attention, and if any attention is paid to the action, it should fall upon the right hand, about which there is nothing changed. The movement of removing the rubber is so small that there is scant likelihood of anyone noticing it at all. As the rubber is so small it will be almost, if not entirely, hidden between the first finger and thumb of the left hand. Even on the off chance of the rubber being noticed, the spectator will suppose that in fiddling with the pencil that the rub-

ber accidentally was twisted off. There is no need to stress hiding the rubber for the matter is of little consequence. However, if the left hand were the one moved away from the pencil and the rubber were noticed, it would, because of the movement, gain importance in the mind of the spectator.

At this stage of the routine, the performer again reaches out with the pencil and indicates a point in the sketch. The point should be one about which a question can be asked. The question, naturally, depends upon the subject of the sketch but should be one asking for help. Such a question could be, "Is there a better way to go?" or "Is there an easier way to make it?" The question should never, at this point, be in the form of seeming to doubt the spectator's understanding of the subject. As the question is made, the performer looks directly at the face of the spectator.

Showing how thumb and first finger mask the container with the rubber eraser removed.

As he raises his eyes, the performer brings his right hand over the mouth of the glass or cup containing the spectator's beverage. The movement of the arm should not be great, and will not be provided the sketch was properly placed before the spectator at the beginning when it first was laid down. As soon as the spectator looks at the performer and begins to answer this question, the performer, by twisting his wrist, turns the point of the pencil toward the ceiling. Simultaneously, he takes his thumb away from the open end of the pencil. The instant the powder falls out of the pencil and into the liquid (which is practically instantaneously and one second is more than ample time to allow), the performer without haste, and most casually, returns the pencil to his pocket. In his pocket he drops the prepared pencil and picks up the duplicate. When he brings his hand out of the pocket, he "still" holds the pencil. This hand and the pencil are rested on the table. After a few seconds the pencil is released. This last part of substituting the pencils is not of great importance. The only reason it is suggested is, on the chance that he wants to make alterations in the sketch or to use a pointer, the spectator can pick up the pencil without needing to ask for it. Having to ask for the pencil would call more attention to the pencil than were it available to pick up. The less the pencil is considered the better the situation.

The point may come to the reader's mind that he would be in great difficulty in performing the trick were the spectator to ask for the pencil at

the point where the powder is only held in the hollow pencil by means of the thumb. This situation will not arise provided the spectator has been asked the proper question. The purpose of the question is to get the spectator to talk; that is, to answer the question with words, not pictures. As soon as he begins to talk, the powder is dropped and the pencil exchanged. If, in answering the question, the spectator seems at all hesitant, or that it might be easier for him to make use of the diagram in making his answer, he should be asked another question. There should be no difficulty at all in keeping the conversation going by this method for the five to ten seconds needed to drop the powder and pocket the pencil. This is one of the instances where confidence of manner is of the utmost importance. Actually confidence or assurance of manner is the real basis for the trick.

Even though again being guilty of repetition, the writer wishes to stress that each of the actions done throughout the routine must be performed without haste, jerks, or exaggeration.

Using the first and second pencils described (with their lesser contents), the trick may be done successfully before a number of people. The contents of the third pencil are so great that the dumping cannot be depended upon to be unseen when shown to more than two persons. It always is possible to notice the direction of attention of two people at the same time. Simultaneously watching the focus of attention of more than two people becomes most uncertain.

IV. Handling of Liquids

A liquid, like a loose solid, requires a container in order to be handled. However, a liquid cannot be held in many containers suitable to hold a powder because of the proneness of liquid to do three things. 1. Many materials suitable to hold a loose solid will absorb a liquid due to the tendency liquids have to be sucked up by the nature of some substances. 2. Because a liquid is continuous, atmospheric pressure will hold it in many forms of containers from which a loose solid readily will pour. 3. Because of surface tension, a liquid has a tendency to cling to a solid and a proportion may be retained in the container when the contents are released. Because of these qualities of a liquid, a proper container has to be nonabsorbtive and be so constructed that all the liquid can be freed easily and quickly when needed.

Two of the qualities of a liquid which make some containers unsuitable can be utilized in a container with flexible walls. Using no stopper at all, because of surface tension and the continuous quality, a liquid will be held in a container having a small aperture regardless of the position of the container. Not having to manipulate a stopper simplifies handling. Because of the flexible walls, the liquid will be forced out of the aperture when pressure is exerted upon the container. Such a container is excellent when working with quantities of a liquid up to 2 cc, even 2½ cc Though the liquid will remain in the container with a much

larger aperture the best size to make the opening
is one-thirty-second of an inch—the size of the
shaft of an ordinary pin. Liquid, when forced out
of a hole of that size, will make an almost invis-
ible stream. Even with so small a stream, 2 cc of
a liquid can, under pressure, be quickly ejected.
When only enough pressure is used to force the
liquid through the aperture, there will be no no-
ticeable sound when the stream hits the surface of
the liquid to which it is added. As in the pre-
viously described tricks with pills and powdered
solids, the purpose of the tricks to be done with
liquids is to put them secretly in another person's
beverage. However, when a very small quantity of
a liquid is used, it is also possible to spray the
liquid on a solid such as bread without either the
action or result being observed.

Several ideas are given below for tricks with
an amount of liquid no more than 2 cc in quantity
and with a description of the containers for such
quantity of liquid. After this data is completed,
there will be found descriptions of containers
suitable for amounts of liquid from 2 cc to 10 cc.

In all the tricks some way will be described to
mask the presence of the liquid container. These
objects must be commonplace and the kind of thing
which would be accepted as natural for a man to
carry in his pockets. The first to be described
will use a paper of matches as the screen. In most
details the routine will be found to be very simi-
lar to the one described earlier in which paper
matches were used to carry a pill.

The container for the liquid is hidden inside the paper of matches. The easiest way to put the container in the paper of matches also makes the trick easy to do. This is done by taking out eight matches (four from the front row and four from the back row) at the left side of the packet when it is opened. After the matches are torn off the base cardboard, a section of that, too, is taken out. This is done with the point of a penknife. The container is made from a piece of polyethylene tubing. Tubing three-eighths of an inch in diameter is a convenient size and the container should be two inches long. The top end of the container is cut at right angles to the wall of the tubing. The bottom end is cut at an angle of approximately forty-five degrees. Polyethylene tubing is very flexible and may be flattened completely with a pair of pliers. Held flat, the tubing can be cut easily with an ordinary pair of scissors. After it has been cut, and while still held with the pliers, the tubing can be fused together with the flame of a match. The easiest way to make the container is to cut and seal the lower end first. Then, working from the inside, a pin is pushed through at the point of the angle. It is much easier properly to place the hole when working from the inside. Having made the hole the top is flattened and sealed. Care should be taken to have the top flattened to agree with the way the bottom is flattened so that both the container's ends will be at the same angle. The container is put into the paper of matches at a slight angle so that the point (with the hole) at the bottom protrudes just enough

so the steam will clear the paper. The bottom fold of the packet, due to the staple, will hold the end of the container firmly. A piece of Scotch tape stuck over the container and with each end of the tape attached to the packet will ensure that the container does not move.

It is necessary to fill the container prior to putting it in the paper of matches. It is filled by compressing the walls of the container to exclude the air and putting the point, with the hole, into the liquid prior to releasing the pressure. A container of this size will hold and readily release forty drops (2 cc) of liquid. The most certain way to force all the liquid out of the container is to press, release, and press a second time. Of course, in releasing the pressure, only enough pressure is removed so that the tube can expand and suck in air. Enough pressure is contained to maintain a firm grip on the paper of matches. Probably the best way to hold the paper of matches so as to exert pressure on the container is with the thumb on the face of the packet and the first and second fingers on the back. The grip is along the left side of the packet (where the container is hidden) and the packet is held so that the point of the container points directly down.

Because it is possible to see the container at the open left side of the packet, care must be taken never to turn that side so that it is within the vision of any spectator. Provided no spectator is behind the performer, he may open the match cover in the normal manner and tear off a match. On the chance that at the time the trick is to be

Manner of holding paper of matches so as to exert pressure on the entire container and properly to direct the expulsion of contents.

done, there may be a spectator in a position to see the container when the cover is opened, it is advisable to break, but not tear off, a match at the extreme right of the packet. It will be found possible to take this match out of the side of the packet and have it seem a natural thing to do.

A considerable amount of experimenting should be done in private to see how the paper of matches may best be handled as matches, as well as in forcing out the liquid. Such experiments also are necessary in order to learn how to aim the stream of liquid accurately.

Some individuals may be disturbed because the container can be seen at the open left side of the paper of matches were that side turned toward the spectators. If that makes a mental hazard, it is quite possible to put the container at the center of the packet so that matches hide it on both sides. This is done by removing the wire staple and taking out all the matches. Then two staples are put, vertically, in the flap while the matches are out. Each staple is three-eighths of an inch from the side of the packet. At each side of the packet are put six matches (three in the front and three in the back row). The matches are held in place by Scotch tape around the inside matches and stuck to the back of the paper. In this case the bottom of the polyethylene container is cut at each side so that there is a center point. The hole is at the point. A small slot is cut in the bottom of the packet and the point of the container is pushed through this slot.

While this second way of hiding a container in a paper of matches permits a more openhanded way of handling the packet, it increases the effort needed to force out the liquid and considerable more preliminary practice.

With either way it is absolutely essential to

have a duplicate paper of matches, minus a container, and which may be exchanged for the prepared packet.

The routine of performance is almost identical with the trick done with the paper of matches to which a pill is attached. The one difference is that the packet has to be held over the mouth of the glass a little longer, for it takes more time to eject the liquid than it does to drop the pill. However, the liquid will mix instantly with the beverage while there may be an interval until the pill dissolves.

There are several other ways the polyethylene tubing can be formed into small containers which may readily be hidden. The different ways of hiding containers will require different routines in using them. They also will need different stories to mask their use.

It is unnecessary for the writer to devise a story to be told to cover the action for using each container, for the reader will be able to fit his own story better to the circumstances of performance. He need only remember that the story has to be rational and simple. Elaborate stories should be avoided, for complications are what cause doubt. By "rational" is meant making the details of the story agree. For instance, a lion cannot be caught in a mousetrap, nor is a lion trap of any use in capturing a mouse. It is quite within reason to catch a mouse in a mousetrap and a lion in a lion trap. It is necessary for the teller of a story to be aware of how the mousetrap, or lion trap, of his story

operates. It is not essential to the story's acceptance that he ever actually used either type of trap, but he must know how they are used. In other words, the details of the story must be correct although the story itself may be totally untrue. The vagaries of a super imagination will be accepted as fact as long as the teller of the tale does not stub his verbal toe and fall down because his details were incorrect. As this invariably is true, a wise liar will use as few details as possible and be certain of the exactness of each detail he uses.

An uncomplicated story, no matter how distant it may be from truth, will be acceptable provided it is told with conviction. Telling a story with conviction is only a matter of acting as if the story were gospel. The key word, of course, is *acting,* but it is easy to act as if one believes a story if he has thought the details so that he can tell it without hesitation or fumbling for a word. Here again, preparedness is essential.

The correct and incorrect use of details in telling an unfactual story is somewhat confusing. Whereas it is absolutely true that the great hazard in telling a lie is due to the use of details, it also is true that details can lend a considerable degree of plausibility to a story, always provided there are not so many as to make the story difficult to follow, but the details must either be factual or ones which can't be controverted.

Of course, in doing a trick, it may not be at all necessary to deviate from the truth and it is

best when this is the situation. It may be that all that need be said is to wonder aloud if it is going to rain—or stop raining as befits the situation. But by this time the reader must be quite familiar with the basic idea that whatever is said is said merely to keep the spectator's attention away from what the performer is doing. As long as the reader understands the purpose and the method, he should never have difficulty with the words.

A container which will hold eight or ten drops can be stuck to the back of a coin the size of a quarter. This container is made by flattening a piece of polyethylene tubing and cutting the end so as to make 180 degrees of a circle. After the round end has been sealed, a pinhole is made at the tip of the arc. Then the tube is flattened so that the other end can be rounded and sealed. The finished container should be oval in shape and look like an ordinary printed uppercase letter O. This container is attached to the center of the reverse side of a coin. It should be so attached that the container is in alignment with the design on the face of the coin and with the hole in the container at the bottom of the design. This makes it possible by looking at the face to know how to hold the coin so as properly to direct the liquid when releasing it.

A container attached to a coin may be used whenever it is natural to handle coins.

A container suitable for holding two to five drops can be made small enough to be hidden between the first finger and thumb and without re-

quiring any carrier at all. The natural position for a relaxed hand is with the fingers curled in toward the palm and with the ball of the thumb touching the first finger. Some individuals may not actually bring the thumb and first finger into contact when naturally relaxed. However, even those people will find that the thumb and first finger almost meet and their hands still appear to be natural when the thumb and first finger are made to touch. In such a position a small container may be held quite invisibly between the ball of the thumb and the side of the first finger. The container is carried in a side pocket of the coat or trousers until needed. The container is taken in the correct position by the fingers while it is still in the pocket.

The liquid is squeezed out of the container while making a gesture in connection with whatever is being said. What is said depends upon the situation and is immaterial as long as it is natural to gesticulate at the time. No rule can be laid down as to whether the container should be held in the right or the left hand. The hand which should be used is the one the performer finds is the most natural to use in making gestures. Of course, the container is carried in the pocket on the side of the hand which is to use it.

The containers may be of two shapes. Both should be tried out by the performer to discover which best fits his fingers. One shape is circular and is about one-half inch in diameter. While many

will find this shape the handiest to use, it has one drawback. That is in knowing the exact location of the opening. This may be remedied by having a nick or bump opposite the opening. By touch, the nick or bump may be located and the container taken into the proper position while the hand still is in the pocket.

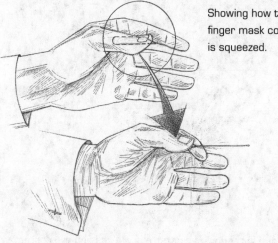

Showing how thumb and first finger mask container as it is squeezed.

The other container is made in the shape of a wedge with a rounded top. The wedge is about an inch long and a quarter of an inch across at its widest part. The hole is made at the point of the wedge. With this shape the container may be picked up instantly in the correct position.

With both these containers the opening should face toward the tip of the thumb. This means that the back of the hand faces the ceiling at the time the liquid is released.

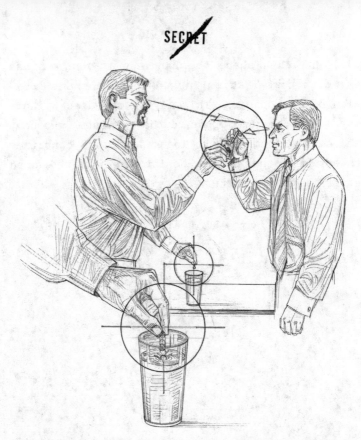

Left hand lowered for action as cigarette is offered and eye contact engaged.

Still another container using the principle of pressure to release the liquid may be made for quantities up to 5 cc. When made of three-eighths-inch tubing, the container will have to be at least three and a half inches long. Such a container can be hidden in a pocket of a wallet (or billfold) and placed near the center fold. The top of the container is cut at right angles to the sidewalls and sealed. The bottom is cut at an angle which has its point at one wall. The hole is made at this point.

At the bottom of the pocket of the wallet a small cut is made so that the extreme tip of the container may be pushed down through this slit. With a container hidden in this way, the wallet may be opened and used in the ordinary manner. When the wallet is closed and squeezed along the edge of the fold, the liquid will be ejected in a stream at the bottom of the wallet. This method of carrying liquid of such quantity has several advantages and, under some circumstances, one major drawback. In order to eject all the liquid, it is necessary to squeeze and release, squeeze and release the container several times. This makes the release of the liquid take longer than some situations permit.

Showing how container may be hidden in a wallet.

Showing how container is squeezed to discharge liquid.

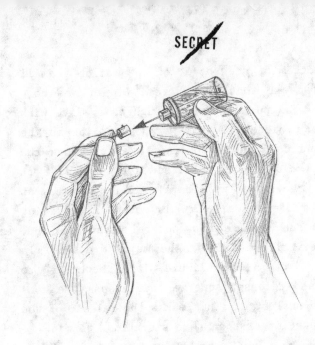

Rigid container showing stopper at top to which thread is attached. Stopper closes top air vent. Exit hole is in center of bottom of container.

A much quicker method of releasing 3 to 10 cc of a liquid makes use of a rigid container. Drugstores use vials made of plastic which are excellent for the purpose. This type of vial is round and has a one-piece body three-quarters of an inch in diameter and two inches long. The outer wall at the top is recessed so that a plastic cup will slide on and seal the top. Plastic is easy to drill and therefore a plastic vial is much better than one of glass. In the center of the bottom of the vial a hole is drilled. The hole should be no smaller than one-sixteenth of an inch and no larger than three-sixteenths. Another hole should be drilled in the top of the cap. This hole may be made from one-eighth to one-quarter inch in di-

ameter. A cork must be cut to fit the hole in the cap. Through the center of the cork (running from top to bottom) a tiny hole is drilled.

Through this hole a piece of heavy linen thread (or fine fish line) is forced. A large knot is made in the thread at the bottom of the hole. The purpose of the knot is to keep the thread from pulling out of the cork.

Once the container has been drilled, and the cork fitted and threaded, it is filled with the liquid. A container of this size will hold 10 cc of liquid. Due to atmospheric pressure, the liquid will remain in the container as long as the cork is in place in the cap. The instant the thread is pulled, the cork will be withdrawn and the liquid will pour out of the hole in the bottom.

In order to hide and yet use such a container, it may be put into a package of cigarettes. To prepare the cigarette package, the seal at the top is care-fully opened with a knife. Then the top is unfolded and all the cigarettes removed. The container is put inside the package, upright and at one end. A mark is made in the bottom of the package to coincide with the hole in the bottom of the container. The container is removed and a hole a little larger than the one in the container is cut through the bottom of the cigarette package. The container is returned to the package. Then a slit is made in the top of the paper (the continuation of the side) which folds over the top of the package. Through this slot the thread is passed so that it hangs down along the side of the package. As many cigarettes are returned to the

packages as are needed to fill the space left by the
container. The cigarettes are not packed as tightly
as when the pack first was opened but tightly enough
to seem as if but one cigarette has been removed.
Then the paper at the top of the package is refolded
and the seal reglued in place. After the glue has
been given a chance to dry, a part of the top (at the
end with the cigarettes) is torn away.

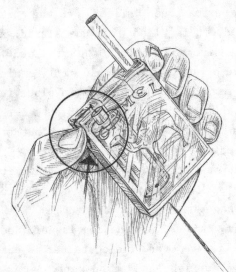

Showing how container is hidden in package of cigarettes. Thumbnail
pulls on knot in exposed end of thread to release stopper. Hole is made
in bottom of cigarette package to correspond with hole in container.

The package should now appear to be one which
has been opened and one cigarette removed. The
thread is tied so as to form a large knot right at
the edge of the top. After the hole has been made,
any surplus thread should be cut off. By picking

this knot with the nail of the first finger, the thread may be drawn down the side of the package. Doing this pulls out the stopper and releases the liquid, which will run out of the hole in the bottom of the package. At the time of pulling the thread, the package of cigarettes is best held with the thumb on the side of the package and the second, third, and little fingers on the other side. A package prepared in this manner may be held out so that a spectator may take a cigarette.

In preparing the routine and its accompanying story for use with this container, it should be borne in mind that it will take one and a quarter seconds for 5 cc to run out through a one-eighth-inch hole and double that time to release 10 cc. A larger hole will speed the release of the liquid but more sound will be heard as the bigger stream hits the surface of the beverage.

The container just described releases its liquid contents by gravity rather than by force. In many ways such release is the more dependable. It can be used in many other forms. For instance, it can be used in a container masquerading as a cigarette. The corked vent hole is on one side at the top of the container. The cigarette is made up of the container wrapped in a cigarette paper and topped by a short length of a real cigarette. The stopper can be held out of sight easily and just as easily picked off. This is but one of the myriad ways of hiding liquid containers made for gravity release. They may be hidden in almost anything which can be carried in the pocket.

Showing how thumbnail can
remove stopper of air vent of
container in cigarette.

Gravity release is approximately as rapid as
pressure release and is less noisy. Furthermore
it requires less manipulation. However, in very
small quantities of liquid—i.e., ten drops or
less—pressure release is more satisfactory. The
method indicated for a particular performer de-
pends largely upon which he can use with more
confidence and ease.

V. Surreptitious Removal of Objects

The previous pages have been giving details for
doing several tricks in which the performer se-
cretly adds something to what is known to be

present, and without the spectator, or specta-
tors, being aware of any addition. In the follow-
ing pages will be details for tricks in which the
performer's secret actions are those of subtrac-
tion rather than addition. It would seem that all
that need be done would be to reverse the rules
for putting down and one would know the rules
for picking up. Probably that would generally be true
in normal events but it is not true in the per-
formance of a trick. Trickery can be accomplished
only when the normal is circumvented. The difficul-
ties of performance are caused by the trickster
having to do unusual acts while apparently, in
his actions, he has in no way deviated from the
normal. As has been pointed out, the success of
a trick largely is due to the manner of the per-
former.

Secretly putting your watch in the pocket of
someone else is, technically, only a little eas-
ier than it is secretly to take a watch from the
pocket of another person. However, the first act
has few mental hazards and in the second they are
manifold. Partly this is due to admonitions from
early childhood on the wrong in taking another's
property. Partly it is due to the realization of
having in one's possession the tangible evidence
of the act. It not only is more blessed to give
than to receive but it is far easier to be noncha-
lant about it.

The action of taking something secretly has
four hazards. The first is getting the object with-
out being observed. The second is stowing away the

object without attracting attention. The third is to try to keep anyone from immediately noticing that something is missing. When, however, these three things have been accomplished successfully, the performer need have little fear of the fourth hazard—that of being searched and, because of the presence of the object, discovered.

Getting the object and secreting it are done simultaneously in most instances. Further, they are done under the one psychological cover. However, because with different objects varying techniques, and combinations of techniques, are required, as the objects vary in size, shape, and weight, the methods of taking and secreting have to be studied separately.

The first point in picking up an object secretly is to make the task as easy as possible. Therefore the performer should get as close as he can to the object. This not only means that less arm movement is required to reach the object, but it makes possible the use of the body as a screen. So as to make it natural to be near the object which is to be picked up, the performer should make a practice of standing close to whatever he is looking at or to the person to whom he is talking. Without trying in any way to give the effect with his eyes, he should act in the manner of a nearsighted person, i.e., as if he were more comfortable being up close.

Having arranged to be in a position easily to pick up the object, the next point is when to pick it up. Here again, as in every other trick, proper timing is of extreme importance. And by "time" is

SECRET

meant when the action should be done and not the speed of the action.

Proper timing includes consideration of preparatory actions. "Preparatory actions" are of two kinds. One is the meaningless action which will cause the spectator to ignore it when it is done with a purpose. For instance, the man who carries his hands in his coat pockets whenever he is not using them will attract no attention when he returns his hands to his pockets at the time he has an article in his hand he wishes to put in his pocket. Of course, it is understood that the article is one he can hold hidden in his closed hand so it will not be seen. The other preparatory action is that of making part of a movement openly in order to lessen the amount of movement which has to be done secretly. For example, a man wishes to take his wallet out of his own right inner coat pocket without being seen to do so. The preparatory action would be to grasp the lapels of his coat. The fingers would bend around and go inside the coat while the palms of the hands would be against the surface of the lapels just a little higher than the top of the pocket. It is apparent that in such a position the man would be instantly ready to hold the coat out with his right hand so that the pocket would be easy to get into. It also is obvious that the left hand would have very little distance to travel to reach the pocket. Holding the lapels in such a manner is a normal gesture and attracts no attention. And yet not only has several feet of movement for the left

147

hand been accomplished openly but the right hand is in a position to make easier the secret operation when it needs to be done.

Moving up close to what is to be secretly picked up is a preparatory action. Standing so that the body is turned to facilitate and shorten the movement is another. In planning any trick, all thought on the possibility of preparatory actions is well spent. Not to consider and learn such actions handicaps the performer greatly and needlessly.

Before going into how to pick up an object secretly and stow it away, it is well to study the possibilities of where the object is to be secreted. Any man naturally would think first, and correctly, of his pockets. In the usual coat and trousers a man has nine pockets, and if he wears a vest, he has four additional pockets. Not all of the thirteen pockets can easily be used. The watch pocket and the two hip pockets in the trousers are all difficult to get into quickly and the motions of doing so are awkward. The upper vest pockets are also unsuitable for any but a very flat object. The side coat pockets, by a telltale bulge, will reveal the presence of any bulky object. And the action of putting anything in either the side coat pockets or the side pockets of the trousers make the elbows stick out behind the back of the body. Often the arm movement may be made, in putting the hand in either trouser or side coat pocket so that it is not noticeable, but there are many times when this movement is very noticeable.

SECRET

The inside coat pocket may be used for many objects and quite undetectably. The outside breast pocket of the coat often is easy to use. Both of these pockets can be used without taking the elbows away from their normal position. Both can be held open so as to make it easier to drop something into them by stuffing a handkerchief down to the bottom of the pocket. The lower vest pockets are good for use with quite small objects, as they also can be reached with little movement.

First the use of the regular pockets will be considered. Later mention will be made of other ways to hide objects about the person.

In order to outline a routine which will give the basic pattern for taking something secretly, let us consider a suppositious situation. The locale is a factory. The desired object is metal and of the approximate size and weight of a cigarette lighter and is one of a number on a workbench. The trickster is a visitor being shown around the factory by a member of the staff.

First, if it is possible to do so, much more interest must be shown by the visitor in the way in which the factory operates than in what is being made—apparently his interest is in the machines rather than the product. This attitude permits all sorts of innocuous questions to be asked about shafting overhead, or the manner in which a machine is bolted to the floor or of gear ratio, or of overall length of machines, and similar questions. Such questions naturally make both guide and visitor look up at one moment, down or sideways at an-

other. The more a person's eyes can be directed in various directions the greater the ease in which things may be done without attracting attention.

Not all interest is to be shown in the tools of manufacture. Some interest also must be shown in the product, but only as it relates to the manufacture. For instance, a question such as "this part is made from a one-inch steel rod, isn't it?" permits the part to be picked up, although interest is directed toward manufacture rather than product.

The supposition now is that after various steps in the progress of manufacture have been shown, the guide and the visitor have reached the bench upon which are several examples of the object of which one is to be taken away. The object is picked up with the left hand as some question of method (no interest should be shown in the object) is asked. The answer should be listened to with every indication of interest while, at the same time, the object is put back on the bench. Please note that it is put back on the bench, but the fingers still retain their grip.

The instant the answer is given—allowing no wait whatsoever—a question should be asked about the machine—"at that end"—"those gears above"—at the same time pointing with the right hand at the spot mentioned. As the guide's eyes go in the direction indicated, the left hand picks up the object and puts it in a pocket.

The pocket used depends upon the exact situation. If no one is standing to the left of the performer and the guide is at his right, the trickster

can use either his left trouser or outside left coat pocket. If he could be observed doing that, he may find that the right inside coat pocket may be reached with a less obvious movement.

If either the trouser or side coat pocket is used, it would be well to put the right hand in the corresponding pocket and leave both hands in the pockets momentarily. The reason is that when both hands are put into pockets, the action becomes one of resting the hands and does not attract attention. The hands must go into opposite pockets; that is, both trouser pockets are used, or both side coat pockets, but never one trouser pocket and one coat pocket. This fact is of importance whenever it becomes necessary to go into a pocket. Simultaneously using opposite pockets does not attract attention.

If the object is put into the inside coat pocket and the performer feels that the action has been unobserved, he need do nothing else. If he feels that there is the slightest chance that it was noticed, he brings out a pencil which had been clipped to the edge of the pocket. He uses the pencil to draw with, make a note, or merely as a pointer. Of course, he has to have been prepared for this situation by having had a pencil in his pocket prior to going to the factory. However, this is the sort of detail which never bothers the person capable of plowing ahead.

According to the above outline, it should have been possible for the trickster to have pocketed an object without anyone having observed the ac-

tion. But this only could be true provided there were so many identical objects on the workbench that one less would not be noticeable. It would be quite apparent, were there but three such objects on the bench when the visitor came, that only two remained when the visitor left. That is, it would be apparent to a workman standing at his bench, though the guide would not have been apt to have counted the number twice. If it were possible to move the other objects into altered positions, and there were five, or more, to begin with, even the bench workman will not notice the absence of one. People seem unable to be aware of numbers above four, except when specifically required to count. On the other hand, because of the way, at times, in which objects are laid out, when one of the number is taken, the pattern is broken, and the absence of the object is noted. In the situation where there is an evenly spaced arrangement of objects removed, it is possible to remove one object and by varying the spacing of several of the remaining objects to alter the pattern so that it appears unbroken. This pattern rearrangement cannot be done instantaneously though usually it can be done very rapidly. For instance were the pattern

OOOOO
AXB
O OO O

it would be very apparent were object X taken away. But if objects A and B were moved respectively to

the right and left, the spacing again being even
and regular, the absence of object X would not be
noticeable.

Were the conditions such that the performer were
alone with the guide and there were a pile or filled
box of identical small objects, the task of secur-
ing one becomes easier. In such a situation there
need be no consideration of an action being seen
by another person, nor of there being a chance of
anyone noticing a reduction in quantity of objects.
Under these conditions the routine would be either
of picking up the object while the attention of the
guide were distracted or waiting until the guide
had turned away to call attention to another part
of the shop. In the latter case the performer should
stand as close to the guide as possible and use his
body as a shield between the guide and the object
to be picked up. This necessitates first, standing
close to the object so it may easily be reached,
second, standing so that his body is between the
object and the guide, and third, having one hand
and arm completely free to touch the guide. While
earlier it was noted that in the main it is inad-
visable to touch another person, in some instances
a partial exception may be made. The other person
may be touched provided it is made to seem acciden-
tal. Standing and walking close to the guide makes
it perfectly natural to seem to be awkward. The arm
is extended and touches the guide ostensibly only
to keep from bumping him. Such a gesture actually
permits turning the guide's body so that he is in
no position to see the object picked up, and even

if it is not possible to turn the guide's body, the action of putting him off balance keeps him from thinking about what the performer is doing with the other hand.

In this situation, once the object is picked up, the performer puts his hand into his pocket—the one closest to the position of the hand at the moment, which would be the side pocket of the trousers or coat. If he is certain that the pocketing action has not been witnessed, the performer may withdraw his hand. Otherwise the moment he is free to do so, the other hand also should be put into a pocket.

Still another situation supposes that a variety of objects are laid out on a bench, shelf, or counter. In this supposition it would be natural for the performer to handle the objects. In such an instance it becomes possible to take one of the objects by a process of confusion. The confusion is brought about entirely through the sequence of the routine and the timing of the actions. This routine may be done with as few as four different objects, although it becomes easier when there are more, as will be seen by experimentation once the routine with four objects is memorized and practiced. For sake of clarity, we will call the objects A, B, C, and D. Object C is the one which the performer wishes to take. The steps in the routine will be numbered.

1. Object A is picked up with the fingers of the left hand. It is held chest high so as

better to see it. After a moment's examination, it is taken by the fingers of the right hand, turned over (using the right hand), and again taken by the fingers of the left hand. The right hand is dropped back to its normal position.

2. The right hand picks up object C and as the right hand is being raised the left hand replaces A. Object C is given a shorter examination than was given A.

3. The left hand picks up B as the right hand moves down with C. Here is the crucial point. As the right hand moves to "replace" C, the object is moved in the fingers so that it may be held between the palm and the second, third, and little fingers. Held thus, the thumb and first finger are free.

4. Object B seems to be of scant interest and is put down almost as soon as it is picked up. The length of the examination is set by the length of time it takes to pick up object D with the thumb and forefinger of the right hand. The instant D is grasped, the left hand replaces B. The left hand moves more rapidly in putting down B than the right hand moves in bringing D up for examination.

5. As quickly as possible, but without a jerk or apparent display of speed, the left hand comes up to the right hand and takes hold of D. When the left hand has a firm

hold of D, the right hand is dropped to the side. As soon as the right hand hangs motionless, the left hand replaces D.

6. Both hands are put into their respective side pockets—either coat or trousers, whichever is more natural. Object C, of course, goes into the right pocket with the hand.

Even from this distance, the writer can hear the reader say, "But that's sleight of hand?" And technically the reader is correct. But all the writer ever promised is that the reader never would be asked to do any manual act he did not do regularly. He often holds some of his change in the manner described when he puts a coin on a counter. The difference is only mental, for he has other coins in his hand. But he need have no worry in the trick for the complication of the "picking up—putting down" routine and its resultant confusion to a watcher will hide the action. Actually the routine is so confusing that the performer is apt to astonish himself, provided he has practiced until he can perform it unhesitatingly, when he finds the object in his pocket.

To review the basis for picking up an object without being seen to do so: 1. When no spectator is looking because of their own reasons or using a routine that directs attention elsewhere. 2. By using the body as a screen. 3. By using a routine which masks the action by confusion.

Beyond the usual pockets of an ordinary suit

of clothes, there are two special pockets which can be of great use and have advantages which the usual pockets do not have. Both must be made larger than ordinary pockets, i.e., be of greater capacity. Both can be used with less arm movement than is required for the usual pockets. Being unusual, the existence of neither pocket is suspected.

First the construction of the pockets will be described and then the manner in which they are used.

One pocket is made to go inside the front of the trousers. The mouth of the pocket is about twelve inches wide. The pocket is as deep as the distance from the waistband of the trousers to the crotch. The bottom of the pocket is rounded concavely, i.e., it is deeper at the corners (which go into the legs of the trousers) than it is at the center. A hem one-half to three-quarters of an inch deep is made on both sides of the top. A tape long enough to go around the performer's body and tie is run through the hem of one side. A wide corset steel is run through the hem on the other side and sewn in place. The reason for the steel is that it holds the pocket out straight and, being flexible, will curve to fit the body. The side with the steel is pinned (with safety pins) to the inside of the waistband of the trousers. An alternate and better method is to sew four buttons to the waistband of the trousers and make corresponding buttonholes at the top of the bag. In this case the buttonholes are put horizontally in the bag and above the

steel. The tape is tied tightly around the body and thus holds the other side of the bag tightly against the body. This pocket can be used either when a coat is, or is not, worn but cannot be used when a vest is worn.

Dumping object into trouser pocket. Note how left hand holds waistband of trousers away from body.

The other pocket is located under the left arm inside the coat. This pocket, too, has a wide mouth which is attached on both sides. However, in this pocket the mouth is vertical. The pocket is triangular-shaped like a piece of pie with the mouth of the pocket where the side crust of the pie would be. This pocket, too, may be buttoned in place or held by safety pins. The mouth of the

pocket is attached to the coat on one side and to the vest or shirt on the other side. The point of the triangle also is attached to the coat.

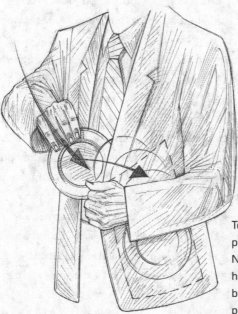

Tossing object into pocket inside of coat. Note how left hand holds coat away from body so that mouth of pocket is open.

It will be plain that if the trousers are pulled away from the body with the one pocket, or the coat pulled away from the body with the other, the pocket will be opened. As the one hand pulls on the trousers the other hand dumps the object to be hidden into it. The reason for the concave pattern of the bottom of the pocket is that the object dropped into the pocket will come to rest in the trouser leg, where there is more space for it.

It likewise will be plain that the other pocket

will be held open when the coat is pulled away from the body with the left hand. This makes it merely a matter of tossing the object inside the coat for it to go into the pocket. While the term tossing is used, this is intended to mean only a small wrist motion which does not cause movement in either the arm or body.

So far, all the notes have been about secretly picking up a small article of three appreciable dimensions and having some weight. While some of the methods mentioned also are suitable for picking up a letter enclosed in an ordinary size envelope, and, on occasion, even a legal size envelope, there are better methods for picking up a flat piece of paper.

One of these methods may be used provided it is immaterial as to how the paper may be creased provided it is pocketed. The main difficulty in folding paper is that the action is noisy. Folding paper has a distinctive and carrying crackling sound.

A full letter-size paper must be either crumpled or folded to make it of a size to go into a pocket. Crumpling paper makes far more noise than folding it. However, crumpling is by far the fastest method of reducing its size. Provided there is enough noise when the action takes place, as in a factory, crumpling the paper may be indicated. Of course, once a paper has been crumpled, it never can be flattened so as to look as it did in its pristine state. Unless the paper is to be returned, this fact is of no importance.

Probably the easiest way to pick up a paper from
a desk, or other flat surface, is by using a book.
"Book" means anything having a number of pages
and includes a magazine, writing pad, or newspa-
per. If it be a newspaper, it should be folded an
extra time or two according to its size, for this
not only makes it less difficult to handle but in-
creases its stiffness.

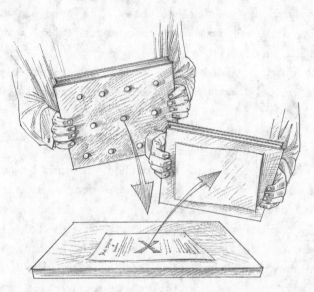

Showing how dabs of wax on rigid surface will pick up paper.

On the back of the book (or other paper object)
are pressed a number of dabs of a special wax. It
would seem to the writer that at this point in
this paper it must be quite unnecessary to mention
that the wax is affixed prior to the meeting and in
solitude. The dabs of wax are put on the book in
the pattern of the spots on a ten of diamonds in a

deck of cards. This pattern will ensure picking up any size paper.

The book is placed on the paper to be appropriated and pressed down. The wax will adhere to the paper and the paper will be taken away with the book when it is picked up. All that need be done further is to remember to carry the book so that the side with the paper is either facing the floor or against the performer's body. The special wax may be obtained from the same source which gave you this paper.

One word is added about folding paper secretly. It is quite impossible to give full details in writing, but if the reader will take a piece of paper as he reads the instructions below, he will find it not difficult to understand.

First, before giving the method, it must be noticed that in order to fold paper secretly, it must be done with one hand. Holding a paper in one hand out in the air makes it almost impossible to fold it. But not only is it not necessary to hold the paper away from the body, it should not be done that way, for the first objective is to hide the paper.

Now having the paper, perhaps in the left hand which picked it up from the desk, bring it against the side of the thigh. With the fingers of the hand it will be found possible to fold over the paper and it may be creased by pressing the paper against the thigh. Once that fold has been made, the same procedure is followed to make a third. With three folds the paper is but one-eighth its

original size. It becomes one-sixteenth the original size with a fourth fold—a size surely small enough to pocket even though the original paper be extra large and the pocket unusually small. It was suggested that the reader experiment in trying out the above suggestions. He will find it much easier to do than he would imagine. The fact that the folding is done against the thigh has the added advantage that folding may be done in that manner with less noise than in any other. No attempt should be made to have even folds or tight creases, for neither has any importance. The sole object is to reduce the size of the paper so that it may easily be pocketed.

Showing successive stages of folding a large sheet of paper so as to make it small enough to hide in the hand. Illustrations show manner in which paper is folded by one hand pressing against the thigh.

The action of folding the paper, according to circumstances, is hidden by the desk at which the performer is seated, or by his turning his body if he is standing.

Summarizing the methods for secretly picking up something, they depend upon hiding the action by direction of the spectator's attention, a physical screen, judging the time when no attention will be paid, confusion brought about by a rehearsed routine purposely complicated, or by a mechanical aid such as a book prepared with an adhesive. These methods may be combined in various ways besides those suggested in the examples. For instance, the wax on the book might be used to pick up a flat, not very heavy, piece of metal. The routines suggested are subject to all sorts of modifications depending upon the nature of the object to be picked up. However, while the routines suggested will work, it is essential to try out any modifications in order to find out if a routine will work in the way in which it has been altered. If it does, it should be practiced. If it does not, other alterations should be tried until a workable method is found and then it should be practiced.

Because of the importance of what is said at the time of the actual picking up, as well as in getting ready to do so, it is of the utmost importance to think out beforehand a variety of things to say. Attempting to devise topics of conversation on the spur of the moment always is difficult and making such an attempt while the mind is focused on a tricky action is practically impossible.

Enough subjects can be figured out ahead of time so that the performer will find he is at no loss for words no matter what situation arises. It is not necessary to figure out exact sentences and memorize them. It is only necessary to have considered a sufficient number of distracting topics so that the mind will not run dry of subjects about which to talk. Some people imagine they have the ability to talk their way out of any situation no matter how incriminating. Even if one has such rare ability, it is far better not to rely too heavily upon it. And those who are willing to plan and rehearse with care and thought should have little worry about how to get out of a bad situation for there will be no such predicament.

VI. Special Aspects of Deception for Women

While much of the general advice and preliminary observations with which this manual began also will apply to the following section, a great deal will not. This is because the previous material was written solely for use by men and the notes below are written for use by women.

Though the writer is a man, he does not have the idea that women lack any talents which men may possess. However, because much of their training, their clothes, and their manners are not those of men, women must use different methods for performing tricks than those used by men.

It might be well to give examples of a few types of these masculine-feminine differences. Men reach

out with the hand, palm down, to take something offered, while women hold out the hand palm up to receive that which is offered. This is one of countless examples of training or of the natural aping which a child does of his elders. From the buttons being on the left side on women's coats, women's clothes are unlike men's. The major difference, as far as performing trickery is concerned, between the clothes of men and women is pockets—their size, type, number, and location. Because of these differences in pockets, women can never use their pockets in the casual manner in which men use theirs.

It is a matter of masculine manners for men to wait on women in public and a matter of feminine manners for women to make such masculine efforts easy for men to perform. Interjecting a sad commentary, it is almost limited to public demonstrations that men may be found waiting on women. In public, even an old man will help a woman to put on her coat in a restaurant. A man will light a woman's cigarette. A man draws a chair from a table for a woman to sit on. These, and a variety of similarly nonarduous attentions which men pay to women, are not reciprocal. Women do not customarily do these things for men. Were they to do any of these things, women would draw attention to themselves and tricksters should never do anything to attract notice. The following pages are devoted to descriptions of methods for women to do exactly the same tricks which in previous pages have been described for performance by men.

Before setting down descriptions as to method,

it must be stated with emphasis that the methods women can use for these tricks are neither harder nor easier to do than the methods described for men. That is, the woman's methods are of the same degree of difficulty for women to do as are the men's method for men to do. Again it should be stressed that the required changes have nothing to do with capabilities but only with social customs. A man makes a lengthy and awkward job of buttoning up a woman's coat he has to put on himself. For that matter, a woman is not particularly handy in buttoning up a man's coat she has to put on.

There are a few other further preliminary points to mention. Women have to vary their technique in performing some tricks according to whether a man is the subject or another woman. Details will be given in each trick described, noting these differences. Here again the changes are necessary because of social custom.

It was stated on an early page that trickery basically depends upon a manner of thinking and that such thinking must not violate the manners or custom of the spectator. For a woman to do some action a woman normally would not do would violate manners and customs at least by being unusual, and the unusual will attract attention which the trickster should avoid. It is not enough for the woman trickster never to perform an action which would appear unfeminine to a man; she also must never do anything which would seem unusual to another woman. In other words, a woman trickster, to be successful, always must act in the manner of a

woman and never do anything in the man's way. Of course this should not be interpreted as suggesting being girly-girly, but merely not being masculine in actions or manners.

Women are not as apt to slouch in their chairs as are men and so do not have to worry about having to avoid that attention arresting weakness. But women do fidget even though they have their own ways of doing so. Constantly patting hair, feeling earrings, or similar feminine actions attract attention to the individual and should not be done.

Earlier in this manual there were instructions for men to follow in order to appear to be stupid. A form of this technique very valuable for the woman's pose is that she just does not understand the subject. She tries to look blank rather than dumb. This is not at all difficult when working in front of a man or men. The reason for this is (and ladies, we might as well face it) that men are never astonished when a woman does not know something. There is a major exception in this regard, for men expect their wives to know all manner of subjects. Noting this exception is merely academic, for husbands will not be the subject of the trickery herein described.

While the pose of lack of knowledge will be readily accepted as fact by a man, such a pose is apt to be suspected by another woman. This point is true also of a show of coyness, shyness, or maidenly modesty. A man will accept almost any degree of such ruses, while another woman will work

more doggedly to satisfy herself of the correctness of her opinion. Even when a man is suspicious, he still may readily be tricked. It is infinitely more difficult to succeed with a trick before a suspicious woman. The obvious answer is, don't do anything to make the woman suspicious.

This next point is put down with hesitation, and not because there is any question of its validity. The plot of a trick should be shorter and more direct when shown to a woman. The hesitation in mentioning this fact is due to the inference which might be made that women have less powers of concentration. This inference the writer does not accept. By many years of experience, the writer knows the truth of the statement and his explanation, true or false, is that a man is more inclined to follow step by step and a woman is likely to think ahead. As with all general statements, this one is not always true and there are both masculine and feminine exceptions. However, it is so generally the case that it is advisable to act always as though no exceptions existed.

The first trick described for men is with a pill which is carried on a paper, or box of matches. As women do not usually light a match to hold to a man's cigarette, this method cannot be used by a woman. It is not recommended even for a woman to use when another woman is the subject because it is not an act generally done.

While the matches are eliminated, the exact technique described may be used with the slipcase of a very small pocket mirror. The pill is attached

to the underside of the case. The mirror inside the case is put in front of the subject and the mirror withdrawn from the case and handed to the person. The mirror and case are carried in the handbag inside an open-ended box such as previously was described. Until the encased mirror has been taken from the handbag, nothing at all is said in regard to it. Just as the mirror is thrust forward the trickster says, "Use this mirror. There's something in the corner of your left eye." As the person takes the mirror, the left hand of the performer is brought back to her body and, in transit, the pill is picked off and dropped off into the glass or cup.

It will be obvious that manipulatively the trick is precisely the same as the one a man would do with the matches. Psychologically, too, it is very much the same. It is a kindly, courteous act to try to help someone about to have a foreign body get into her eye, just as it is kind to light another's cigarette. It is quite immaterial that the foreign body is imaginary, for even if the subject should say, "I don't see anything," it is acceptable to assure him that he must have brushed it away.

A woman readily can use the tricks described for men in which wallets, notebooks, and paper pads are used as pill carriers.

Women will find it very easy to hold pills at the base of the third and little fingers as described in the men's section. However, a woman should never attempt to do this trick while wearing gloves or if she is accustomed to using a

quantity of hand cream. Both gloves and cream make the performance uncertain.

Even though a woman will find it easy to handle a pill manually and will be able in rehearsal to manipulate a very small pill, the trick should not be attempted with a very small pill. The reason for this is the excitement brought about by actual performance is apt to make the hands moist. A tiny pill is difficult to release because the moisture makes it adhere to the flesh.

Coins are not suitable carriers for pills when a woman is performing. However, the same general idea may be followed by showing pictures in a small locket—the pill is stuck on the back of the locket. In certain circumstances the monogram on a compact might serve as the excuse to show the compact. The pill would be on the bottom of the compact. Reversing the position of the pill, it is possible to show the maker's name, or the hallmark on the bottom of the compact.

Because cosmetics are not carried by all classes of women in every country, it is possible to utilize their containers only where it would be a natural thing to do. Again it must be stressed that only those actions which are acceptable locally are permissible for a woman trickster. Manners for women are more restrictive and more rigid than are those for men. It is essential that a woman trickster inform herself of all the taboos of the district in which she is to operate. A man should have such knowledge but it is imperative for a woman to know such things.

In handling powdered solids, a woman will find two of the previously described pencil containers easy to handle. The paper tube simulating a pencil should not be used by a woman. No changes need be made in the wooden pencils except that they should be shorter than the lengths suggested for men to use. There are two reasons for making the pencils shorter. One reason is that a short pencil can be carried more easily in a handbag. The other reason is that men expect a woman to carry only a stub of a pencil if she carries one at all.

The instructions regarding the manner in which men are to use loaded pencils in their tricks are those for women, too. However, there are two points which may well be altered. The first is brought about because it is more difficult to exchange pencils in a handbag than it is in a pocket. The other point is due to the masculine belief that no woman can draw as clear a diagram as can a man. Neither of these points raises any real difficulty but both have to be taken into consideration.

If the loaded pencils are well made, there is no reason why they have to be exchanged for normal pencils at the beginning of the trick, as they may be handled safely by the subject and without in any way exciting his suspicion. Actually the only reason it was suggested that the exchange be made in the instructions for men is that it avoids a psychological hazard for the performer if he does not permit the loaded pencil to leave his possession.

A man almost certainly will alter any diagram a woman has drawn in order to ask a question. A man

will answer a question in his way and will find it necessary to add to or change the sketch in order to give his answer. As this is usually the case, it is well to accept that it will happen. It does not in any way change the performance of the trick, for if the man has his own pencil, he probably will use it, but no difficulty will arise even if he borrows the loaded pencil. In the event that the loaded pencil is borrowed, the performance of the trick is slightly delayed until the pencil is returned. Then the trickster, pretending to review the explanation given by the man, goes ahead in the performance of the trick as previously described.

The reason a woman cannot use the paper-tube pencil is that she cannot lend it, for while such a pencil has the appearance of a genuine pencil, it does not feel like one. However, if the woman trickster has an ability to draw with some degree of skill, it is possible for her even to use the paper tube pencil. This is because the subject of women's dresses is one of which a man does not claim an exhaustive knowledge and he will not wish to redraw the sketch. It is possibly more difficult to bring clothes into a casual conversation particularly if the man is comparatively a stranger. It might be done to show why a dress of some total stranger across the room was costly or cheap, homemade or store-bought. Being male, the writer probably is stressing the wrong point, and very likely some other point about the stranger's clothes would be more natural for a woman to make in her sketch, but the idea is sound.

All the above suggestions in regard to tricks with powdered solids are made for a woman trickster to use when the subject is a man. When the subject is a woman, the conversations would be different although the manipulations would be the same. One woman would not be apt to ask another mechanical question and it would be particularly unlikely that she would make a diagram in asking the question. A woman seldom sketches a map for the purpose of asking directions of another woman. A man accepts these things as commonplace but they would be unusual enough to a woman to attract attention. It is possible for a woman to ask for an address and, after having written it down, have it read to make certain it is correct. The pencil may be used by the trickster to point out the number or spelling in order to inquire if it is correctly written. It is also possible for one woman to sketch clothes, floor plans for the arrangement of furniture, jewelry designs, etc., for another woman. While these things are possible, it is true that sketching is not as usual an aid to conversation with women as with men. Though unusual, sketching or writing can be used among women when words alone do not express an idea or in order not to have to rely on memory. All that is necessary is to lead the conversation so that the use of a pencil becomes essential.

In this type of trick a woman is apt to move more rapidly than a man. As rapidity not only makes the trick less certain in aim but also much more likely to be noticed, women have to take

particular pains when practicing to move slowly. Practice should be done with very slow movements because actual performance always will be done more quickly than is done in rehearsal.

On the subject of arm and hand movements by a woman, there is a point of naturalness which causes some women difficulty. It will be remembered that naturalness of movement is the best cover for any action which has to be done secretly. Some women become "fluttery" in their manual actions when required to do something which they do not wish to be seen. The fluttery effect of their gestures is caused by making extra and unnecessary motions. In practice, these extra motions may be eliminated easily by concentrating on just what actions are essential. For those women whose hands are constantly in motion, an extra motion or two at the time the trick is performed probably will not attract attention, but even such persons will benefit by doing their tricks in the simplest and most direct way.

In the instructions for men it was suggested that a man could rise from his chair in order to reach across a large table. Even though the action would not necessitate standing, but merely raising a little off the chair, it is not something a woman should do unless the subject is another woman. Usually, in a restaurant, the woman is seated in the more protected chair. Frequently this means that the woman's place at a table is more difficult to get into as well as harder to leave. A woman seldom is given a choice of where

she would like to sit. She is given the chair
which, in theory at least, is preferable. The "seat
of honor" very often by its very position makes
trickery more difficult if not altogether impossi-
ble. On the other hand, frequently tables for two
are arranged so that the man and woman sit side by
side, which makes trickery easier. It is permissi-
ble for a woman to mention that she would prefer a
particular table if she can sight one suitable for
her purposes upon entering the restaurant. Once a
table is chosen, it is too conspicuous to demand
changing to another table.

Several of the methods suggested to mask con-
tainers of liquid in the tricks described for men
are totally unsuitable for women. Hiding contain-
ers in match folders or in packages of cigarettes
cannot be used. Neither can a masculine billfold
be used, for no woman would carry such a thing.
The use of coins, too, is eliminated as masks for
the containers. All of these methods are not to be
used by women because they depend upon material or
actions which are unfeminine.

Some of the methods men can use may be used by
women. For instance, the small containers (with
capacity for two to five drops) which are held be-
tween the first finger and the ball of the thumb
will be found easy to use. Care must be taken to
make these containers of a size and shape that
they may be hidden by the fingers. They have to
be made especially for feminine hands, which are
smaller than the hands of men.

It is far better to carry these containers out-

side of the handbag. If the woman is wearing a jacket which has a side pocket (a breast pocket cannot be gotten at easily), the container may be carried in the pocket. In the case of no jacket and no pocket, it may be found possible to make a small pocket which will be hidden by a flounce or plait in blouse or shirt. Such a pocket often can be made by a few properly placed stitches. Care must be made to ensure that the pocket is hidden even when the person is walking about or seated. Care must also be given to have the pocket of such a size and in such a location that the container is available instantly and without fumbling. If the attire is such that it is not possible to carry the container in either a regular or a special pocket, it is possible to carry it in the handbag. The excuse (never mentioned) of getting a handkerchief permits picking up the container as well. In such case it is better to pick up the container at the time of getting the handkerchief rather than at the time of returning it to the bag. If the woman is seated so that her lap cannot be seen at any angle, it is possible to take the container from its concealment sometime before using it and leave it on her lap until needed.

The stories which are told to distract attention from the movement of the hands are left for the reader to devise. Besides what previously has been set down in the section devoted to masculine performers, the only additional advice is that a woman must be certain that the story violates no feminine custom.

One simple ruse by which a woman may hand something to a man without exciting any suspicion is to untangle a chain. A chain such as is used to hang a pendant, locket, or religious symbol around the neck usually is made of very small links. Such a chain may be knotted in a tangle so that it becomes rather difficult to straighten out. When the tangling is done so that it keeps the pendant from being taken off, it is most natural to hold the pendant when giving the chain to another person. This brings both hands of the trickster close to the person asked to untangle the chain. One hand delivers the knotted chain but the other hand, at least momentarily, maintains hold of the pendant.

The hand holding the pendant, probably the left hand would be more natural, can hold a liquid container as well. The pendant might even be used as a mask. Another possibility is to have the pendant wrapped in a piece of tissue paper or handkerchief. A liquid container can be attached to the underside of the paper or cloth and be in a position easy to use. A liquid container never should be attached to, or even inside, a pendant. Most people's curiosity causes them to peep.

Probably the best cover for a container is a handkerchief. Many women quite regularly hold handkerchiefs in their hands. This is so generally true that the action excites no suspicion whatsoever. Some women crumple the handkerchief into a ball while others hold it by the center and allow the edges to hang below the hand. A handkerchief may be held in either manner and yet be a perfect

cover for a container. There are three details to
understand in using a handkerchief for such a pur-
pose: 1. how to attach the container to the hand-
kerchief; 2. the manner in which the handkerchief
is taken from the pocket or handbag; 3. the way
the container is emptied.

The container should be placed with the outlet
at the center of the handkerchief. Right at the
center of the handkerchief a small hole should be
cut in the cloth so that the tip of the container
can be pushed through. Then the container should
be sewn into a pocket in the handkerchief. The
pocket may be made by folding part of the handker-
chief over the container, or by adding a piece of
similar material. The latter method is suggested
only when the handkerchief is of so small a size
that there is not enough material for a fold. The
pocket should be made so tight around the con-
tainer that there can be no movement. This is nec-
essary so that only the very tip of the container
will extend through the cut in the cloth. The tip
should extend only enough so that the cloth will
not obstruct the ejection of the liquid and that
means only that the opening is free from the mate-
rial. A thirty-second of an inch beyond the cloth
will be found to be ample.

When the handkerchief is taken from the pocket
(or handbag) is the time to get the container in
the proper position so that the liquid can be re-
leased. In order that this may be done easily, it
is necessary for the handkerchief to have been put
into the pocket (or handbag) in such a position as

to make this action possible. The manner in which
the handkerchief is held in the hand will vary ac-
cording to the person doing the trick. It will de-
pend upon the size of the handkerchief, the size of
the person's hand, the size of the container used,
and the manner which the performer finds most natu-
ral to hold a handkerchief. These things can be
learned only through experimentation. Two things
are necessary. First, the container must be held so
that the liquid may be ejected downward when the
hand is held in a natural position. Second, care
must be taken that no part of the handkerchief
will cover the mouth of the container and thereby
interfere with the flow of the liquid.

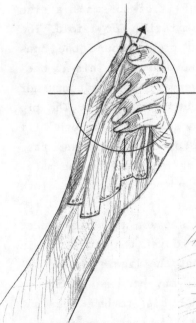

Showing how a woman can hold
handkerchief so that hidden
container may be used. The
inside pocket should be sewn to
position the tip of the tubing at
the handkerchief's opening.

To use the handkerchief as a mask for a liquid container requires that there be a reasonable excuse for the hand holding the handkerchief to move over the object into which the liquid is to go. This may be done by handing a menu to the subject of the trick or passing the sugar bowl, bread plate, etc. Both hands should be used in the operation of passing but the hand with the handkerchief (the left hand is suggested) releases the passed object before the other hand is removed.

The handkerchief cover is very practical but it needs considerable experimentation by the performer and somewhat more practice than most of the other methods. However, it can be used when none of the other methods are practical.

Women on occasion carry small "purses" of brocade, petit point, suede, etc. The writer's masculine memory (in such matters undoubtedly masculinity inaccurate) is that such purses are called "evening bags." Provided that the time, the place, and the girl would make such a bag an expected adjunct, it may be used to advantage to hold a liquid container. The container is sewn into position inside the bag so that the mouth of the container will stick out through a minute hole at the bottom corner of the bag.

A bag is suitable for either a container which has to be pressed to eject the liquid or a rigid container from which the contents are released by removing a cork. This latter-type container was described in a previous section of this manual. At that time it was suggested hiding the container

in a package of cigarettes. When such a container
is hidden in a bag, the thread attached to the
cork is run though the upper part of the material
of the bag. A small bead is tied to the thread on
the outside of the bag. The purpose of the bead
is to have something which may be seen and eas-
ily grasped so that the cork can be released with-
out fumbling. In case the bag is of a material
or design which would make the bead noticeable,
there are two alternatives. One is to sew a num-
ber of beads onto the bag where such added decora-
tion would be in keeping. The other is to run the
thread through the material to the outside of the
bag and, at a point about a half an inch distant,
run the thread back through the bag and fasten it
to the inner surface of the bag. This will make
a loop of thread flat against the outside surface
of the bag which, by slipping a fingernail under
the loop, makes it simple to pull the thread and
thereby remove the cork. The thread used must
be extra strong to avoid any chance of having
it break. Linen thread usually called "carpet
thread" (sometimes called "shoe thread" or "button
thread") is suitable. When thread of a matching
color is used, it is invisible, and even a con-
trasting color is not apt to be noticed and, when
noticed, is meaningless.

The advantage of the use of an evening bag for
holding a container is that a container of large
capacity can be used. As these bags always are
held in the hand, when not left on the lap, they
excite no notice when in the hand. It may be found

easier to use the bags while standing near a punch bowl, or coffee urn, if the occasion be such as to have these things. However, there should be no difficulty using it while seated at a table. Here again the writer being unable to know or even to guess all the circumstances and situations in which the tricks might be performed must leave many details to the performer's greater knowledge of the particular occasion.

In ending this section, it might be well to stress by repetition several points regarding women tricksters. The primary and chief point is that a woman trickster never should be seen to do anything which would be unnatural for a woman to do in the locality where the trick is performed. She should take advantage of any of the mistaken ideas men cherish about women because aiding a person to fool himself by letting him follow his false beliefs is the easiest way to deceive. It is so much easier to nudge than it is to push (even when the nudge is verbal) and far less apparent. No matter which type of woman her role requires her to act, the woman trickster should be a calm, rather than a fluttery, example of that type. Finally, no matter what the speed of her speech, she must remember to make her gestures deliberate.

VII. Surreptitious Removal of Objects by Women

Secretly taking small objects is easier, in many ways, for a woman than it is for a man. This is because women are less apt to obey that admonition

of childhood to "look with your eyes and not with your hands." Possibly this trait is what makes women such careful buyers—women don't just look, they inspect. Because handling is so necessary a part of getting possession of an object, it is a great advantage to be able to handle the object openly without having to make an explanation or give any reason for the action.

On the other hand, women's clothes restrict the number of places an object can be hidden rapidly and secretly. Depending upon the type of attire, women have no pockets at all or very few. And women's pockets always are the wrong size and construction and in the wrong locations to hide an object easily and quickly. Further, because women's pockets are almost invariably of small capacity, they will hold only the smallest of objects. These facts do not make the task of secreting an object about a woman's person an impossibility by any means, but they do show that a woman must use different methods than those available for men. They also indicate that a woman rarely will find it possible to hide other than small objects.

The difficulty connected with any description of ways in which either obvious pockets in feminine attire, or hidden ones, may be used is caused by constantly changing fashions. As fashions change, so, particularly, do the pockets change in location, size, and shape. Of course there is the possibility that the style will permit no pockets whatsoever. While the following suggestions about pockets cannot all be followed, and in many in-

stances none can be used, they are worth mention-
ing for those times when they will serve.

There are five pieces of women's apparel in which
sometimes pockets may be found. These five articles
of clothing are skirts, blouses, jackets, coats,
and belts. The pockets now referred to are those
which are plainly visible to others, i.e., neither
secret nor hidden pockets. These pockets, both in
location and design, are made more for decorative
purposes than utilitarian. For the reasons stated
above, few are useful in trickery. However, some
may be altered so as to be useful without changing
their outward appearance.

Skirt pockets, though occasionally placed at
the hips, usually are at the front. The front
pockets seldom are big enough to be useful as
they are but often can be made of service. It will
be found possible with most of these pockets to
make an opening at the bottom of the pocket right
through the material of the skirt. To this open-
ing can be sewed a silken (or other material of
little friction) tube. This tube may itself give
the pocket sufficient capacity to make it of use.
However, this depends upon the cloth of the skirt.
Tweed, or similarly heavy material which will not
be pulled out of shape by weight in the pocket,
will permit enlarging of the pocket. Thinner mate-
rial requires other treatment. For thin material
the silken tube should extend to a pocket inside
the skirt. It may be that this pocket can be fas-
tened to a slip or petticoat, but it probably will
be found more practical to hang a pocket by tapes

from the waistband of the skirt. The practical-
ity of such a pocket depends upon the design of
the garment and particularly its fullness. Such
an inner pocket also can be used in skirts having
no visible pockets but having plaits deep enough
to hide a small opening. Care, of course, must be
taken that the inner pocket will hang so as to
make no visible bulge. These pockets can be made
and have been made and used successfully. Making
such a pocket can only be the result of feminine
ingenuity, skill, and knowledge. It is, obviously,
no project for an untutored male.

Blouse pockets, because of where they are
placed, are unsuitable for trickery. Such pockets
are too hard to reach undetectably and, further,
their contents are obvious.

Jacket pockets, when not over the hips, some-
times can be used as they are. If this is not pos-
sible, there is seldom any way of altering them.
Once in a great while it will be found practical
to make them of use by cutting an opening through
the material of the jacket and making a pocket
between the material and the lining. It also is
possible with some jackets to make pockets on
the inside. These pockets should be at about the
waistline and that, of course, cannot be done with
a fitted garment.

That coats can be worn only in certain weather
is very obvious. However, on such occasions as
they can be worn, they are most useful, for their
pockets are more apt to be large and heavy enough
to serve without any alteration. Coats also will

allow special inside pockets to be added and used. Some coats have inside pockets but usually they are not placed where they may be used easily in trickery.

Some belts are designed with pockets which can be used. Other belts can have pockets added on the inside which will be found handy. Occasionally belts can be used to cover the opening in a dress which is the mouth to a hidden pocket.

Women can use handkerchiefs in deceiving in a manner a man could never do. The handkerchiefs are used in conjunction with a handbag. The reason women can use handkerchiefs in trickery is that women so customarily carry a handkerchief in their hands that no attention is attracted to this action. The handkerchief is used as an actual physical cover for that object which is to be hidden and carried away. As is true with all tricks, there is a sequence of actions which must be memorized in order to deceive the spectator. Parenthetically, may it be noted that it always is advisable to assume that there is a spectator watching. This precaution will avoid the chance of being caught doing some action in an abrupt way in the belief that no one was looking.

The routine, making use of a handkerchief, is as follows. A handkerchief is taken from the handbag. It will facilitate matters to have had the handkerchief already unfolded when it was stuffed into the bag. When the handkerchief is in the hand, it is used immediately after the bag has been closed. In the winter an eye might be wiped

with the cloth, and in the summer the forehead might be patted. It is reasonable after either of these actions to continue holding the handkerchief. Unless one obviously has a cold, it would be more natural to return the handkerchief to the bag once the nose had been wiped.

Once this preliminary maneuver has been accomplished, the handkerchief is taken with the left hand. At this time it would be well, if easy to do, to hold the center of the handkerchief in the fist and let the four corners dangle. It might even be natural to hold a corner of the cloth and let the rest of the handkerchief hang down. Incidentally these actions should be done, if possible, sometime ahead of the moment when the handkerchief is used for the trickery. This is in order that full concentration may be made on doing the trick.

At this point consideration has to be given to the style of the handbag. If it be one which can be hung from the arm, the strap of the bag should be over the left forearm—about midway between wrist and elbow. If it is not such a bag, it should be held (with the elbow bent) between the left forearm and the body. In either case it will be obvious that the left arm has to be held still or the handbag will be dropped. Holding the handbag in either way means that any picking up which is done has to be done with the right hand. It may be assumed, for example, that the object to be made away with is anything up to the size of a box of safety matches. Now please follow closely the seven following steps:

a. The object is picked up with the right hand and looked at.

b. (While actually this is a double step, it must be done in a continuous way as if it were but one.) The object is put in the left hand in order that the right hand may take the pocketbook which "seemingly" is slipping. This move is varied according to the style of handbag. If it is the kind which is gripped between forearm and body, the bag is moved up to the armpit and grasped there. If it be the type with a handle, it is taken off the left arm and held by the handle in the right hand.

c. As the handbag moving is taking place, the left hand crumples the handkerchief around the object.

d. The handkerchief is changed over to the right hand. In this move it should be possible to conclude completely covering the object with the handkerchief.

e. The left hand (still closed as if it were holding something) is dropped to the table from which the object was picked up.

f. The left hand retrieves the "loaded" handkerchief as the right hand makes some natural movement with the handbag.

g. After an interval of a minute or so, the handkerchief is replaced in the handbag. Because of the possibility of needing a handkerchief for any normal purpose right after the trick has been done, it is ad-

visable to be prepared for such a situa-
tion by having another handkerchief tucked
in the other end of the handbag.

Reading the above, one is apt to think but
where is the trick? Why should anyone be confused
by such simple actions. There are two reasons. The
chief one is that every action made seems natural
and logical. The other reason is that there are
three objects (object, handkerchief, and handbag)
and two hands to watch. Because of the naturalness
of the actions, they do not call for close obser-
vation and it requires exceedingly close attention
to keep track of the location of three objects in
two moving hands. Again let it be pointed out that
no rapidity is to be used. The hands move slowly
but their movement is continuous. This routine
should be carefully practiced in private until the
sequence of moves is second nature.

Nothing has been said about using either of
women's traditional hiding places—stocking tip and
front of dress. This is because in most instances
neither can be used inconspicuously. Further, ei-
ther because of costume or anatomy, in neither
place can an object of any size or weight be hid-
den. However, by all means use either or both
spots as hiding places when the article or ar-
ticles to be taken are suitable and the situation
makes their use feasible.

As has been noted earlier, there is no wrong or
right way to do a trick. If it works and is simple
to do, it is a good trick. It often is necessary

to alter the performance of a trick in some slight way due to circumstances of the moment because conditions seem suspicious. This is because there is, almost invariably, some detail which has not been taken into consideration which will give the trick away. Saying it in short, and again, nothing so ensures the success of a trick as proper planning.

It is to be hoped that those women who read this section will accept, in this one instance, a man's statements as being authoritative. Trickery is a field in which men long have been active and successful. That is, those men have been successful who have followed the tested methods. These methods have been discovered through centuries of trial and error. It always has been impossible to know if a method will be deceiving except through actual performance, and, therefore, it is imperative that a trickster adhere to tested methods. Using tested methods needs only knowledge, preparation and practice, and the patience to acquire these. Rely on these, ladies, rather than upon your brilliant minds.

VIII. Working as a Team

Everything on the preceding pages has been written for the performance of trickery by the man or woman working alone. The following suggestions are made for those occasions when the trickster is in the company of a colleague. Whereas both may be capable of trickery, it is wise in any given trick

for one to be the performer and the other to be the assistant. On a second trick it is quite possible for the roles to be reversed and have the trickster become the assistant. But in a trick there always must be one person who makes the decisions as to when, where, and how. The assistant must follow the lead of the trickster.

Naturally there are three combinations of trickery-working teams. There may be two men, a man and a woman, or two women. This is mentioned because, as the makeup of a team varies, so does the role of assistant. In most instances the assistant's job is to aid by attracting the attention of the spectators before, during, or after the performance of the trick, according to when it is most needed. Naturally what the assistant does, and at which point in the performance his action takes place, is decided upon, and practiced, ahead of time. When the assistant does his part depends upon a signal given by the trickster. (The types of signal will be described below.) What is done often depends upon whether the assistant is a man or a woman.

While the above assumed that the trickster and assistant were known to be acquaintances, even friends, there may be occasion when the two are thought, by the spectators, to be total strangers. In such circumstances added methods can be used.

Before going into why and what the assistant does, it would be best to tell when the trick is to be done. As it is the trickster who has to be ready for the performance of the trick, it is his decision as to when the trick is to be done. He

then signals the assistant of his readiness. This should be a physical rather than a verbal signal. Verbal signals often have to be delayed in order not to interrupt a person who is speaking, and they are almost impossible to plan so as not to seem quite incongruous when spoken. Physical signals can be given at any time and should seem to be perfectly natural, and therefore non-attention-attracting actions. Smoothing down an eyebrow, pulling the lobe of an ear, or similar action makes a good signal. The assistant is bound to see the action, for it is high—a table-height action may be overlooked unless the assistant keeps staring at the trickster, which, of course, he must not do. The action of the signal, while it must be completely natural, cannot be anything which the trickster might be apt to do unconsciously. The assistant does not act immediately after the signal is given, but only either after a prescribed interval or following some action of the trickster according to the demands of the particular trick to be performed. Usually the trickster acknowledges having noticed the signal by blinking his eyes, stroking his chin, or in some other prearranged manner. After the signal has been acknowledged, both trickster and assistant know the other to be ready to assume his role.

The type of aid an assistant can give varies with the time the aid is given. Aid prior to the performance of a trick is of two general kinds.

SECRET

a. The assistant either by speech or action "sets the stage" for the performance. As examples: The assistant brings up the subject of the designs on certain coins. The trickster takes coins from his pocket to see whether the assistant is correct. The trickster shows a coin to the victim and performs the trick with a coin and pill as described in an earlier section of this manual. This type of conversational opening may be used by either a man or a woman. Similarly, the assistant takes a package of cigarettes from his pocket and offers cigarettes to everyone in the party. This makes it natural for the trickster to strike a match to offer a light to his neighbors and perform the trick of the pill on the package of matches.

There are two advantages to having the trick performed in this manner. The first is that the trickster was not the one to bring up the idea of another cigarette, and second, he had ample time to get set with the prepared package of matches. This action, if men were present, would be done only when a man is the assistant, for it would be less natural for a woman to offer cigarettes to a mixed group. However, it would be completely natural for one woman to offer other women cigarettes and for a second woman (the trickster) to offer a light.

194

The most frequent way in which an assistant can aid prior to the trick is verbally. For instance, the assistant can bring up the subject about which the diagram, or sketch, is drawn (for the trick with the loaded pencil). The magician's role, in drawing the diagram, is that he cannot understand the description and asks the victim to go over the sketch with him. In this instance, the assistant may be either man or woman, but the trickster (for the reasons given earlier) must be a man. Another way in which the assistant can aid prior to a trick is to express great interest in seeing a factory (or some other place when the trick to be performed is to acquire some object secretly). The trickster's role is one of lack of interest and he joins the party "only" to be a good sport. As he has no interest in factory or products (or whatever), he may do things unobserved and with greater freedom. The trickster, however, should act just as carefully as though he were alone and the focus of all attention.

b. The second way an assistant can aid prior to performance is to be the one carrying the properties by which the trick is performed. Examples are: The trickster finds he has no matches, or that he lacks a pencil, or that he wishes for a cigarette. The assistant lends the trickster

that which he wishes and, it should be needless to mention, it would be the prepared paper of matches, or pencil, or pack of cigarettes. There are two advantages to working in this way. The first is that a borrowed object "must" be innocent and just what it appears to be, and the second is that both before and after the trick (for the borrowed objects are returned) the trickster does not have the trickery items on his person.

Although it requires considerable practice in order to make the act seem accidental, an assistant can draw everyone's attention to himself by spilling his drink (coffee, wine, or water), or by having all the matches of a package flare up as he lights one. An attention arresting action of this sort by the assistant permits the trickster to do many actions quite unobserved. The same result may be obtained by the assistant getting angry and pounding the table. This requires more than average ability in acting on the part of the assistant. Further, there are many occasions when this technique would be unsuitable, particularly because in a public place it would attract general attention to the group. However, the method is noted because of its effectiveness at such times as it may be used.

There may be times when a woman can pick up something without being observed which her male companion could not do. The woman would then pass

the object to the man to secrete. The transfer nat-
urally would depend upon the place where it would
occur, the size and form of the object, and also
upon the way the man was dressed. The three gen-
eral methods which may be used are: 1. the woman
might pass the object to the hand of the man; 2.
the woman might put the object into something
(such as a hat) which the man later will pick up;
3. the woman might put the object directly into
one of the man's pockets.

Naturally, in each of these methods the man would
be aware of what the woman intended to do and so
would be in a position to aid her by distracting at-
tention from her action. If the first method is used
(i.e., passing the object from the woman's hand to
the man's hand), the man has to cooperate by having
his hand held so as immediately to be able to ac-
cept the object and, further, to hold his hand in a
position where the woman may reach it inconspicu-
ously. This would mean that the man held his hand
either down at his side in a normal position or at
his back over his buttocks. The woman would get as
close to the man as possible prior to passing the
article to him. In making this move, the woman (of
course with the man's cooperation) would use the
body of the man as a screen to hide the action from
the person to whom the man was talking. Upon re-
ceipt of the article, the man would put it in his
pocket. He would not do this unless circumstances
would make it so that no movement could be seen
until after the woman had stepped away. He would
use that pocket which, in the situation, he could

reach most easily. If the second method is used, it is because it would not be natural for the man or woman to get close together.

As such situations arise, this method is given. The method is suggested only where no other means can be used. The man's job is to leave his hat, overcoat, large envelope, etc., at a point where both sexes are permitted. He further must take care to pick up whatever has been "loaded" so as neither to disclose, nor drop the object itself. The woman's job, after getting the object, is to have some reason for getting close to the man's possessions. This may be done by having left some possessions of hers to which it is natural for her to need to go (as for a handkerchief) alongside of the article the man has put down. It is inadvisable to go to the man's possessions even with a seemingly legitimate excuse such as getting a package of cigarettes out of the man's overcoat pocket. This type of action is apt to be remembered and will likely connect the man and woman too closely for the complete success of the trick.

In using the third method, the chances of detection are very small. The method can only be used, however, when the man is wearing garments which have pockets which the woman can readily use. These pockets are the side pockets of overcoats and jackets. When the man is wearing no coat at all, it may be possible also to use a hip pocket of the trousers. Of course, this can only be done with quite a small object and with a man whose anatomy does not protrude and whose trousers are

ample in size. It will facilitate matters if the pocket is held partially open by having a handkerchief crumpled at the bottom of the pocket.

Though these methods are suggested for use by a woman as the trickster and a man as assistant (and are almost impossible to use when the role of the man and woman are reversed), they have other uses. There are times when they can be used by two men and times, also, when suitable for two women. The hand-to-hand passing method and the method of putting the object directly into the assistant's pocket also can be used in every combination of trickster and assistant in a delayed-action routine. Delayed action means that the transfer is not done at the time of the acquisition of the object. At the time the object is taken, the trickster secrets it in a pocket where it is easily available. Later the object is passed to the assistant. This may be done most easily in a crowd. The method is particularly good when the trickster and assistant are believed to be strangers. It also is useful when it is necessary for the trickster to remain but when the assistant can leave the premises.

Another means of passing an object secretly from one person to another may be used in a variety of ways by both men and women. The great advantage of this method is that the contact between two persons is made openly. An object openly is handed by one person to another. The object passed is the cover for the secret object exchanging hands. The covering object may be almost anything provided it is larger than that which it hides and is some-

thing which easily may be held by one hand. A book or magazine is suitable to use as an example of a cover. The book is grasped with the thumb on top and the fingers underneath. The book actually is held between the thumb and the third and little fingers. The secret object is held by the first and second fingers, pressing it against the back of the book. The one receiving the book uses both hands, palms up and with the tips of the fingers of one hand pointing toward those of the other. As soon as the receiver feels the hidden object, he presses it against the book with the fingers of the hand which best can hold it. The other hand holds the book. After the transfer has been completed and the giver has moved away, the secret object is pocketed as soon as the action will be convenient and will not be apparent. The covering object may be a plate, a cigarette box, paper pad, or a countless number of other things. Neither person's task is at all difficult but both should practice the actions so as to be able to do them naturally. This method will be useful both when the assistant's part is to give the trickster something he will need for his trick and when the trickster wants to get rid of something by giving it to the assistant.

The chief hazard in performing the secret passing of an object in the manner described is psychological. When the receiver's first knowledge that he is to be given the object is at the time he touches it, he will find great difficulty in controlling his involuntary reflexes. When the person is aware that he is secretly to receive the object,

there will be no reflex jerk. Therefore, it is essential that either through prearrangement between the passer and receiver or by a signal given and acknowledged prior to passing, the receiver knows that the action is to take place.

On the subject of signals, it must be noted that no signal is made twice during one session. Repetition of any signal, no matter how inconspicuously natural it may be, is apt to attract attention. Further, having two or more signals with the same meaning ensures that there will be no occasion when one or other can't be given.

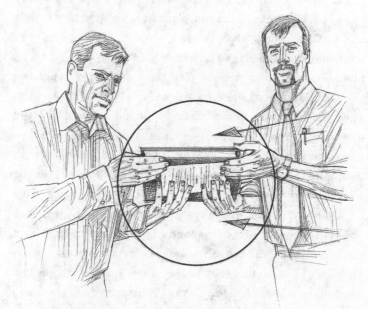

Passing one object under cover of another. Position of hands of passer and receiver make interchange easy, certain, and unnoticeable.

Another use for signals is when one person expects or hopes that he will have an assistant but does not know the identity of that individual. Here, of course, it is of extreme importance that the assistant give acknowledgment that the signal has been noted before any action takes place.

The signals mentioned above are only to indicate either being prepared for action or to establish identity and the latter is merely an addition of the former. Where a signal is indicated to designate one of a variety of possible choices, a code is required. The best code is a combination of physical signal and counting. In its operation the signaler, upon making his actions, starts to count in his mind. He counts slowly and evenly. The receiver, upon noting the signal, also counts in his mind at the same rate of speed. The sender, upon reaching the number he wishes to signal, gives a stop sign and the receiver knows that the code number is, for example, nine. Naturally, this system takes practice, but it is far easier than it sounds and is completely undetectable. The only difficulty is for the two people to learn to count at the same rate of speed. In the old days of slow-speed negatives, photographers counted seconds by repeating the word *chim-pan-zee* after each numeral. By this means photographers learned to judge from one through ten seconds with accuracy. Making the interval between numbers of greater length makes it easier for two people to count in unison. For instance repeating, "one great big chimpanzee, two great big chimpanzees, three . . . ," two people will find it quite

easy to learn to count in unison. By this means any one of ten prearranged plans may be transmitted undetectably from one person to another without speech. Because numerals above ten have two or more syllables and throw out even timing in counting and it is easier in memorizing to limit a numbered code to groups of ten, this system goes only from one through ten. In the event that more than ten variants are needed, it is advisable to have groups one, two, three, etc., and each group made up of ten items. Having more than one group requires that a signal also must be given to indicate which group is being used. This is done by having some slight variation in the "stop counting" signal or in the way the hand is held between signals. There is no reason why the starting signal and the stopping signal cannot be identical. If it is a natural and inconspicuous gesture such as smoothing an eyebrow, there is no reason why it cannot be repeated a few seconds later. It is only on a subsequent occasion that it is advisable to change the signal.

Where due to inadequate light, or other reasons, it is not possible to give a "sight" signal, the counting code can be utilized by a sound to start and stop the count. The sound has to be one that can be made easily and naturally and one that causes no surprise to those who hear it. Among such sound signals are moving the foot along the floor (easier to do when seated), tapping a cigarette four times on something hard such as a table or matchbox (the fourth tap is the signal to start counting), clearing the throat, or, where the com-

pany is permissive and the person has the control, a belch. Each of these signals may be repeated for the stop-counting sign except tapping the cigarette and that may be made by scratching a match. There are countless other suitable sounds for signals and those given are merely sample types.

Great care must be made in designating the signals to have them such that they do not take the receiver by surprise and thereby delay the start of his counting. As the count is invisible, there is no way for the sender to know if it has been done properly by the receiver. It is not like an incomplete pass in football, which is, according to your side, so pleasantly or horribly obvious.

So much for signals which are merely one aid to cooperative efforts. The major point in two people working together is the degree of oneness with which the job can be done. Success is attained by skillful work as a duet—two soloists, no matter how talented, are bound to have trouble.

In this work there is nothing which demands that the cooperating couple be alike in sex, size, manner, or temperament—as long as there is nothing to interfere with their working as a team. Often unlike individuals will, in this work, find that their differences will make their task easier and that one complements the other.

In the realm of trickery, more practice is needed to ensure success in teamwork than is needed for a person working alone. The single worker will, at times, find it possible and indicated to change pace, or even make some change in

procedure. In teamwork, where the second person cannot know what is in the mind of the first person, such changes would interfere with the second person knowing when and how to perform his part. This difficulty will be eliminated somewhat by following the rule that in each trick one must be the performer and the other the assistant. Nevertheless, practice is required, for as in dancing, where it is the man's job to lead and the woman's to follow, it takes practice to be a good partner.

However, as has been noted many times in these pages, the main thing is to understand exactly what is to be done and how it is to be done. Having such knowledge reduces the rehearsal time in teamwork just as it does for the individual.

Recognition Signals

The problem is that A and B, who have to work together, do not know or have descriptions for recognizing one another. A variation of the problem is that only one knows the other.

The problem is involved because of the many conditions which must be considered. It is possible that A and B may be able to meet and converse. It also is quite possible that it is advisable never to meet. A may be of a totally different social stratum (by role or fact), so that there would be few places both A and B could go. It might be that because of the job of one (such as a waiter), it would be either easy or impossible to have the meeting or identification take place at the job locale. Many jobs would materially limit the hours during which the worker could absent himself so as to be at another location.

Other conditions also must be considered. Were A to arrive at an airport, train, or bus station, it might be necessary for B to be able at a distance, and instantly, to recognize A. This would require

some sign or signal visible at a distance and yet not noticeable to the uninformed. Almost the same conditions would apply were A and B to pass one another on the street or in a square or public park.

Other signs and signals might be better were the contact to be made in a lobby of a business building, in a museum, gallery, or library. Still other means of identification might serve were the meeting in a restaurant, bar, or store. Of course, no clothing variations could be used were the meeting between two bathers at a public beach.

In each of these situations, and others which may come to mind, it will be remembered that while A must recognize B, it also is necessary for B to identify A. And each must have a way of knowing that the other has made the identification.

Because the problem has so many variations, it is obvious that there must be different means of identification available to meet the different conditions.

The most obvious signaling device may be called "The Chrysanthemum in the Buttonhole Technique." Naturally, such a boutonniere would rarely be suitable, but it exemplifies the qualifications such a signaling device should have. First, a flower in the buttonhole is not an unusual practice of men everywhere. Second, it can be seen instantly. Third, it has color and color attracts attention. An alternate to color is differentiation in size. (A chrysanthemum certainly is larger than any flower normally worn.) Fourth, of itself the wearing of a flower is meaningless. (However, in the

case of flowers, any specific flower lacks the basic qualification of availability anywhere and at any season of the year.)

It would seem best to divide methods for signaling into two classifications: those to be used at a distance and those for close-up use. Whereas every method which occurs to this writer for distance might also be used for close-up as well, there are a number of close-up methods which have a subtlety that makes them admirable for this purpose and they could serve a wider range of uses than most distance methods.

For distance signaling (other than manual) are variations in attire. These must be both permissible so as not to attract attention and yet clearly visible at a distance to the knowing observer. A varicolored feather in a hatband is such a device. Such feathers are generally worn and the visible, but not noticeable, distinction would be in the combination of colors used. A necktie made of material of a particular shade, or having a combination of unusual colors, might be used. Tying a tie (either four-in-hand or bow) with an unusual knot cannot be seen at a distance but can be used closeup. A twist in a knot is easily seen by anyone looking for it and is unlikely to be observed by anyone else. Even when it is noticed, it is ascribed to error rather than intent. Variations in the bow of a hatband also are easy to make and will pass unnoticed by anyone not especially looking for it. Here again, however, the change in the bow cannot be seen at a great distance.

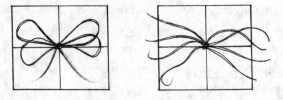

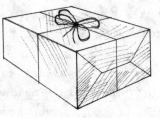

Variations of ribbons
and bows on a package
become covert recogni-
tion signals.

Carrying a parcel which is, to use the retail
store's term, "gift wrapped" can be seen at a dis-
tance. The special paper and/or the color of the
ribbon or string can be seen at an amazing dis-
tance. Naturally, the situation would have to be
such that carrying a gift would be natural and
there would have to be a gift in the package on
the chance that it would be opened. Instead of
gift wrapping the parcel, ordinary paper could
be used and the paper held closed by several wide
colored rubber bands. Or the rubber bands could be
put around the package in a prescribed manner. In-
stead of a package, a book might be used and held
closed by the rubber bands. Another way of using a
book would be to have it covered with a protective
paper, as is commonly done with schoolbooks.

Ink (invisible except when special colored glasses are used) on packages, book wrappers, or baggage labels can be seen at a distance. The special value of such ink is that added information can be given by writing a large code letter or number.

Court plaster, surgeon's tape, Band-Aids, or any similar covering for cuts makes an excellent signaling device. It may be used on the face at any spot where one might cut himself shaving, or on almost any part of the hands, or, when in swimming, on an ankle or foot. The location of the tape, its size, and its shape all may be used to modify the signal, or to make it more definite that it is a signal. In some instances, it may well be necessary to have the tape cover an actual cut in the flesh. Except for that one point, the method has every advantage possible and is useful at a distance and close up.

While some of the following signals also can be used for considerable distance, most are for nearby use.

It might be well to point out that the absence of something often is as usable a signal as can be found. A missing vest or sleeve button, a shoelace missing in a workingman's shoe, or dissimilar laces, the absence of a bow on the ribbon of a hat, a strap at only one end of a suitcase, are examples of missing things which do not attract attention but are most apparently absent to anyone looking for such discrepancy. Care must be taken to eliminate only such objects as coincidence would be most unlikely to find uninten-

tionally missing in another person's apparel or equipment.

Cutting an eraser on the end of a pencil into either a wedge shape or a point is a good middle distance signal. The pencil, point down, would be stuck in the breast pocket of the coat or shirt.

Another middle-distance signal would be the colored thread marking of a handkerchief left protruding from the breast pocket. Such threads are commonly used in many parts of the world by laundries as identification. A colored monogram in a handkerchief can be noticed easily. In either instance, the color used would be the important factor.

Organization lapel buttons, because of their variations in shape, design, and color, are quickly and easily identified. Of course they rarely, if

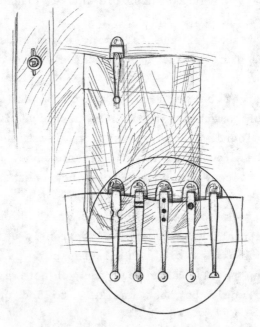

ever, could be used for the purpose under consid-
eration, but the general idea can be followed with
pen and pencil clips. The tip of the clip which goes
outside the pocket is altered so as to be identifi-
able. This may be done by filing the clip to change
its shape, drilling one or more holes in it, or col-
oring it with enamel—paint or colored sealing wax.
Naturally a specially designed clip is even bet-
ter, for its distinctive pattern may be so subtle.
On another page are suggested designs for altering
standard-type clips.

Clips also can be made from a variety of easily
obtainable metal objects. For example. a "blackhead
ejector" sold in drugstores may be made into a clip
by heating and bending. The hole is filled with col-
ored sealing wax. The cost—ten cents for the tool.

In such instances where A and B can get within
fifteen feet or so of one another, shoelaces make
an excellent signaling device. There are several
ways in which laces can be used and no one of
them ever will be noticed provided the laces are
treated identically in both shoes.

The first suggestion is to have the shoelace run
as a double strand through the eyelets nearest the
instep, i.e., toward the toes. First, the shoestring
is cut in half. Then the tip of one lace is pushed
from the inside of the shoe up through one hole,
across the instep, and down through the opposite
hole. The tip of the other half is treated in the
same way but is started from the opposite side.
While the cut ends still are outside the shoe, each
is tied, with a slipknot, around the other lace. The

tips of the laces then are drawn so as to have the two knots inside the shoe and each by one of the eyelets. (See illustration.) The shoe then is laced in the normal way. For one who is looking for such a possibility, the double lace is easy to distinguish. It will never be seen by one not particularly looking for it. Though it will not be noticed, it is without reason except to mend a broken lace were the shoes to be examined.

Because shoelaces are inserted in shoes in three standard ways, any deviation in these ways becomes useful for signaling. On other pages are illustrations of the standard ways of lacing shoes and several ways in which shoes could be laced but never are. None of these alternate ways will attract attention, yet each is very obvious to one looking for such a signal.

Using one of these shoelacing patterns is an excellent way to identify a person. Because there are several such patterns, added information could be given by the choice of pattern used. "I have information for you." "I'll follow your instruction." "I have brought another person." What need be said is not for this writer to suggest—merely the means to say it.

Alteration of design (such as with the shoe-laces) is almost as much of an attention attractor to the person looking for it as is color. Another design variant is using one different button on a shirt or vest. While the buttons so used may be unlike the other visible buttons in several ac-

ceptable ways, the use of a button of a different size is probably the best variation and, generally speaking, such a button is easier to obtain. The button should be but a little larger (or smaller) than the other buttons. When on a shirt, and a tie is worn, the tie must be one which does not cover at least two buttons. The difference in size is known by comparison. Were an outsider to notice an odd-size button—which is most unlikely—he would think that the wearer merely did not have a matching button to replace one he had lost.

Variations of tying a shoelace can be used for signaling.

Just as the trousers, as many men wear them, would be of a length to hide the shoelaces when the person is standing, so can the occupational

use of an apron hide vest buttons. Neither of these signs can be used on all occasions but both are very good at such times as they can be used.

Another similar clothing variation is the use of one grommet in one buckle hole of a belt which does not have such metal protection in any of the other holes.

The old schoolboy stunt of sticking a thumbtack in the heel of a shoe might also be useful on some occasions. It is something which could be acquired accidentally and to avoid the possibility of an inadvertent thumbtack being in the heel of the wrong person, the tack used for the signal should be stuck in a specified location on the right heel. To find a tack in a particular spot, in the right heel, and on a particular day, and at a certain place and time, of a second person would be asking too much of coincidence.

A method of attracting attention, and done for that obvious purpose, is yelling. "Hi, Pete," or "Aya, Pedro," or any such call is done for the obvious purpose of getting the attention of the one called. If the caller stands three-quarter view to the person whose attention he actually wishes to attract, rather than the imaginary Pete, the yell will serve its purpose and without connecting the two people. Naturally, as soon as the call is made the caller should wave a greeting to the imaginary Pete, and naturally, there have to be several men in that direction, so no one can know of Pete's nonexistence. This means of attracting attention only is possible where there

is a crowd, such as at a railway station, but if the crowd were large enough, it could be the only quick way. The name used should be one found in some form in all languages and in a way be something like the "Hey Rube" call circus people use for emergencies.

Acknowledgment of recognition is most important, for otherwise neither person could be certain of the other having noticed his signal. Further, it would be safest were the acknowledgment of recognition also acknowledged. Were this done, each person would be certain of the other's awareness of his presence.

At a distance, the act of rubbing the back of the neck under the collar can be seen easily. It appears to be a most natural act and does not attract attention, yet it is one which almost never is done. Note that it is not scratching the back of the neck but rubbing it with the balls of the fingers and with the fingers straight.

At a short distance the smoking signals, or drinking signals, might well be used for acknowledgment. It might be best to signal a designated number if such signals are used.

Where the contact is between waiter and patron, or clerk and customer, the acknowledgment could be by the patron asking for something unusual but not too odd. Or the waiter-clerk could offer a service or item that would be the signal of acknowledgment. In each instance, the signal would be verbal but would be without special meaning except to the persons listening for it.

The acknowledgment could be touching the special button, clip, shoelace, etc. by the one who has the original signal. Acknowledgment can use a larger variety of natural methods than would be feasible for the original signals. All that is required is that they be simple, quick, and natural.

A common type of button is made with an eye, affixed to a shank, which protrudes from the back of the button. Such buttons always are used for uniforms, and, frequently, on overcoats and other clothing. These buttons usually are made of plastic.

A coat button could be easily marked to convey a signal.

Such a button can be used at the buttonhole of the coat lapel. A cord is tied to the button and the cord runs down to the breast pocket of the coat. On the other end of the cord should be fastened a watch, key, glasses case, or any other object which should be easy to get at and would be a disadvantage to its owner were it lost. Such a button is not unlike those made commercially for just such use.

A button, such as one of these, can be seen at a fair distance and is therefore useful for identification purposes. By filing or drilling one of these buttons, added information may be given. (See sketch.)

Metal buttons can be left with the finish (usually brass or chrome) given them at the factory or they can be colored with an enamel paint. Wooden buttons may be left as natural wood, or they can be stained or painted. Plastic buttons can be purchased in a fairly wide variety of colors.

The size of the button, its color, and its design all can be used for eye-catching purposes for the one looking.

Such buttons, too, can be used by women for identification purposes. One method would be to wear the button as an ornament—a piece of ribbon could be pulled through the eye and the entire "button and bow" pinned from the other side of the cloth with a safety pin. In material with a loose weave, the threads of the cloth can be pushed apart far enough for the eye to go through the cloth without doing any damage. Again, the button

(this time minus ribbon) would be held in place with a safety pin. The button, either of shiny metal or of a suitable color, can be an attractive piece of costume ornament. The button also can be pushed through a hole made in a handbag and used with a string holding a door key—the button would be on the outside of the bag.

Ribbon bows (without the button) can be used for purposes of ornamentation (as well as identification) by women. Bows often are worn at the neckline, or, like a flower, just below the shoulder. For this special purpose, the bow should be of ribbon of certain color, or colors, and tied in an observably different way. (See sketches of two such ways to tie ribbon.) A wristband of ribbon also may be used. Here, too, the color or colors of the ribbon and the way the knot is made are the means of identification. Great care must be taken when ribbon identification is used by a woman so that the man knows what he is looking for. If this were a woman-to-woman meeting, this difficulty does not exist. Men do not visualize a double bow (or any other kind) from a woman's description. Nor do most men have any idea of colors from the names of the colors by which women identify them. The knowledge of men generally concerning colors is limited largely to the colors of traffic lights, their school colors, and those they don't like. So ladies, help us.

Wide rubber bands around a small wrapped parcel, or around a book, can be seen at a distance of fifty feet. The pattern made by the number of

bands and the way they are put around the object can give additional information. (See sketches.) It should be noted that the book used is unwrapped and cannot be of so dark a color or complicated a design that the rubber bands become invisible.

Rubber bands around a wrapped package were useful for signaling.

This type of package may also be carried by a man, though with a man it might, though it is unlikely, be noticed because it is a somewhat elaborate way to do up a package.

The court plaster and surgeon's tape suggested for use by men can be used by women by making adaptations. A Band-Aid can be used on a finger or back of hand. Instead of tape on the face, a woman can use beauty spots. If beauty spots be used, there must be a definite understanding of their

(or its) location. It might be well also to have a specific size and design decided upon. The design might be an oval rather than a circle. It should not be a butterfly, or heart, or other pattern which because of its design would attract attention.

A number of the ideas suggested for use by men also can be used by women. Many cannot. No woman would be certain of being unnoticed were she to rub the back of her neck. A man could push his hat to the back of his head to acknowledge having received a signal. And such action with a man would pass unnoticed, for it is quite natural. For a woman to push her hat to the back of her head would be so fantastic an act that everyone would look.

Toying with a necklace or bracelet, on the other hand, is for a woman similar to the way a man plays with a watch chain. Usually, for the things a man will do naturally, there are actions—counterparts which a woman may naturally do. But it has to be kept in mind, few of these actions are identical.

No attempt should be made to know and look for all the various signals and codes suggested in these pages. What have been set down are only suggestions. Some may be thought to be unusable as given, some may be adapted and made of use, and some may be of use solely as starting a trend of thought toward usable methods. The point is that whatever is used must be decided upon long before it ever is needed. Every detail then has to be studied, and fully understood, by everyone who

ever may be called upon to use the method. Any material which is successful is good. Success will depend upon people, and when one of the elements is a person, there can be no certainty of success unless that person has full knowledge and understanding. No one can be assured he has such knowledge and understanding until he has actually tried out the method to his satisfaction and under calm circumstances. In actual use there are too many distractions to try to recall unmemorized details.

NOTES

1. John Marks, *The Search for the Manchurian Candidate* (New York: W. W. Norton & Company, 1979), p. 204.

2. The headquarters compound for the Central Intelligence Agency, the George Bush Center for Intelligence, is located in Langley, VA. See www.cia.gov/about-cia/todays-cia/george-bush-center-for-intelligence/index.html

3. Special Study Group, J. H. Doolittle, Chairman, *Report on the Covert Activities of the Central Intelligence Agency* (declassified), September 30, 1954, pp. 6–7.

4. Henry Kissinger, Georgetown University Speech, May 2008.

5. For an explanation of secret inks, see Robert Wallace and H. Keith Melton, *Spycraft: The Secret History of the CIA's Spytechs from Communism to Al-Qaeda* (New York: Dutton Books, 2008), pp. 427–437.

6. Arthur C. Clarke, *Profiles of the Future* (New York: Harper & Row, 1962).

7. Public awareness of the dangers of "mind warfare" arose after Richard Condon's 1959 novel, *The Manchurian Candidate* (New York: McGraw-Hill), became a hit movie in 1962. The plot involved a brainwashed Korean War POW who returns and is remotely controlled as a Communist assassin in a plot to overthrow the U.S. government.

8. Allen Dulles, "Brain Warfare," Speech to the National Alumni Conference of the Graduate Council of Princeton University, Hot Springs, VA, April 10, 1953.

9. Some of MKULTRA's concepts had been partially researched

by the Office of Strategic Services in World War II and later in authorized CIA programs such as "Project Bluebird" (1950) and "Project Artichoke" (1951), which studied mind control, interrogation, and behavior modification. See John Waller, "The Myth of the Rogue Elephant Interred," *Studies in Intelligence* 22:3 (Washington, DC: Central Intelligence Agency, 1978), p. 6.

10. Prepared Statement of Admiral Stansfield Turner in the Joint Hearing Before the Select Committee on Intelligence and the Subcommittee on Health and Scientific Research of the Committee on Human Resources, United States Senate, 95th Congress, 1st Session, August 3, 1977. The DCI grouped MKULTRA's 149 subprojects into fifteen categories. Among these were (1) research into behavior modification, drug acquisition and testing, and clandestine administration of drugs, (2) financial and cover mechanisms for each of the subprojects, (3) subprojects, of which there were 33, funded under the MKULTRA umbrella but unrelated to behavioral modification, drugs, or toxins. Polygraph research and control of animal activity were examples offered. The process to phase out all of the MKULTRA projects required several years.

11. See Project MKULTRA, the CIA's Program of Research in Behavioral Modification: Joint Hearing Before the Select Committee on Intelligence and the Subcommittee on Health and Scientific Research of the Committee on Human Resources, United States Senate, 95th Congress, 1st Session, August 3, 1977. Published by U.S. Government Printing Office, 1977, p. 69. See also H. Keith Melton, *CIA Special Weapons and Equipment: Spy Devices of the Cold War* (New York: Sterling Publishing, 1993), p. 115.

12. On the Frank Olson Project Web site (www.FrankOlsonProject .org.Documents/DeepCreekMemo.html) are images of two documents purportedly found in a desk drawer of the family home that appear to be the original CIA invitation to the Deep Creek rendezvous in 1953.

13. Associated Press, "Family in LSD Case Gets Ford Apology," *New*

York Times Magazine, July 22, 1975. These actions did not permanently close the case and the New York City district attorney reopened the investigation in 1998. See Letter from New York Assistant District Attorney Stephen E. Saracco to the Office of the General Counsel, CIA, May 1, 1998.

14. Christopher Andrew and Vasili Mitrokhin, *The Sword and the Shield: The Mitrokhin Archive and the Secret History of the KGB* (New York: Basic Books, 1999), pp. 358–359.

15. Ibid.

16. Ibid., pp. 359, 361. The device had been produced at the intelligence service's secret arms laboratory at Khozyaistvo Zheleznovo. Khokhlov would himself become the target of a KGB attempt in 1957 to poison him using radioactive thallium—selected in the belief that it would degrade and leave no trace of the cause of his death.

17. Ibid., p. 361. For photos of KGB assassination weapons, see H. Keith Melton, *The Ultimate Spy Book* (New York: DK Publishing, 2002), pp.182–187. Soviet assassination operations continued during the Cold War, and in 1978 the KGB supplied the infamous ricin-pellet-firing umbrella weapon to the Bulgarian intelligence service (DS) for the London operation that killed dissident Georgi Markov.

18. "Colby revealed that the agency in 1952 began a super-secret research program, code-named MKNAOMI, partly to find countermeasures to chemical and biological weapons that might be used by the Russian KGB. Former CIA Director Richard Helms reported that a KGB agent used poison darts and poison spray to assassinate two Ukrainian liberation leaders in West Germany. The CIA also wanted to find a substitute for the cyanide L-pill, the suicide capsule used in World War II. Cyanide takes up to 15 minutes to work and causes an agonizingly painful death by asphyxiation." "Of Dart Guns and Poisons," *Time,* September 29, 1975.

19. Ibid.

20. Ibid. The article quotes Charles Sweeny, who is identified as a former Defense Department engineer and testified to his participation in joint tests between the CIA and Defense Department in the 1960s.

21. MKULTRA Briefing Book, Central Intelligence Agency, January 1976; released 1999.

22. For a listing of the substances, see "The Exotic Arsenal," *Time*, September 29, 1975.

23. Larry Devlin, *Chief of Station, Congo* (Public Affairs, New York City, 2007), pp. 94–95. Lumumba was later executed by Katangan authorities, see "Correspondent: Who Killed Lumumba—Transcript," BBC, 00.36.57.

24. Roger Morris, "Remember: Saddam Was Our Man. A Tyrant 40 Years in the Making," *New York Times,* March 14, 2003.

25. MKULTRA Briefing Book, Central Intelligence Agency, January 1976.

26. "Minutes of the Meeting of the Special Group (Augmented) on Operation Mongoose on October 4, 1962." U.S. attorney general Robert Kennedy and CIA director John McCone were in attendance. Original document in the Gerald R. Ford Library.

27. U.S. Senate Select Committee to Study Governmental Operations with Respect to Intelligence Activities, *Alleged Assassination Plots Involving Foreign Leaders: An Interim Report,* 94th Congress, 1st Session (Senate Report Number 94-465), November 20, 1975, p. 71.

28. Ibid., p. 72.

29. Ibid.

30. David Atlee Phillips, *The Night Watch* (New York: Atheneum, 1977), p. 91.

31. Warren Hinkle and William Turner, *The Fish Is Red: The Story of the Secret War Against Castro* (New York: Harper & Row, 1981),

pp. 30–31, and U.S. Senate, *Alleged Assassination Plots Involving Foreign Leaders,* p. 73.

32. David Wise and Thomas B. Ross, *The Espionage Establishment* (New York: Random House, 1970), p. 130.

33. U.S. Senate, *Alleged Assassination Plots Involving Foreign Leaders,* p. 85.

34. Ibid., pp. 85–86.

35. Ibid.

36. Ibid., pp. 88–89. Blackleaf-40 is a commercially available concentrate of nicotine sulfate used for horticulture and containing 40 percent of alkaloidal nicotine as a parasiticide. (See *Saunders Comprehensive Veterinary Dictionary,* 3rd edition.) The plan was for Cubela (code name AMLASH), a physician, to prepare the pen with poison after returning to Cuba. Instead of continuing with the plan at a time when Castro's personal security would be on edge following the assassination of President Kennedy, Cubela disposed of the pen in Paris.

37. *Weekly Compilation of Presidential Documents,* vol. 12 (February 23, 1976), p. 15.

38. Ben Robinson, *MagiCIAn: John Mulholland's Secret Life* (Lybrary .com, 2008), p. 84, states that Mulholland came to the attention of the CIA "because of the agency's face-to-face meeting with a supposed psychic" and that he could aid the CIA as their best consulting critic in their search for the "unlimited powers of the mind." The February 26, 1970, *New York Times* obituary for John Mulholland references his books on magic, performances in more than forty countries and charity shows for Mrs. Franklin D. Roosevelt.

39. Mulholland's obituary in the *New York Times* cites that his first book, *Beware of Familiar Spirits,* an exposé of fraudulent mediums and fortune-tellers, was published in 1938. His later books included *Quicker Than the Eye, Story of Magic, The Art of Illusion,* and in 1967, *The Magical Mind.* See "John Mulholland,

Notes

Magician and Author, 71, Dies," *New York Times*, February 26, 1970.

40. MKULTRA Document 4-29. Letter to Dr. Sidney Gottlieb, April 10, 1973.

41. MKULTRA Briefing Book, p. 13.

42. Robinson, *MagiCIAn,* p. 88. Robinson reprints a letter on Chemrophyl stationery from Grifford (Gottlieb) to Mulholland dated May 3, 1953. A confirmation of Dr. Gottlieb's cover name is found on a receipt in the author's papers from the TSS Budget office in July of 1953 for a payment of three hundred dollars to Mulholland as part of Subproject 4 and contains the typed name Sherman C. Grifford. The initials *SG* were the same for Sidney Gottlieb as well as Sherman Grifford.

43. Robinson, *MagiCIAn,* p. 169. The common initials of *SG* for Sherman Granger/Sidney Gottlieb remained consistent.

44. Ibid., pp. 98–99.

45. Memorandum for the Record, Project MKULTRA, Subproject 34, Central Intelligence Agency, MKULTRA Document 34-46, October 1, 1954.

46. Memorandum for the Record, "Definition of a Task Under MKULTRA Subproject 34," Central Intelligence Agency, MKULTRA Document 34-39, August 25, 1955.

47. Memorandum for the Record, "MKULTRA, Subproject 34-39," June 20, 1956.

48. Michael Edwards, "The Sphinx and the Spy: The Clandestine World of John Mulholland," *Genii: The Conjurors' Magazine,* April 2001.

49. Marks, *The Search for the Manchurian Candidate,* p. 204.

50. Unclassified CIA memo dated January 23, 1977, in the author's files.

51. Marks, *The Search for the Manchurian Candidate,* p. 219.

Notes

52. Evan Thomas, *The Very Best Men: Four Who Dared: The Early Years of the CIA* (New York: Simon & Schuster, 1996), p. 212.

53. "John Mulholland, Magician and Author, 71, Dies."

54. Joseph Treaser, "C.I.A. Hired Magician in Behavior Project," *New York Times,* August 3, 1977.

55. Edwards, "The Sphinx & the Spy: The Clandestine World of John Mulholland."

56. Ibid.

57. Robinson, *MagiCIAn,* p. 136. Robinson commented that though only 46 percent of the original manual was made public, his possession of Mulholland's original handwritten notes and rough draft of the manual from the Milbourne Christopher Collection allowed him to "piece together what information the government has withheld from public inspection."

58. John Mulholland, "Some Operational Applications of the Art of Deception," 1953.

59. Jim Steinmeyer, *Hiding the Elephant: How Magicians Invented the Impossible and Learned to Disappear* (New York: Carroll & Graf, 2003), p. 80.

60. Dariel Fitzkee, *Magic by Misdirection* (Pomeroy, OH: Lee Jacobs Publication, 1975), p. 69.

61. A "dead drop" is a secure form of impersonal communication that allows the agent and handler to exchange materials (money, documents, film, etc.) without a direct encounter. Dead drops were "timed operations" in which the dropped package remained in a location for only a short time until retrieved by the agent or the handler.

62. Henrietta Goodden, *Camouflage and Art: Design and Deception in World War 2* (London: Unicorn Press, 2007), p. 34.

63. Boyer Bell and Barton Whaley, *Cheating and Deception* (New Brunswick, NJ: Transaction Publishers, 1991), pp. 78–80.

64. New Grey Marine 671 diesel engines increased the speed of the

boats from three to fifteen knots for infiltration operations. See Wallace and Melton, *Spycraft*, p. 281. Photographs of the modified junks are shown in *Spycraft*'s second photo supplement following p. 358.

65. In a 1998 interview, Tony Mendez commented that the KGB surveillance teams, faced with the choice between "believing their eyes"—and thus admitting that they had lost sight of their CIA surveillance target—or rationalizing the lapse in surveillance as being inconsequential, invariably chose the latter.

66. Tony and Jonna Mendez presentation at the International Spy Museum, Washington, DC, October 27, 2008.

67. Benjamin Weiser, *A Secret Life: The Polish Officer, His Covert Mission, and the Price He Paid to Save His Country* (New York: Public Affairs, 2000), pp. 74–75.

68. Ibid., p. 77.

69. Ibid.

70. The authors retraced each of Hanssen's identified dead drop sites and noted their similarities. Most sites appeared to provide quick access from a nearby parking location, good "cover" from foliage, and, after reaching the sites, excellent visibility of the footpaths leading to them.

71. Hanssen's eventual arrest on February 21, 2001, was not a result of bad stage management or sloppy tradecraft, though he was certainly guilty of the latter. In an interview with Melton in December of 2007, retired CIA officer Brian Kelley recounted that Hanssen became complacent. He was observed when servicing his dead drops by two ladies from his neighborhood who were walking through the park in the early morning hours and saw him lying on his stomach on a footbridge in the park near their home in Vienna, Virginia. The incident was not reported before his arrest, and at the time the women thought Hanssen was involved in a drug transaction. Retired intelligence officer Victor Cherkashin, the first KGB handler for both Robert Han-

ssen and Aldrich Ames, alleges that information about the spy was first provided by a retired senior SVR officer, cryptonym AVENGER. According to Cherkashin, this information led the CIA to Ames, and then to another retired top-level KGB officer, who gave them the KGB/SVR files on Hanssen in November of 2000. See Cherkashin, *Spy Handler: Memoir of a KGB Officer: The True Story of the Man Who Recruited Robert Hanssen and Aldrich Ames* (New York: Basic Books, 2005), p. 251.

72. Antonio J. Mendez, *The Master of Disguise: My Secret Life in the CIA* (New York: Morrow, 1999), pp. 140–141.

73. Keith Melton interview in Moscow with Yuri Kobaladze, July 1995. Kobaladze was a former KGB intelligence officer in the London *rezidentura* and worked for Gordievsky. Kobaladze rose to become the first press officer for the SVR following the collapse of the Soviet Union and was promoted to the rank of general.

74. Keith Melton interview with Oleg Gordievsky on July 4, 1995, at his residence outside London, England.

75. For an illustrated explanation of "the impassable corks" trick, see: http://magic.about.com/od/libraryofsimpletricks/ss/magic corks.htm.

76. Tony Mendez, "A Classic Case of Deception," Center for the Study of Intelligence, Central Intelligence Agency, wwwcia. gov/library/center-for-the-study-of-intelligence/csi-publi cations/csi-studies/studies/winter99-00/art1.html.

77. Harry Kellar was the leading stage magician in the early 1900s. Quoted from Jim Steinmeyer's review of *The Master of Disguise: My Secret Life in the CIA* by Antonio Mendez. *Studies in Intelligence,* www.cia.gov/library/center-for-the-study-of-intelligence/ kent-csi/docs/v46i1a09p.htm.

78. Weiser, *A Secret Life,* p. 66.

79. See photo, Melton, *The Ultimate Spy Book,* p. 79.

80. Melton interview in May 2008 with former undercover officer discussing examples learned in the UK from operations infiltrating suspicious members of the IRA.

81. Mendez recounted advice given to him early in his CIA career as quoted in Jim Steinmeyer's review of *The Master of Disguise: My Secret Life in the CIA* by Antonio Mendez. *Studies in Intelligence,* www.cia.gov/library/center-for-the-study-of-intelligence/kent-csi/docs/v46i1a09p.htm.

82. The term *walk-in* is used by intelligence professionals to refer to a broad range of volunteers such as *walk-ups, write-ins,* or *call-ins.*

83. In 1968, no category of the Academy Awards existed to recognize "makeup effects." John Chambers received an honorary award for his makeup work in the 1968 film *Planet of the Apes*. See Variety Film Database, http://www.variety.com/review/VE1117794029.html?categoryid=31&cs=1. One of the masks Chambers created for *Planet of the Apes* was loaned by Tony Mendez to the International Spy Museum in Washington, DC, where it is on display in the disguise section of "Spy School."

84. How the FBI identifies a traitor is usually not explained, but most often the tips come either from defectors or from counterespionage operations to penetrate opposing intelligence services. FBI special agent Earl Edwin Pitts, former NSA employee Robert Lipka, and retired U.S. Army lieutenant colonel George Trofimoff were all victims of such "tips" and their own greed.

85. Dong-Phuong Nguem, "Trofimoff, 75, Sentenced to Life in Prison for Spying," *St. Petersburg Times,* September 28, 2001.

86. Other theories exist to explain Houdini's passage through the wall. Walter Gibson and Morris Young provide a description and illustration (*Houdini on Magic* [New York: Dover, 1953], p. 221) showing the brick wall resting on top of a carpet. Houdini is depicted squeezing beneath the wall in the slack space created when an underlying trapdoor is opened to cause the carpet to sag. For Adams's explanation of the trick using a dif-

ferent technique, see blog.modernmechanix.com/2008/03/13/
exposing-houdinis-tricks-of-magic/?Qwd=./Modern-
Mechanix/11-1929/houdinis_tricks&Qif=houdinis_tricks_0
.jpg&Qiv=thumbs&Qis=XL#qdig.

87. Ibid.

88. In the 2006 movie *The Prestige,* the magician appears to achieve
the impossible, that of human transportation across the stage.
Only in the closing scenes is it explained that using an unseen
identical twin brother created the illusion.

89. Antonio and Jonna Mendez, *Spy Dust: Two Masters of Disguise
Reveal the Tools and Operations that Helped Win the Cold War* (New
York: Atria Books, 2002), pp. 254–273. These retired CIA
technical officers and former chiefs of disguise recount a de-
tailed identity transfer and exfiltration of a couple (code name
ORB and his wife) from Moscow. Their account of the escape
is likely sanitized to safeguard the identity of the individuals
involved.

90. For a description of the development of the JIB, see Wallace and
Melton, *Spycraft,* pp. 130–131. Former intelligence officer Ed-
ward Lee Howard, who had completed clandestine training for
a posting to Moscow, was fired by the CIA in 1983 and later be-
trayed secrets to the KGB. In 1985, while living in New Mexico,
Howard employed a homemade JIB to escape FBI surveillance
and fled to Moscow. See *Spycraft,* pp. 154–155.

91. Unpublished Keith Melton lecture, "The Evolution of Trade-
craft," first presented in 2001.

92. Keith Melton's archive has World War II photographs from
the British Inter-Services Research Bureau with the rubber-
cow camouflage opened to show the two-man team, as well as
closed.

93. Kenneth Silverman, *Houdini!: The Career of Ehrich Weiss* (New
York: HarperCollins, 1996), pp. 99–100.

94. Ibid.

95. William Kalush and Larry Sloman, *The Secret Life of Houdini: The Making of America's First Superhero* (New York: Atria Books, 2006), pp. 132–133.

96. Ibid., p. 133.

97. An additional hollow finger was used as a concealment in the palm.

98. Kalush and Sloman, *The Secret Life of Houdini,* p. 133.

99. Ibid., pp. 97–99.

100. Ibid., p. 100.

101. Ibid., p. 233.

102. Clayton Hutton, *Official Secret* (London: Max Parish, 1960), pp. 2–3.

103. Ibid., p. 5.

104. Ibid., p. 7.

105. Ibid., p. 287.

106. M.R.D. Foot and James Langley, *MI9: Escape and Evasion* (London: Bodley Head, 1979), pp. 34–35.

107. Eventually German security learned of the right-hand threads and MI9 switched to a pressure fit. The war ended before German guards became aware of the final evolution of the design. See H. Keith Melton, *OSS Special Weapons and Equipment: Spy Devices of World War II* (New York: Sterling Publishing, 1991), p. 113.

108. Foot and Langley, *MI9: Escape and Evasion,* p. 109.

109. The Mokana shoe used a hollow heel as a concealment for escape tools. See: Will Goldston, *Tricks and Illusions for Amateur and Professional Conjurers* (London: George Routledge & Sons), 1920, pp. 138, 140. Also see Kalush and Sloman, *The Secret Life of Houdini,* p. 179.

110. Kalush and Sloman, *The Secret Life of Houdini,* p. 179.

Notes

111. Charles Fraser-Smith, *The Secret War of Charles Fraser-Smith* (London: Michael Joseph, 1981), cover.

112. Hutton, *Official Secret,* photo supplement following p. 48.

113. Charles Connell, *The Hidden Catch* (London: Elek Books, 1955), photograph preceding p. 65.

114. See article by Steranko, *Genii: The Conjurors' Magazine,* October 1964.

115. Kalush and Sloman, *The Secret Life of Houdini,* p. 179.

116. H. Keith Melton, *CIA Special Weapons and Equipment: Spy Devices of the Cold War* (New York: Sterling Publications, 1993), p. 106. Leatherman is a commercially available multitool. See: http://www.leatherman.com/multi-tools/default.aspx.

117. Kalush and Sloman, *The Secret Life of Houdini,* pp. 178, 181.

118. Melton, *CIA Special Weapons,* p. 75.

119. Ibid., p. 72.

120. Eddie Sachs, *Sleight of Hand: A Practical Manual of Legerdemain* (London, L.U. Gill 1885), p. 2, "Formerly conjurers appeared clothed in long robes and tall, pointed hats, both covered with mystic signs and symbols. Robert Houdini, whom we may consider the father of modern conjuring, being the first to perform in the now conventional evening dress. This innovation had the effect of increasing the genuineness of the performance, as it was an easy matter to conceal large articles beneath a flowing robe, such as had been previously worn; but the close-fitting dress suit affords no means of concealment—to the minds of the audience, at any rate."

121. Wallace and Melton, *Spycraft,* pp. 228–229, describes a topcoat tailored to hide an eavesdropping device that a CIA officer carried for weeks until he had the opportunity to install the bug.

122. Fitzkee, *Magic by Misdirection,* p. 87.

123. British Special Operations, Executive (SOE) crafted waistcoats

and various styles of money belts in World War II to conceal stacks of currency or small equipment. The special clothing camouflaged the "load" in pockets designed to fit in the small of the user's back in the upper chest to avoid detection. For photographs see: Mark Seaman, *Secret Agent's Handbook: The WWII Spy Manual of Devices, Disguises, Gadgets, and Concealed Weapons* (Guilford, CT: The Lyons Press, 2001), pp. 138–139, 143.

124. By dropping the matchbox through his coat to the floor, Jacob could deny that he had retrieved it from the drop site. However, the distinction was of little consequence since, unbeknownst to him, the KGB had secretly photographed all of his actions at the drop site. Jacob was detained and declared persona non grata (PNG'd) from Russia. For a KGB surveillance photo of Jacob about to clear the drop see Wallace and Melton, *Spycraft*, photo section following p. 166, and pp. 28–30.

125. Goldston, *Tricks and Illusions,* pp. 138, 140; Kalush and Sloman, *The Secret Life of Houdini,* p. 179.

126. See Melton, *Ultimate Spy,* pp. 107, 159, for photos. In a March 2009 interview, retired RCMP Security Service counterintelligence officer Dan Mulvenna related an incident according to which the Canadians in the early 1970s secretly placed a transmitter in the heel of an StB officer's street shoe while he was on the tennis court. Technicians, J-Operations or J-OPS, replaced the heel of his shoe, which he believed was securely stowed in his club locker.

127. *Bugging* is a term in common use that refers to the various forms of clandestine electronic audio surveillance, or eavesdropping. See Melton, *Ultimate Spy*, pp. 102–111, for photos, and Wallace and Melton, *Spycraft*, pp. 405–416, for details.

128. Athan G. Theoharis with Richard H. Immerman, *The Central Intelligence Agency: Security Under Scrutiny* (Westport, CT: Greenwood Press, 2006), p. 313.

129. *The Trial of the U2: Exclusive Authorized Account of the Court*

Notes

Proceedings of the Case of Francis Gary Powers, heard before the Military Division of the Supreme Court of the USSR, Moscow, August 17, 18, 19, 1960, (Chicago: Translation World Publishers, 1960). Also see Gary Powers and Curt Gentry, *Operation Overflight* (New York: Brassey's, 2003), pp. 50–51.

130. The device was not an offensive weapon, but a means to provide a fast means of suicide. Previous research in World War II had produced a lethal pill (L-pill) using cyanide, which took fifteen minutes to work and caused death painfully by asphyxiation. The poison on the needle carried by Powers was shellfish toxin and would have resulted in paralysis and death within ten seconds. See "Of Dart Guns and Poisons," *Time,* September 29, 1975.

131. *The Trial of the U2,* p. 38.

132. Powers pled guilty to espionage at his trial in August of 1960 and received a ten-year sentence. He was released in 1962 as part of a spy swap involving KGB spy Rudolf Abel. See Norman Polmar and Thomas B. Allen, *Spy Book: The Encyclopedia of Espionage* (New York: Random House, 1998), pp. 448–449.

133. Voice codes convey meaning clandestinely by altering the inflection, sequence, or selection of words used between the performer and his confederate.

134. The exploitation of a believing audience with a hidden earpiece receiver by a televangelist/performer/faith healer was depicted in the 1992 movie *Leap of Faith,* starring Steve Martin.

135. An earlier solution by the CIA was to hide the receiver inside the bowl of a smoking pipe and use bone conductivity to allow him to "hear" when he bit down on the pipe stem. See Wallace and Melton, *Spycraft,* p. 418.

136. See a photo of the Phonak and ear camouflage in the second photo supplement of Wallace and Melton, *Spycraft,* following p. 358.

137. Communicating secrets in high-threat postings, such as Mos-

Notes

cow, was a constant concern for CIA officers who suspected audio eavesdropping from within even their own embassy. One temporary, but effective, solution was the "Magic Slate." Instead of talking, messages would be written on a slate and handed to another officer, who read it and then lifted the transparency to erase the words. The slates were never left where an adversary could have access. Their tools, ordinary children's toys, were identical in function and derived from the "slates" used by spiritualists and performers, including Houdini, to summon messages from communicative spirits almost a century earlier.

138. A prototype of the false scrotum is in Keith Melton's Florida museum and descriptions of its development and use are included in museum tours and Melton's "The Evolution of Tradecraft" lecture. The wearer donned the concealment by inserting one testicle at a time into the false scrotum. Once loaded, it was held in place until access was required to the radio. The concealment was built and successfully tested, but it was never employed operationally.

139. An example of this exfiltration technique is on display in Moscow at the Border Guard Museum and credited to a smuggling ring in 1905. Following the dissolution of the KGB at the end of the Cold War, the Border Guards are now part of FSB, the Federal Counterintelligence Service of the Russian Federation.

140. Keith Melton interview with Tony Mendez, July 1998.

141. For a detailed description of dead drops and concealments, see Wallace and Melton, *Spycraft,* pp. 388–400.

142. See Melton, *Ultimate Spy,* pp. 154–163, for photos of concealments and dead drops.

143. For a photo of the dead rat concealment, see Wallace and Melton, *Spycraft,* photo section following p. 358. If necessary, the rats' fur could be dyed using commercially available hair-coloring products so as to match the fur of indigenous rats observed in the operational area.

Notes

144. CIA agent Aleksandr Ogorodnik committed suicide following his arrest after biting into a CIA-supplied fountain pen (working) that contained an L-pill (suicide) in the cap. See Wallace and Melton, *Spycraft*, pp. 101–102.

145 Quoted from Jim Steinmeyer's review of *The Master of Disguise: My Secret Life in the CIA* by Antonio Mendez. *Studies in Intelligence,* www.cia.gov/library/center-for-the-study-of-intelligence/kent-csi/docs/v46i1a09p.htm.

146. Steinmeyer, *Hiding the Elephant,* p. 80, describes sight lines as "the imaginary lines of vision, the boundaries of what an audience will see or what they will be prevented from seeing."

147. Henry Hay, *The Amateur Magician's Handbook* (Edison, NJ: Castle Books, 1982), p. 129.

148. Fitzkee, *Magic by Misdirection,* p. 104.

149. Professional coin manipulators employ a variety of coins for deceptions; half dollars or silver dollars are more visible to audiences and easier to handle, while the smaller, thinner, and lighter dimes and pennies are better for palming (concealing in the hand) and more likely to be sharply milled. See Hay, *The Amateur Magician's Handbook,* p. 129.

150. The Soviet intelligence service (NKVD) began concealing soft film in hollow coins as early as 1933–1934 to facilitate their covert communication with agents. The NKVD conducted sophisticated intelligence operations globally between the world wars at a time in which U.S. intelligence capabilities had been almost eliminated. (Keith Melton interviewed the retired former chief of clandestine photography for the KGB's First Directorate in Moscow during 1994.) Separating the film's emulsion layer from its transparent base produces soft film. The thin emulsion is fragile, but easier to conceal. Microdots are optical reductions of a photographic negative to a size that is illegible without magnification, usually one millimeter or smaller in area. One-time-pads are groups of random numbers or letters arranged in columns, used for encoding and de-

coding messages. Since the codes are used only once, a properly employed OTP is theoretically unbreakable. Secure-data storage cards are forms of nonvolatile digital memory, which can be as small as 32 mm by 24 mm by 2.1 mm and can store gigabytes of data. See Wallace and Melton, *Spycraft,* pp. 429–435.

151. See photographs of the nickel and the complete story on the official FBI Web site: www.fbi.gov/libref/historic/famcases/abel/abel.htm.

152. The term used for Soviet and Russian intelligence officers operating abroad without benefits of "diplomatic cover." Illegals pose as legitimate residents of the target country and are protected only by a strong cover.

153. Robert J. Lamphere, *The FBI-KGB War, A Special Agent's Story* (New York: Random House, 1986), pp. 270–271. An examination of the ciphered message by FBI experts concluded that it was prepared using a Cyrillic typewriter. A conversation with "two men from the RCMP" confirmed the importance of the "nickel and cipher" to Lamphere and convinced him it was created using a one-time-pad (called a gama) and intended for use by a Soviet illegal officer operating in the United States.

154. Polmar and Allen, *Spybook,* p. 530.

155. Andrew and Mitrokhin, *The Sword and the Shield*, pp. 159–160.

156. To compensate for the missing weight of the milled-out inner core, it would be possible to add an inner ring of denser metal within the cavity to restore the coin to its original weight.

157. When the coin is fitted into the machined ring and struck against a hard surface, inertia separates the two sides of the coin and reveals the secret cavity.

158. Tom Mangold, *Cold Warrior: James Jesus Angleton: The CIA's Master Spy Hunter* (New York: Simon & Schuster, 1991), p. 215. In a positive transparency, the background is clear and only the text of the message appears in black. To aid in concealment, the KGB developed techniques to strip the emulsion of film away

from its backing and bleach it in diluted iodine to make it clear. The thin emulsion would appear clear, but could be redeveloped and fixed using ordinary film processing chemicals for viewing. See Wallace and Melton, *Spycraft,* pp. 429–431.

159. Mangold, p. 215.

160. Melton, "The Evolution of Tradecraft."

161. The internal CIA Museum is considered the "most secret museum in the world" and the "best museum that you'll never get to see." Some of its unclassified holdings are displayed in two museums inside the CIA headquarters buildings in Langley, Virginia.

162. www.cia.gov/about-cia/cia-museum/cia-museum-tour/flash-movie-text.html.

163. Donated artifacts sometimes arrive at the CIA Museum curator's office without any history and have been known to even appear anonymously on the curator's desk during a lunch hour. The necessary compartmentation of clandestine operations may result in the operational history of an artifact being lost.

164. A concealment device, or CD, includes a hidden compartment to which access is obtained for locks, hinges, and latches. The mechanical actions necessary to open a professional CD are normally a sequence of unnatural twists, turns, and pulls. See Wallace and Melton, *Spycraft,* p. 390.

165. Robinson, *MagiCIAn,* p. 163. Mulholland's "dope" coin is cited as being in the Robinson collection.

166. Robert Lee Holtz, "Behold the Appearance of the Invisibility Cloak," *Wall Street Journal*, March 13, 2009.

167. In the story, the scientist, Griffin, makes himself invisible by altering his body's refractive index to that of air so that he becomes invisible. Unfortunately for the character, the alteration is not reversible and is accompanied by mental instability. In 1933 Universal Pictures made it into a movie of the same name.

Wells's novel can be downloaded from www.gutenberg.org/etext/5230.

168. Jim Steinmeyer, *Hiding the Elephant.*

169. In a similar manner, the "best" espionage tradecraft, including clandestine techniques and devices, will always employ the "best" available technology. The objectives of espionage do not change, but the tools employed by the spy are constantly changing and becoming more capable.

SELECTED BIBLIOGRAPHY

Bookplate from John Mulholland's extensive library of magic and conjuring.

Andrew, Christopher, and Vasili Mitrokhin. *The Sword and the Shield: The Mitrokhin Archive and the Secret History of the KGB*. New York: Basic Books, 1999.

Bell, Boyer, and Barton Whaley. *Cheating and Deception*. New Brunswick, NJ: Transaction Publishers, 1991.

Cherkashin, Victor. *Spy Handler: Memoir of a KGB Officer: The True Story of the Man Who Recruited Robert Hanssen and Aldrich Ames*. New York: Basic Books, 2005.

Connell, Charles. *The Hidden Catch*. London: Elek Books, 1955.

Cook, Andrew M. *MI5's First Spymaster*. Gloucestershire, England: Tempus Publishing, 2004.

Dawes, Edwin. *The Great Illusionists*. London: David & Charles, 1979.

Devlin, Larry. *Chief of Station, Congo*. New York: Public Affairs, 2007.

Fisher, David. *The War Magician: How Jasper Maskelyne and his Magic Gang Altered the Course of World War II*. New York: Coward-McCann, 1983.

Fitzkee, Dariel. *Magic by Misdirection.* Pomeroy, OH: Lee Jacobs Publication, 1975.

Foot, M.R.D., and James Langley. *MI9: Escape and Evasion.* London: Bodley Head, 1979.

Fraser-Smith, Charles. *The Secret War of Charles Fraser-Smith.* London: Michael Joseph, 1981.

Gibson, Walter, and Morris Young. *Houdini on Magic.* New York: Dover Publications, 1953.

Goldston, Will. *Tricks and Illusions.* London: George Routledge & Sons, 1908.

Goodden, Henrietta. *Camouflage and Art: Design and Deception in World War 2.* London: Unicorn Press, 2007.

Hutton, Clayton. *Official Secret.* London: Max Parish, 1960.

Kalush, William, and Larry Sloman. *The Secret Life of Houdini: The Making of America's First Superhero.* New York: Atria Books, 2006.

Lamphere, Robert J. *The FBI-KGB War, A Special Agent's Story.* New York: Random House, 1986.

Mangold, Tom. *Cold Warrior: James Jesus Angleton: The CIA's Master Spy Hunter.* New York: Simon & Schuster, 1991.

Marks, John. *The Search for the Manchurian Candidate.* New York: W. W. Norton & Company, 1979.

Melton, H. Keith. *CIA Special Weapons & Equipment: Spy Devices of the Cold War.* New York: Sterling Publications, 1993.

———. *OSS Special Weapons and Devices: Spy Devices of World War II.* New York: Sterling Publishing, 1991.

———. *Ultimate Spy.* London: DK, 2002.

Mendez, Antonio J. *The Master of Disguise: My Secret Life in the CIA.* New York: Morrow, 1999.

Mendez, Antonio J., and Jonna Mendez. *Spy Dust: Two Masters of Disguise Reveal the Tools and Operations That Helped Win the Cold War.* New

York: Atria Books, 2002.

Mulholland, John. *Mulholland's Book of Magic.* New York: Charles Scribner's Sons, 1963.

Polmar, Norman, and Thomas B. Allen. *Spy Book: The Encyclopedia of Espionage.* New York: Random House, 1998.

Powers, Gary, with Curt Gentry. *Operation Overflight.* London: Hodder & Stoughton, Ltd., 1971.

Robinson, Ben. *MagiCIAn: John Mulholland's Secret Life.* Lybrary.com, 2008.

Roco, Mihail C., and William Sims Bainbridge. *Nanotechnology; Societal Implications II.* U.S. National Science Foundation, National Science and Technology Council, 2007.

Sachs, Eddie. *Sleight of Hand: A Practical Manual of Legerdemain.* London: L.U. Gill, 1885.

Seaman, Mark. *Secret Agent's Handbook: The World War I Spy Manual of Devices, Disguises, Gadgets, and Concealed Weapons.* Guilford, CT: Lyons Press, 2001.

Silverman, Kenneth. *Houdini!: The Career of Ehrich Weiss.* New York: HarperCollins, 1996.

Snider, L. Britt. *The Agency and the Hill: The CIA's Relationship with Congress, 1964-2004.* Washington, DC: Central Intelligence Agency, The Center for the Study of Intelligence, 2008.

Steinmeyer, Jim. *Art and Other Essays on Illusion & Artifice.* (New York: Carroll & Graf Publishers, 2006).

———. *Hiding the Elephant: How Magicians Invented the Impossible and Learned to Disappear.* New York: Carroll & Graf Publishers, 2003.

———. Book Review: "The Master of Disguise: My Secret Life in the CIA," *Studies in Intelligence* 46:2. Central Intelligence Agency, 2002.

Theoharis, Athan G., with Richard H. Immerman, Loch Johnson, Kathryn Olmsted, and John Prados. *The Central Intelligence Agency.* Westport, CT: Greenwood Publishing Group, 2006.

Selected Bibliography

Thomas, Evan. *The Very Best Men: Four Who Dared: The Early Years of the CIA.* New York: Simon & Schuster, 1996.

U.S. Senate, Select Committee on Intelligence and the Subcommittee on Health and Scientific Research of the Committee on Human Resources. *Project MKULTRA: The CIA's Program of Research in Behavioral Modification.* 95th Congress, 1st Session, August 3, 1977.

Waldron, Daniel. *Blackstone: A Magician's Life.* Glenwood, IL: Meyerbooks, 1999.

Wallace, Robert, and H. Keith Melton. *Spycraft: The Secret History of the CIA's Spytechs from Communism to Al-Qaeda.* New York: Dutton Books, 2008.

Weiser, Benjamin. *A Secret Life: The Polish Officer, His Covert Mission, and the Price He Paid to Save His Country.* New York: Public Affairs, 2004.

Wise, David, and Thomas B. Ross. *The Espionage Establishment.* New York: Random House, 1970.

About the Authors

H. KEITH MELTON, a graduate of the U.S. Naval Academy, is an intelligence historian and a specialist in clandestine technology and espionage "tradecraft." Recognized internationally as an authority on spy technology, Melton has assembled an unparalleled collection of over eight thousand spy devices, books, and papers of eminent spies. He is the author of several books, including *CIA Special Weapons and Equipment*, *Ultimate Spy*, and coauthor, with Bob Wallace, of *Spycraft: The Secret History of the CIA's Spytechs from Communism to Al-Qaeda* (Dutton, 2008). He is also a member of the board of directors for the International Spy Museum in Washington, D.C., and the technical tradecraft historian at the Interagency Training Center. He lives in Florida.

ROBERT WALLACE retired from the CIA in 2003 after thirty-two years of service as an operations officer and senior executive, including an assignment as director of the Office of Technical Service. Wallace was awarded the Intelligence Medal of Merit and the Distinguished Career Intelligence Medal. Under his leadership, OTS received two Meritorious Unit Citations. Wallace is coauthor, with H. Keith Melton, of *Spycraft: The Secret History of the CIA's Spytechs from Communism to Al-Qaeda* (Dutton, 2008). He is founder of the Artemus Consulting Group, and a resource for the oral history program of the CIA's Center for the Study of Intelligence. He lives in Virginia.